IMAGES
of America

HISTORIC DOWNTOWN
ROSENBERG

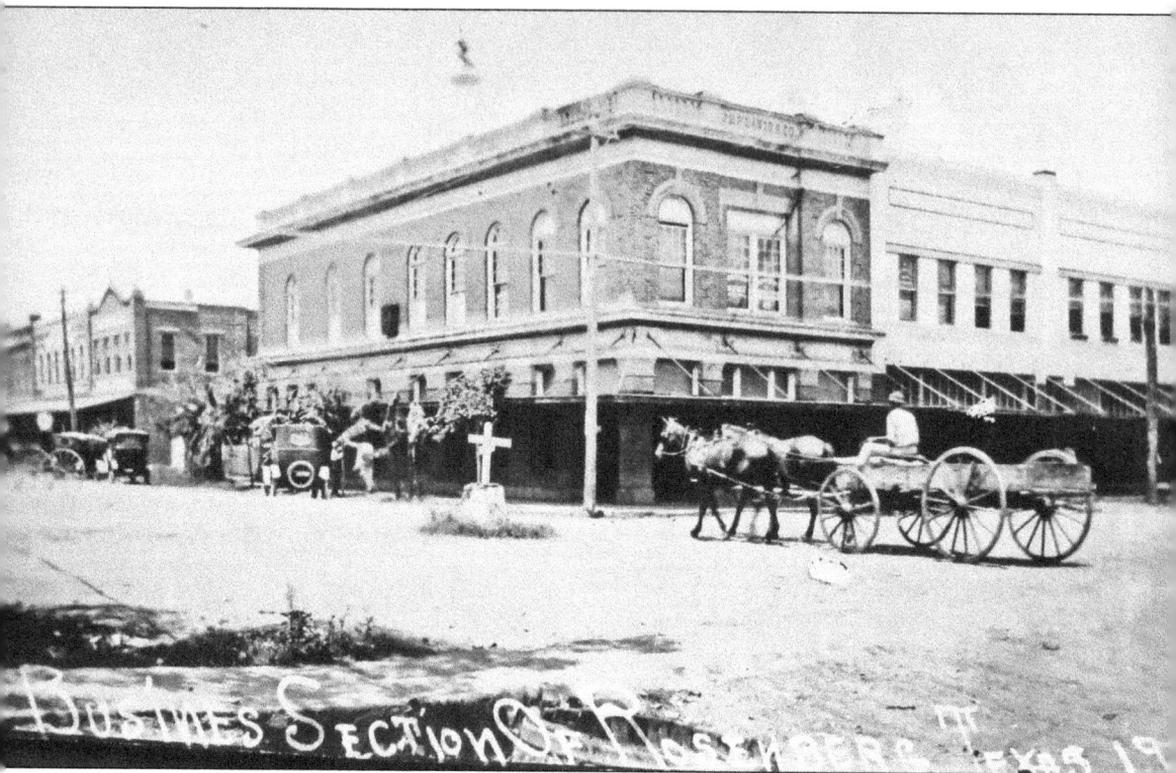

The business district of Rosenberg, Texas, in 1921 was active and alive. Defined in this photograph by the wooden street marker in the middle of the intersection, this was the geographical heart of downtown, the crossroads of Main (Third) Street and Avenue G. A horse-drawn buggy crosses in front of the J.H.P. Davis Bank, the first brick building, constructed in 1907. Both horse-powered and gasoline-powered vehicles roamed the dirt streets. Multiple businesses catering to either mode of transportation were available to help people, should they need it. The railroad, one block north, still fed the downtown with travelers and rail workers needing food and shelter. A large general mercantile was located in the middle of the two-story building beyond the bank. If he needed to mail a letter, the man in the buggy had passed up the post office a few doors behind him. The new Liberty Theater, one block south, could entertain customers with the latest movie. (Courtesy of Wayne and Jan Forster.)

On the Cover: In the mid-1950s, a mother and daughter admire the special chocolates and stuffed rabbits on display in the window of Boring's Variety Store, located on Main Street in Rosenberg. Shoppers came here for medicine and, in this case, to find the perfect Easter treat. (Courtesy of Anne Boring and Heather Boring Hartt.)

IMAGES
of America
HISTORIC DOWNTOWN
ROSENBERG

The Rosenberg Historians

ARCADIA
PUBLISHING

Published by Arcadia Publishing
Charleston, South Carolina

Library of Congress Control Number: 2015935345

For all general information, please contact Arcadia Publishing:
Telephone 843-853-2070
Fax 843-853-0044
E-mail sales@arcadiapublishing.com
For customer service and orders:
Toll-Free 1-888-313-2665

Visit us on the Internet at www.arcadiapublishing.com

This book is dedicated to everyone who ever set foot in
downtown Rosenberg. If only the buildings could speak! Main
Street was the center of activity. Now, with the rejuvenation
of downtown, Main Street is back and as vibrant as it was
just before and after the move into the 20th century.

CONTENTS

ACKNOWLEDGMENTS

As the Rosenberg Historians, we are proud of the book and want to thank everyone who helped answer questions and reminisced of a simpler time. Unless otherwise noted, photographs are from the following Rosenberg Historians: Sherry Bergen, Eva Blasé, William C. Butler, Anne Boring, Heather Boring Hartt, Burnette Boyett, Wayne and Jan Forster, Frank Gutowsky, Leon Ullrich, Edwin Ubernosky, James Urbish, and Charles Volek. Several photographs appear courtesy of the Fort Bend County Museum Association in Richmond, Texas, and from the George Memorial Library in Richmond. We tried to use as many family photographs as possible, collected from those named above. BAC Photography and Design took the current photographs; thank you, Brandon Campbell.

The Rosenberg Historians are made up of the following: Rudy Antrich Jr., Carolyn Vilt Banfield, Neil Banfield, Larry Barcak, Barbara Roane Bleil, Suzanne Myers Boone, Renee Barcak Butler, Sandy Delaro Campos, Bettegene Mullins Coyle, Marjorie DeShazo Engelhardt, Eleanor Ernest, Mary Fleming, Frank Gutowsky, Jennifer Whitten Hartman, Leona Band Hausler, Barbara Kubala Jochec, Tim Kaminski, Shirley Kennelly, James and Geneva Lane, Joyce Bezecny Lolley, Lydia Turrichi Mahlmann, Clyde Marek, Jeannette Foerster Mathews, Martha Tappe Ray, Dr. Travis Reese, Bennie Richter, Larry J. Schmidt, Sandra Crow Sindel, Jerry Sindel, Rae Taylor, Lupe Arredondo Uresti, Marsha and Bob Vogelsang, Wolfram M. Von-Maszewski, and Jeffrey Whitten.

INTRODUCTION

The city of Rosenberg began because of the railroad. In 1873, a group of businessmen who wanted to leave Houston's rail center attempted to organize a railroad in the city of Richmond, but they were turned down. They then curved their rail line around Richmond and founded Rosenberg. The town was named after Henry von Rosenberg, the first president of the Gulf, Colorado & Santa Fe Railroad (GC&SF). This was the beginning of Rosenberg.

In 1881, the New York, Texas & Mexican Railway was built between Rosenberg and Victoria. It was nicknamed the "Macaroni Line," because Italian workers laid the tracks.

In 1883, George Seal, president of the GC&SF, purchased 200 acres and laid out the town. Initially, the town was laid on the north side of the tracks, but floods from the Brazos River necessitated that the town be moved south of the tracks.

Several businesses, like Mrs. Ebell's Hotel and Boarding House (the building still remains), the Union Depot, and the Harvey House were built to accommodate railroad commuters. The depot was busy 24 hours a day. During this time, Main Street was the place to be. Farmers came to town to contract workers for cotton picking; children and adults came to town to enjoy a day of entertainment. The town, although very active, was known as the "City of Mud" because, when it rained, the streets turned soft and wet. They were finally paved in the 1930s. The property owners on Main Street had to help pay for the paving of the street based on how many feet of their property faced the street. The project was very expensive but much needed.

Many important happenings shaped Main Street. Bonnie and Clyde had their last meal at the Eagle Café before their death in Louisiana. John Wayne, Shirley Temple, and Roy Rogers, to name a few, came to the Cole Theater to promote their movies.

Downtown Rosenberg was the center of activity for many years. Then the train station was closed as a result of changing transportation methods. With the addition of the freeway and new businesses, downtown Rosenberg began to disappear. The central part of Rosenberg became a ghost town in many ways. The Cole Theater, which had been in downtown since 1919, began to suffer because of competition from modern theaters. It finally shut its doors in the early 1980s. Nothing was left in downtown except a few bars and antique stores. Then, a group of Rosenberg citizens came together to revitalize the area and added a replica Railroad Train Station Museum. Next, a Rosenberg native bought several buildings and began transforming downtown back to the way it once was. It took 10 years, but downtown Rosenberg began a resurgence, and people came to visit the new businesses housed in the remodeled buildings. In 2013, downtown Rosenberg was designated a Cultural Arts District. In 2015, downtown Rosenberg became the 89th Texas Main Street.

Rosenberg, as many downtowns in the nation, was the center of activity, and many memories remain. This book has been written with the help of many people who grew up in Rosenberg. Their memories are still very vibrant. It is hoped that, upon finishing this book, the reader, too, will have memories to share.

One

HISTORIC DOWNTOWN

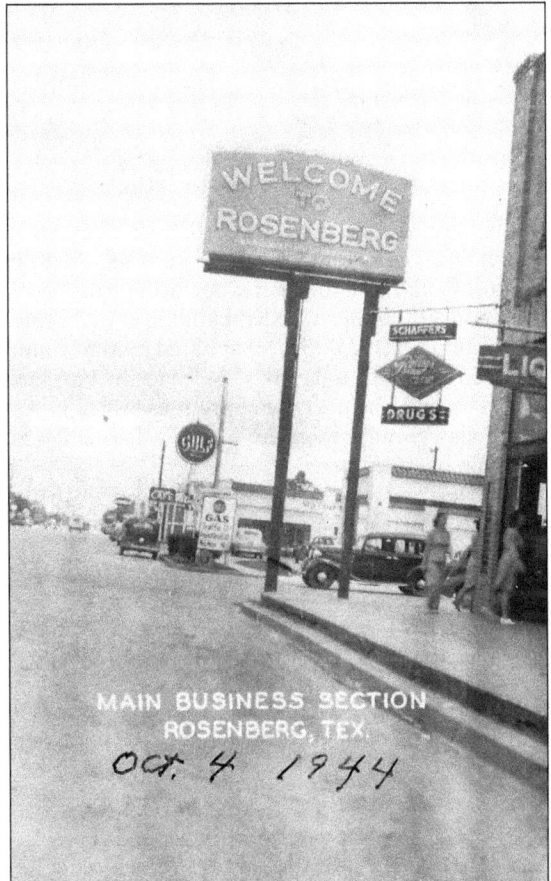

A sign in downtown Rosenberg, on the corner of Old Spanish Trail (OST) and Main Street, welcomed visitors to town. These thoroughfares today are known as Highway 90A and Third Street, respectively. Third Street, having the majority of the businesses in town, was informally referred to as "Main Street."

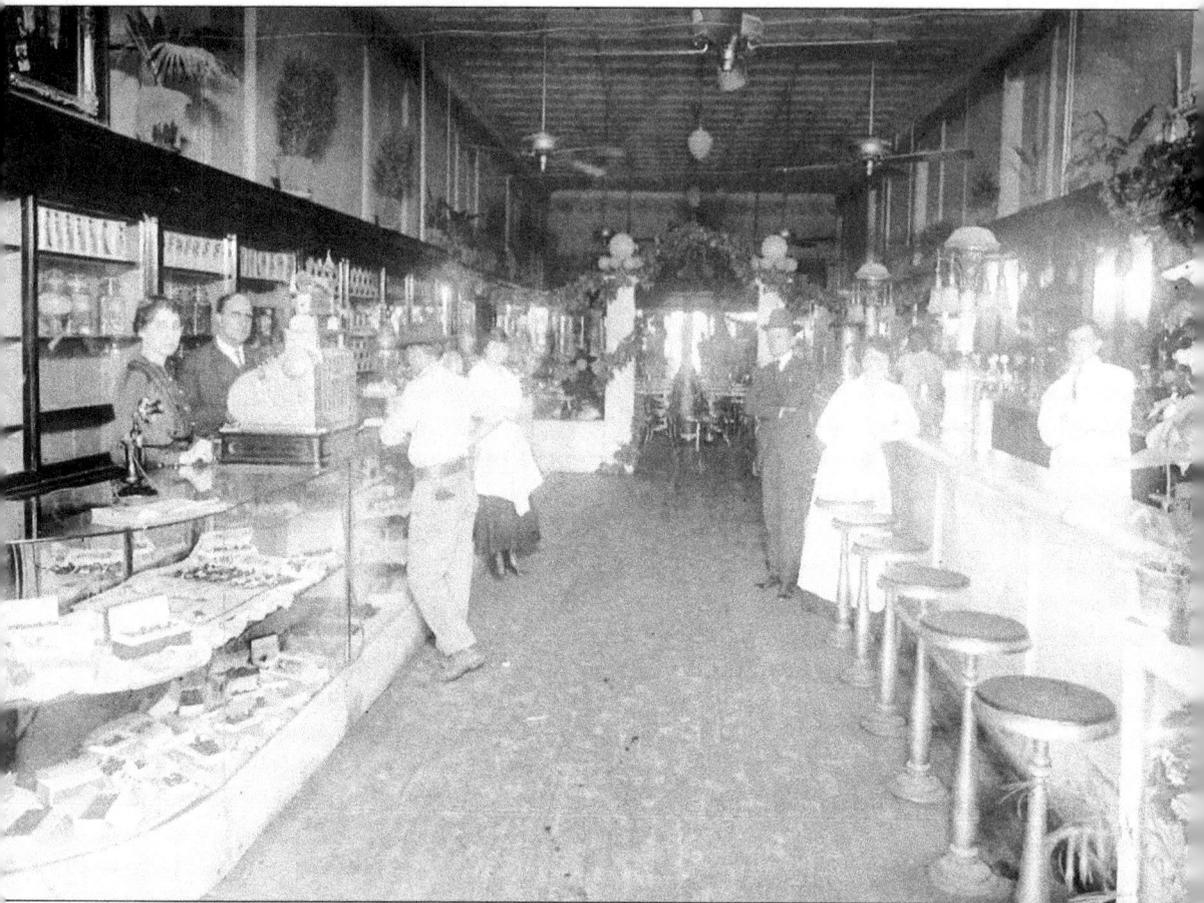

The interior of Cumings Drug Store is seen here in the early 1910s. It began as E.W. (Edward Walter) Cumings Drug Store, operating from 1910 to the early 1920s. The establishment had moved in 1910 from a wooden building at 812 Third Street. Pickard and Huggins Pharmacy and Soda Fountain (1923–1967) purchased it from Cumings. Frank Dedek purchased the business and changed the name to Frank's Pharmacy in 1967, and he operated it through the early 1980s. Ed Smith became the next owner from the early 1980s until 2001. Another Time Antique Shoppe and Soda Fountain was here from 2001 to 2003. Since then, Another Time Soda Fountain & Café has operated here.

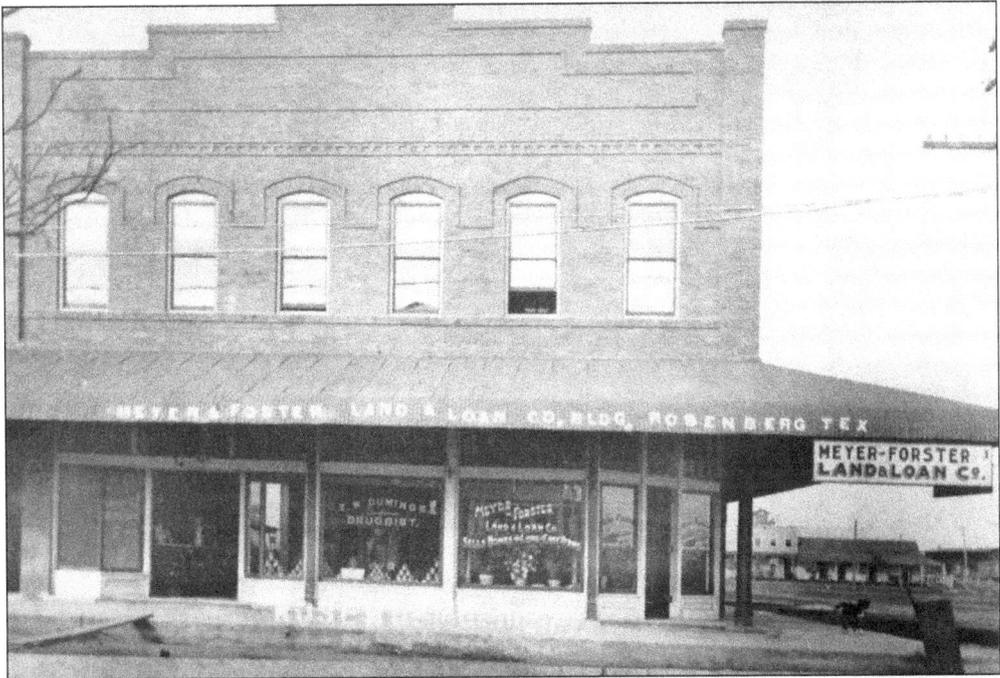

Within this building, Dr. Stuckey, Dr. Nabor, Dr. J.S. Yates, Dr. Balke, Dr. Eugene F. Hopkins, and Dr. Franz Amman all had offices upstairs. It was also home to Jean Foshee Dance Studio and KFRD, the first radio station in Rosenberg. Cumings Drug Store (1910–early 1920s) sold the business to Pickard and Huggins Pharmacy (1923–1967). In 2003, it became Another Time Soda Fountain & Café, which remains today. The joke in the early days, when the doctors, pharmacy, and casket maker (L.W. Cumings) were all in the same building, went that if the doctor and the medicine failed, the casket was ready.

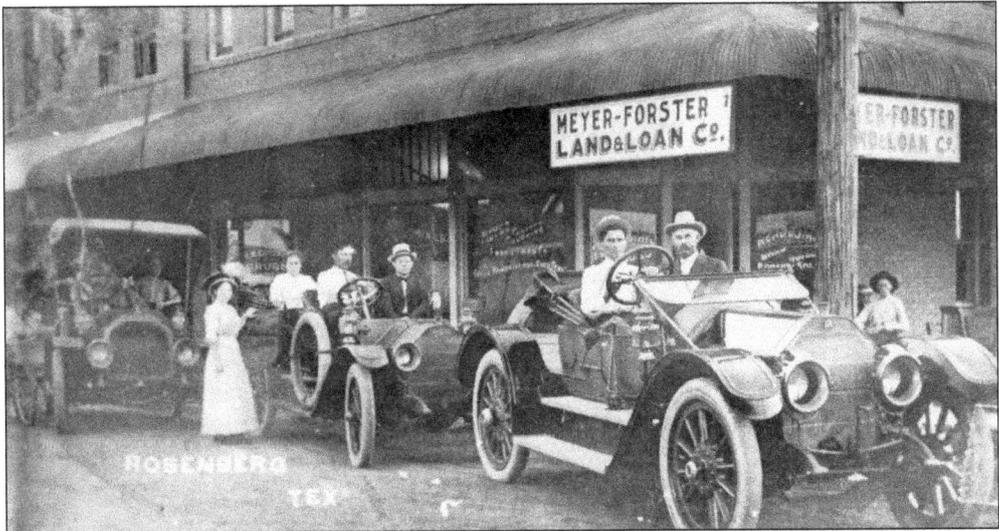

The Meyer-Forster-Mulcahy Building was constructed in 1910. Prospective customers are seen here outside the building. Forster Land & Loan Company, a real estate developer, was owned by H.A. Meyer, president, and Fritz Forster, one of five brothers who came from Germany in the mid-1800s. Among Fritz's brothers was "Pa" Forester. Meyer also served as mayor of Rosenberg.

11

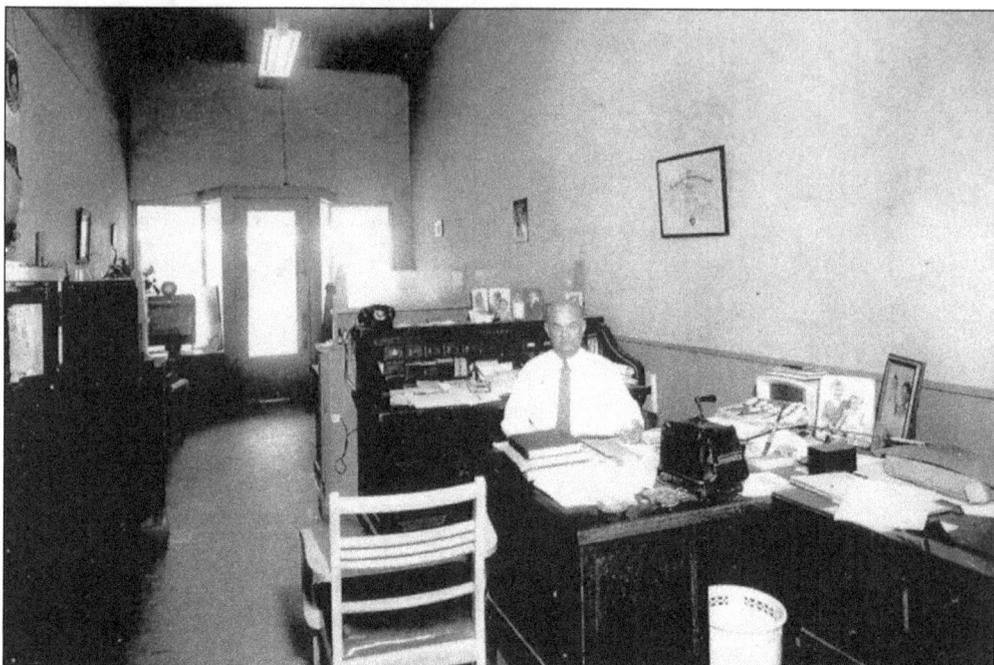

Alvin "Sona" E. Foerster is shown above in his office in 1960. After renovation, this area became part of the Pickard and Huggins Drugstore. It was originally owned by Ernst, nicknamed "Pa," who came from Germany in 1890 when he was 16. Pa married Alvina Moers, who was a member of a pioneer Rosenberg family. Their son Alvin later took over. This address for the Foerster Insurance Agency, 804 Third Street, no longer exists. The site became part of Frank's Pharmacy. The phone number was 13, indicating that it was the 13th line installed in Rosenberg. Pictured below, at 800 Third Street today, is Another Time Soda Fountain & Café. (Below, courtesy of BAC Photography and Design.)

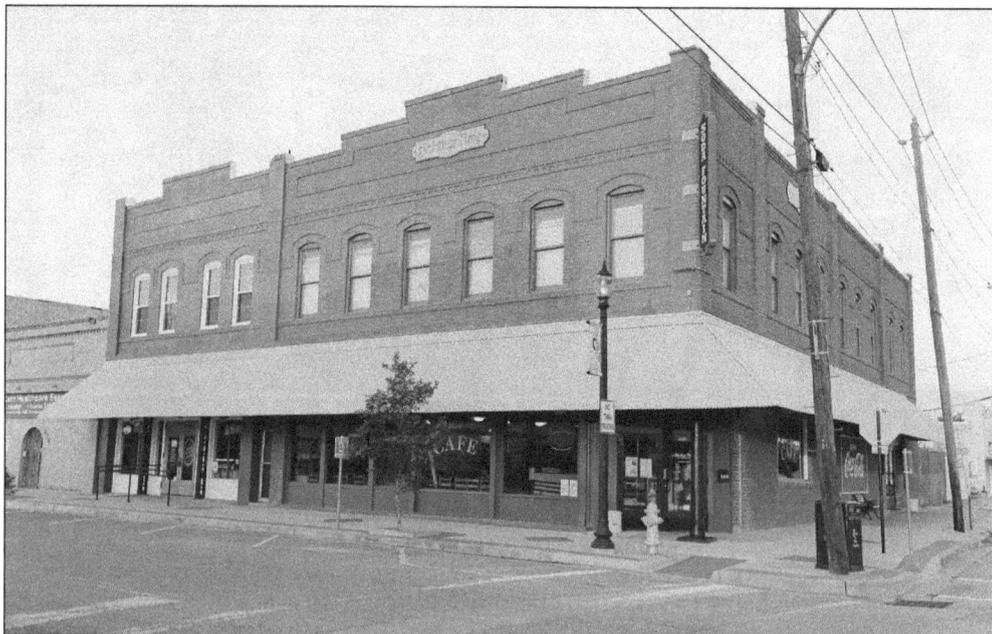

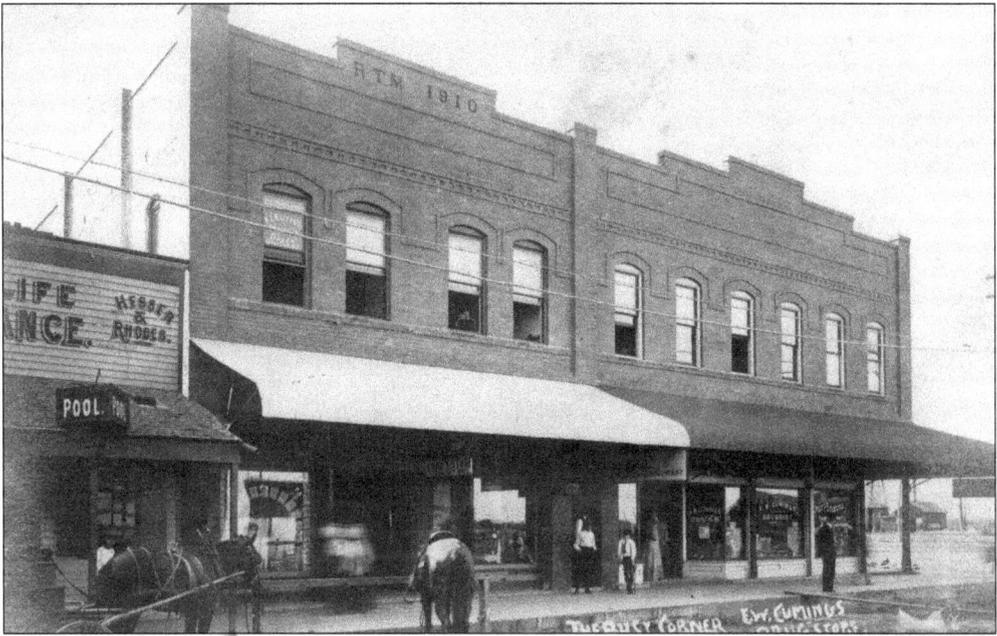

In the above photograph, the building with the light awning was the R.T. Mulcahy Building, as indicated by the initials at the top of the building. The first telephone in Rosenberg was installed in Mayor Mulcahy's upstairs office. R.T. Mulcahy was the second mayor of Rosenberg. His family owned the building from 1910 to 1973. Simmons Food Market, owned by Mr. O. Simmons, operated here from 1948 to 1952. Ernest Kubala was the butcher. It was the first grocery store in town to have air-conditioning. White Auto Store opened here in 1952, and Gene McConathy was the owner. That was followed by Cleon Shanks & Co., CPA (1978–2009), Tiaras and Tutus (2010–2011), and the Old Main Street Bakery (right), which opened in February 2014 at 808 Third Street. (Right, courtesy of BAC Photography and Design.)

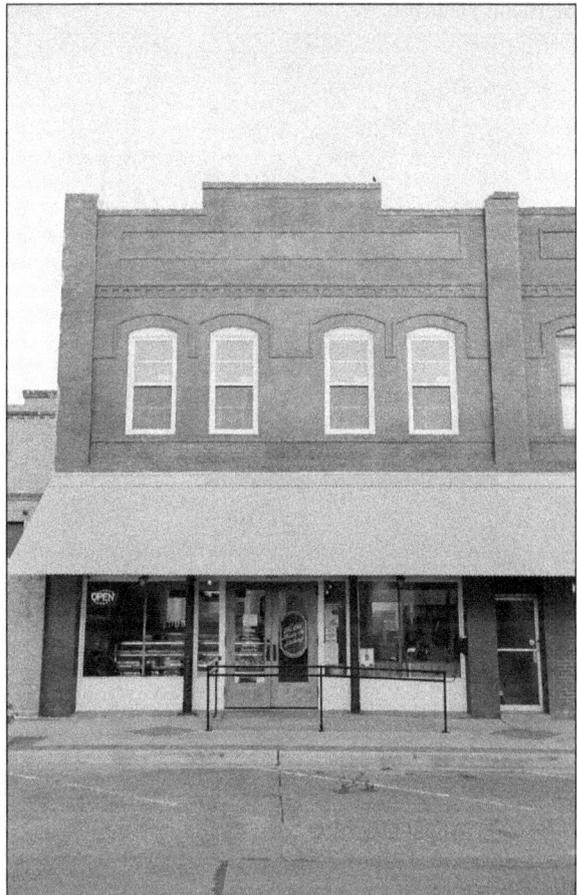

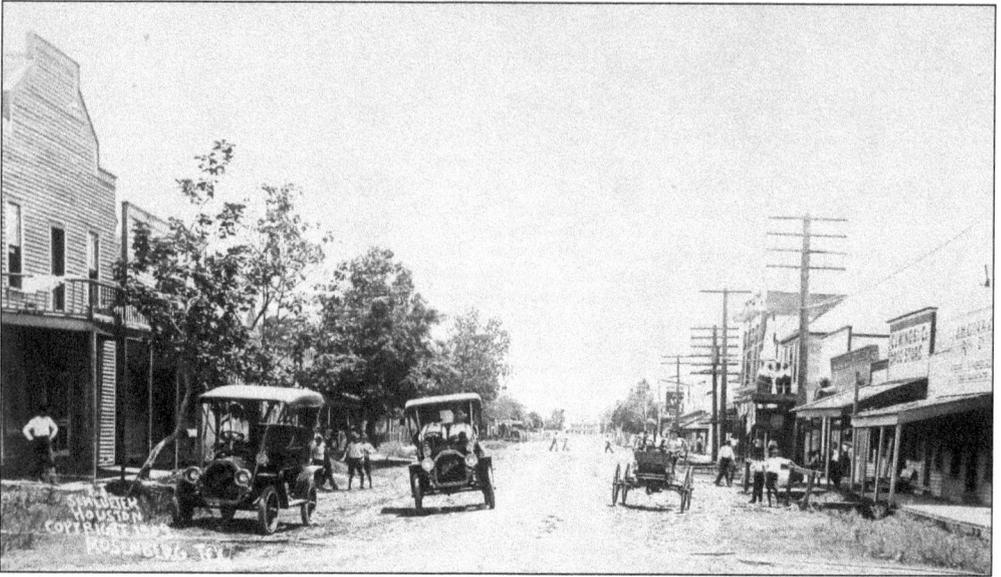

The original Cumings Drug Store, the second wooden building from the right, was located at 812 Main Street. A later brick building was the home to M. Lewis Dry Goods. It now houses SierCam Health Care.

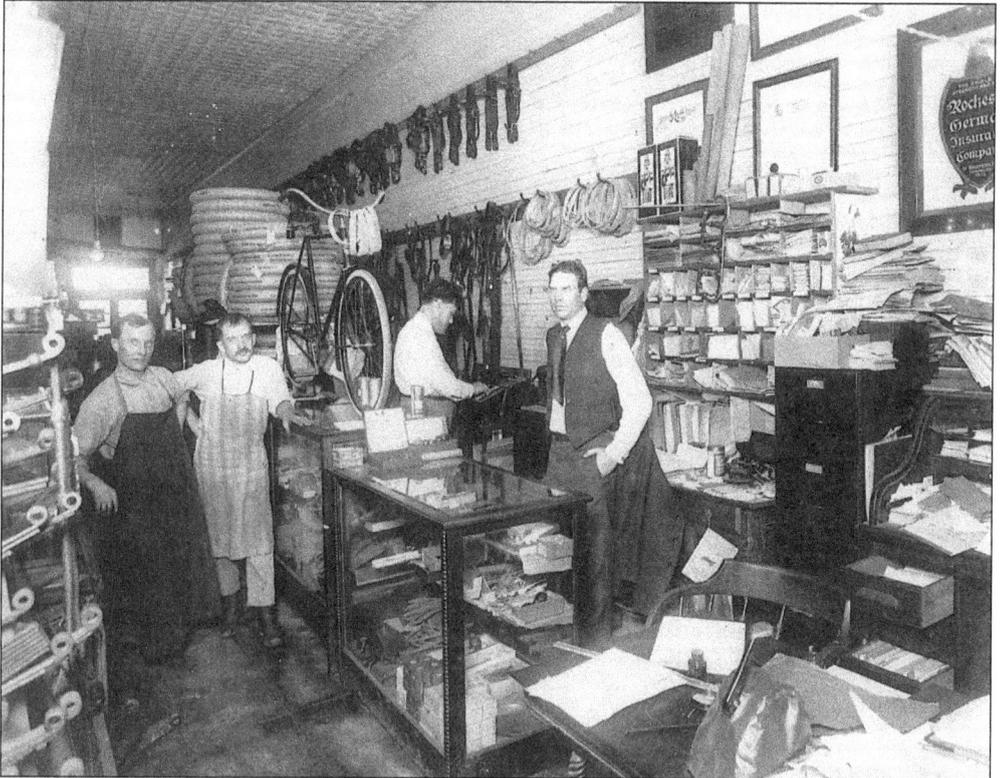

A.A Urbish Saddlery was located at 812 Main Street. Here, owner Anton Urbish (behind the counter at right) poses with employees. This photograph shows the transition from horse buggies to automobiles in the 1930s.

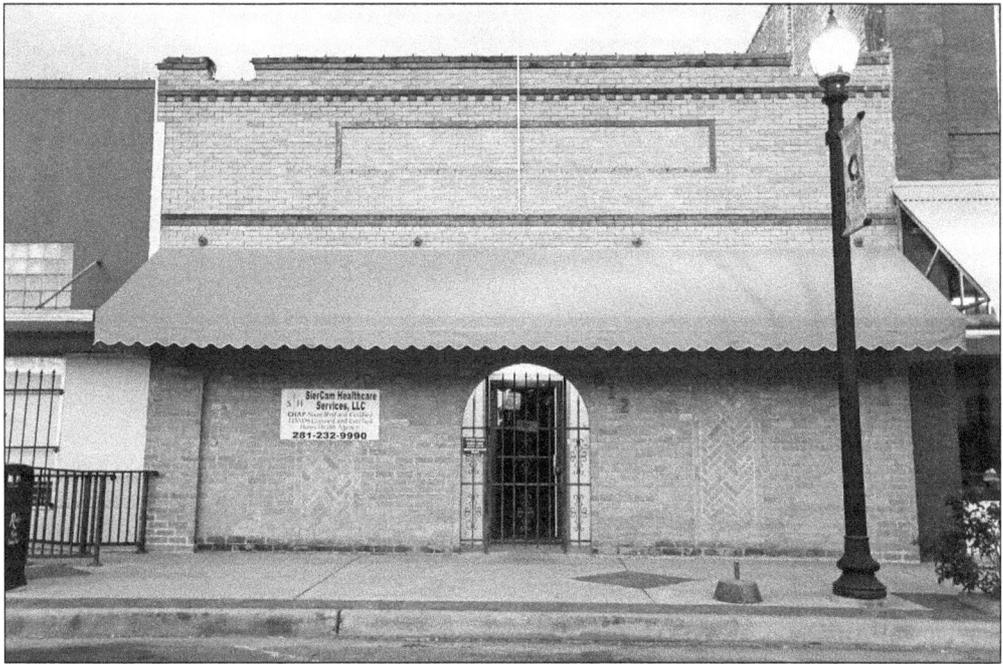

The photograph below shows the window of A.A. Urbish Saddlery. It displays many of the wares sold in the 1920s. Cumings Drug Store, located here in a wooden building, moved away in 1910. Next, it became M. Lewis Dry Goods (1910–1920), then the Saddle Shop (1920–1923), owned by E.E. Hesser. A.A. Urbish Saddlery occupied the location from 1923 to 1935. It was owned by Anton Urbish and his wife, Antonea. Ignac Rainosek, who worked for them, was an expert saddle maker. The Urbishes also had a gun store, re-topped leather tops on cars, and sold gasoline behind their store. Stuart Wade's Saddlery opened here in 1935. He retained Rainosek as an employee. Businesses that followed were Joe Naylor, dentist (1980–1984); Annie's Beauty Mart (1980–1984); Department of Public Welfare; Michael Danziger, attorney, with Bill Mann, attorney (1984–2008); and Patriot Strategic Investments in 2008. It has been SierCam Health Care (above) from 2009 to the present, located at 812 Third Street. (Above, courtesy of BAC Photography and Design.)

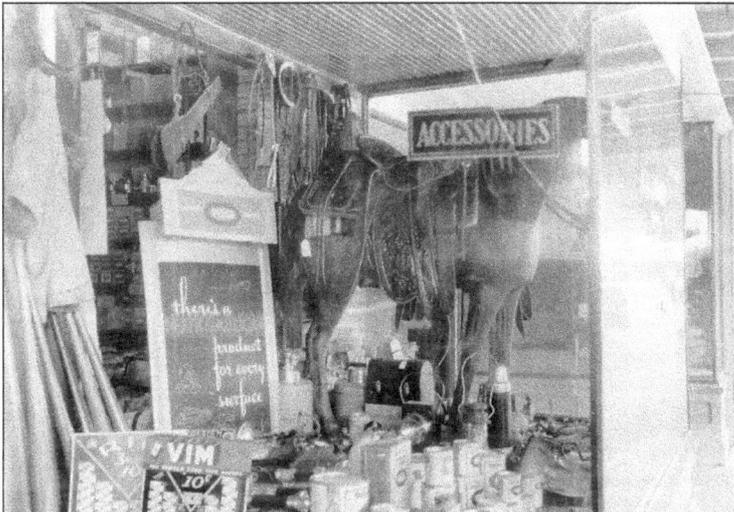

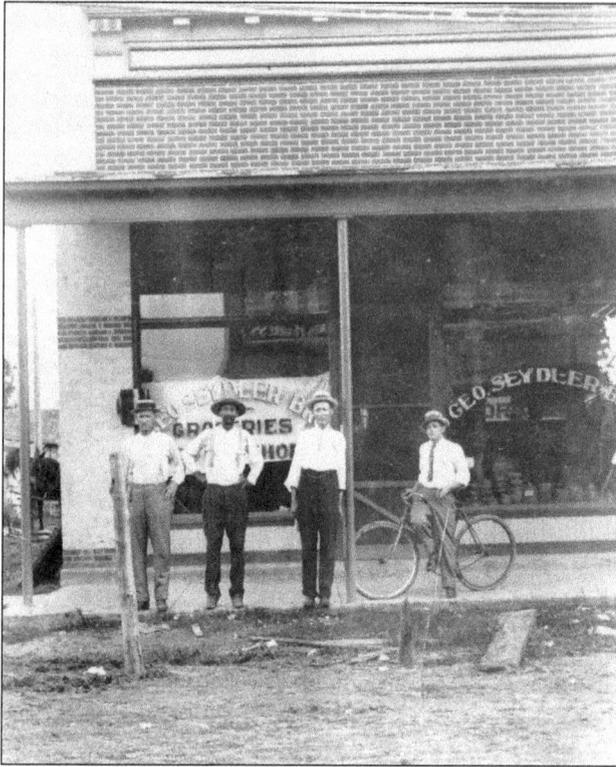

Prior to 1920, the Geo. Seydler Bro. Grocery Store was located at 814 Main Street. It later became the site of Alexander Food and Meat Market (1939–1940), then FBC Food Market (1942–1972). FBC, which stood for Fort Bend County, was owned by John Hajdik and Jack Blasdell. In 1948, Blasdell sold out to Hajdik. He and his wife, Marie, ran the business until their son Kenneth and his wife, Mary Sue, took over in 1972. It was Hajdik's Grocery Store from 1972 to 1975. The name was changed when Kenneth took over. In 1975, it moved to a bigger location on Avenue H and Second Street. It became La Superior Tortilla Bakery late in 1984.

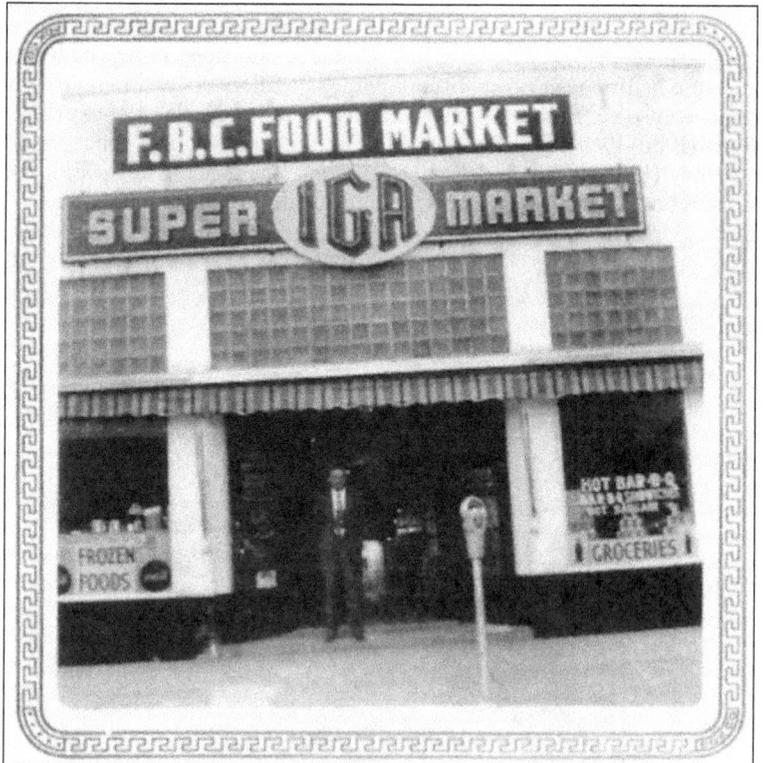

Here is FBC Food Market, located at 814 Main Street. Owner John Hajdik stands in front of his business in 1955.

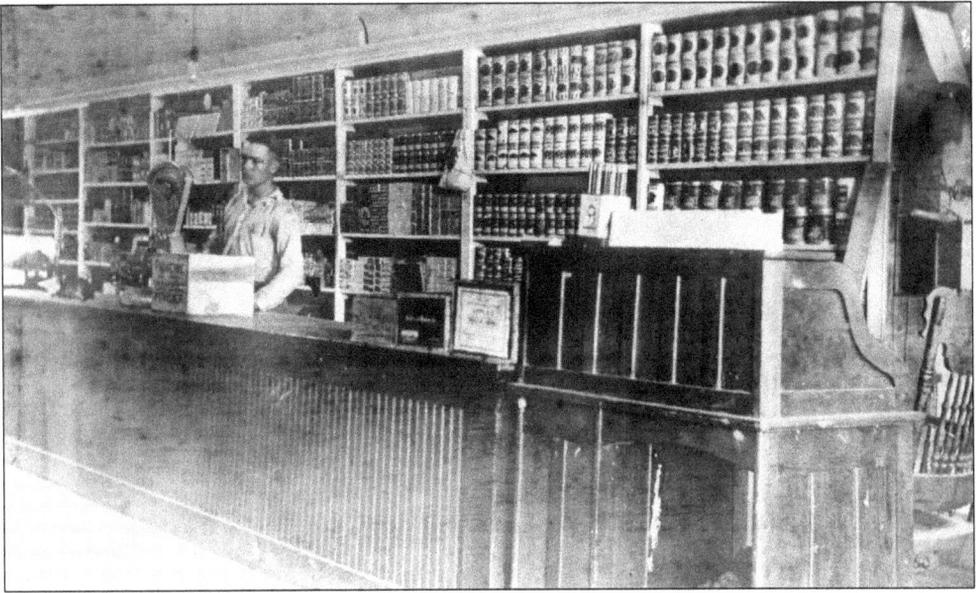

Seen above is the interior of Charles Seydler Grocery Store, 814 Main Street, with employee Phillip Brandt. Pictured below, at 814 Third Street today, is the Becerra Building. (Below, courtesy of BAC Photography and Design.)

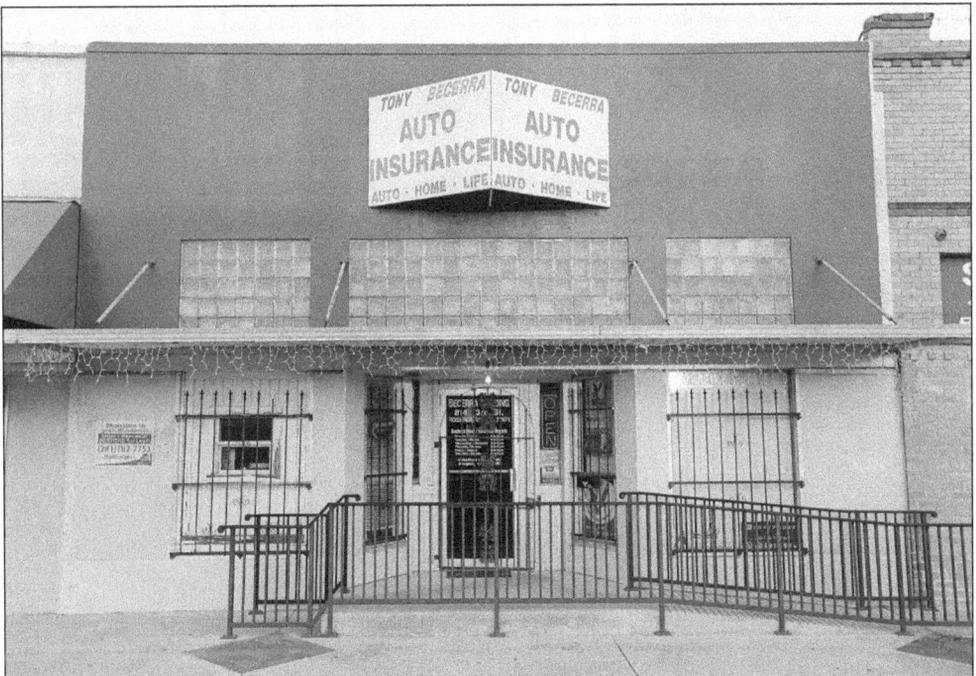

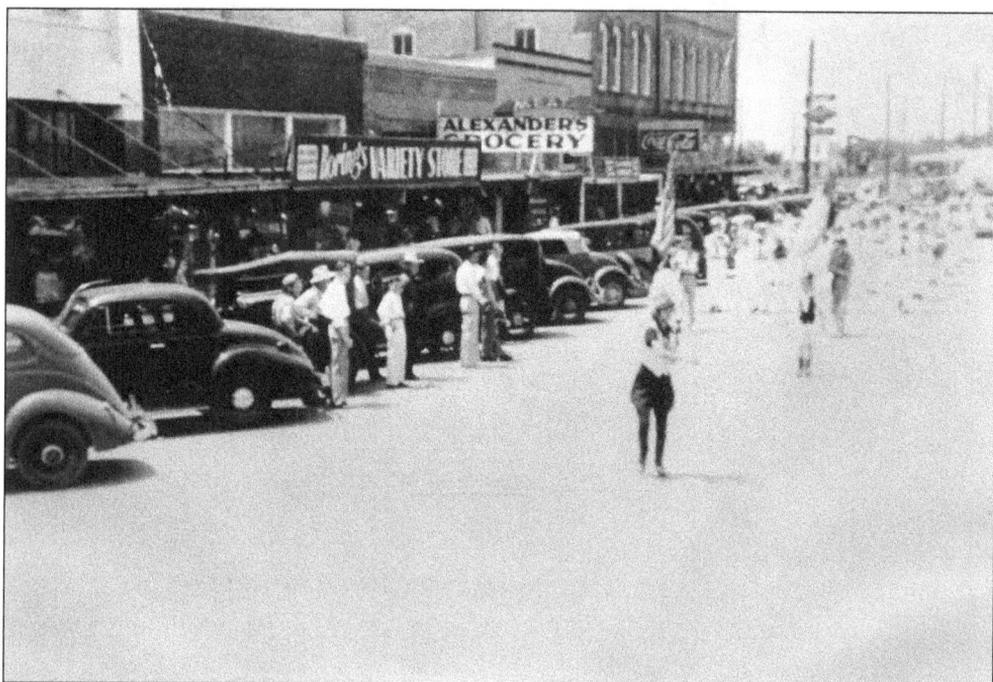

Boring's Variety Store, located at 816–818 Main Street, was a great location to watch the Fort Bend County Fair Parade in 1939.

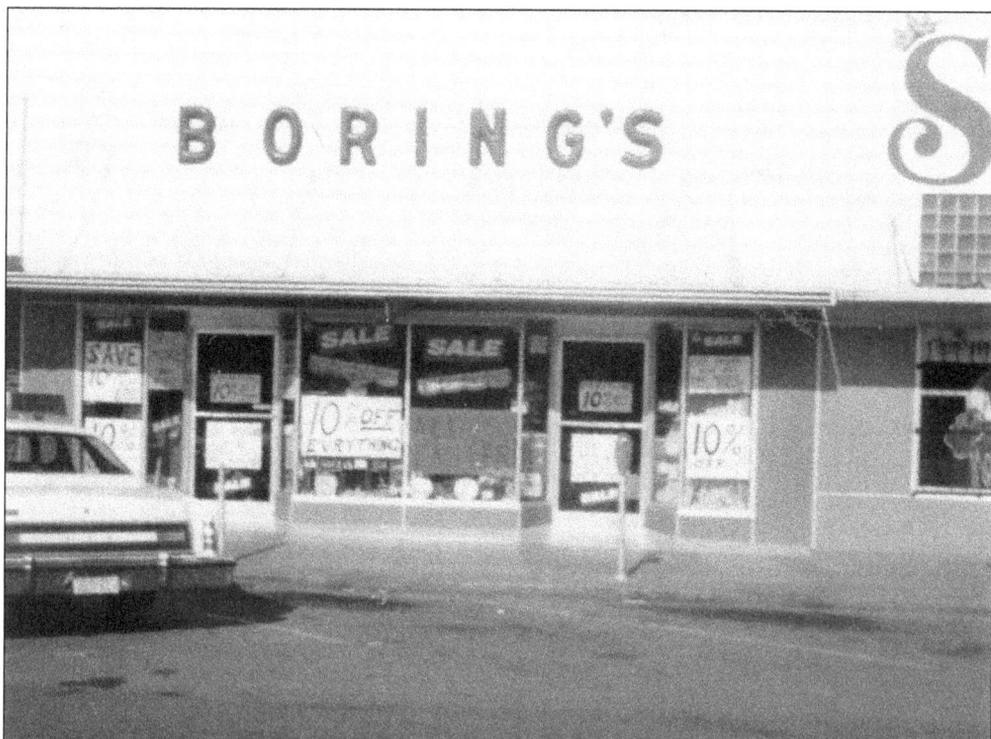

Boring's Variety Store held a going-out-of-business sale after being in business since 1924. The store closed in 1980. Marjorie DeShazo Engelhardt worked there on Saturdays for 50¢ an hour.

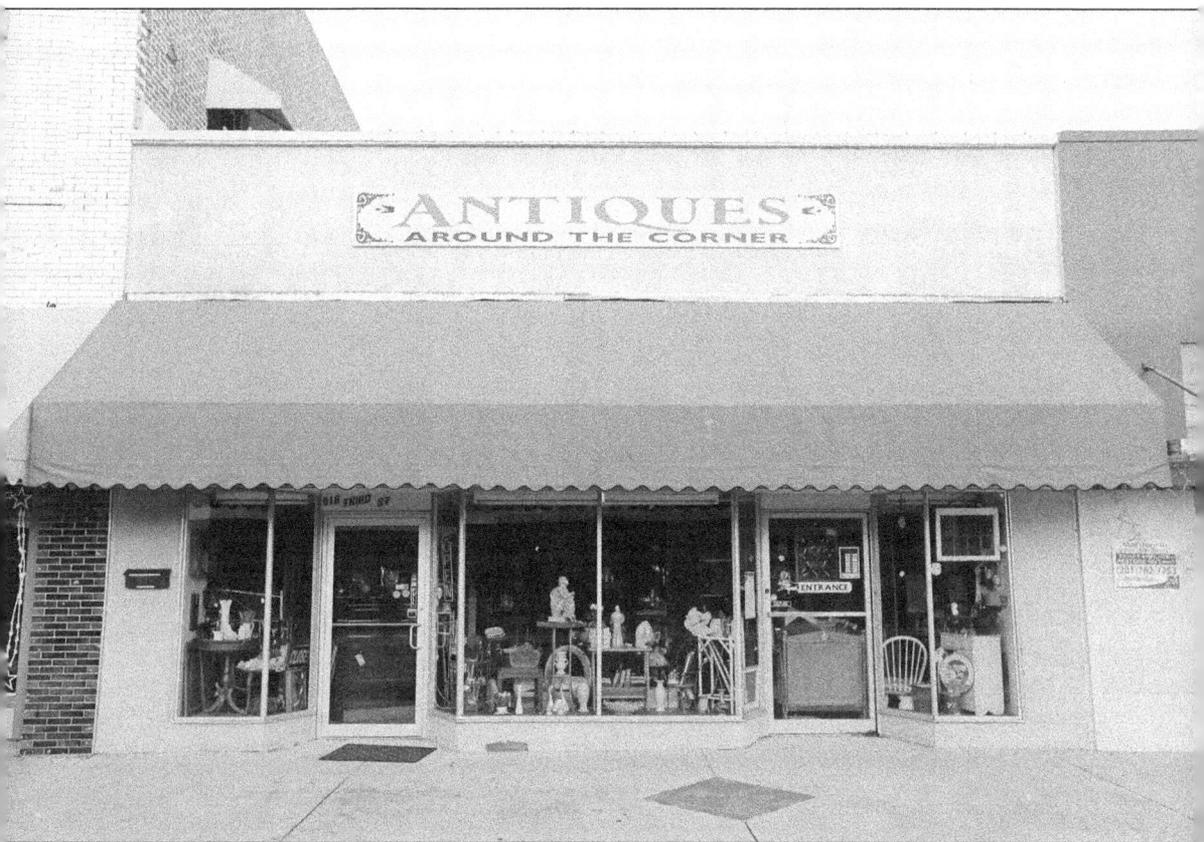

The longtime site of Boring's Variety Store, 816–818 Third Street, was the location of Rosenzweig's Dry Goods Store in 1902, when the site was occupied by a wooden building. Boring's Variety Store operated from 1924 to 1980. It was Garden Emporium, a resale shop (1997–2003), and then Antiques Around the Corner (pictured) from 2005 to the present. (Courtesy of BAC Photography and Design.)

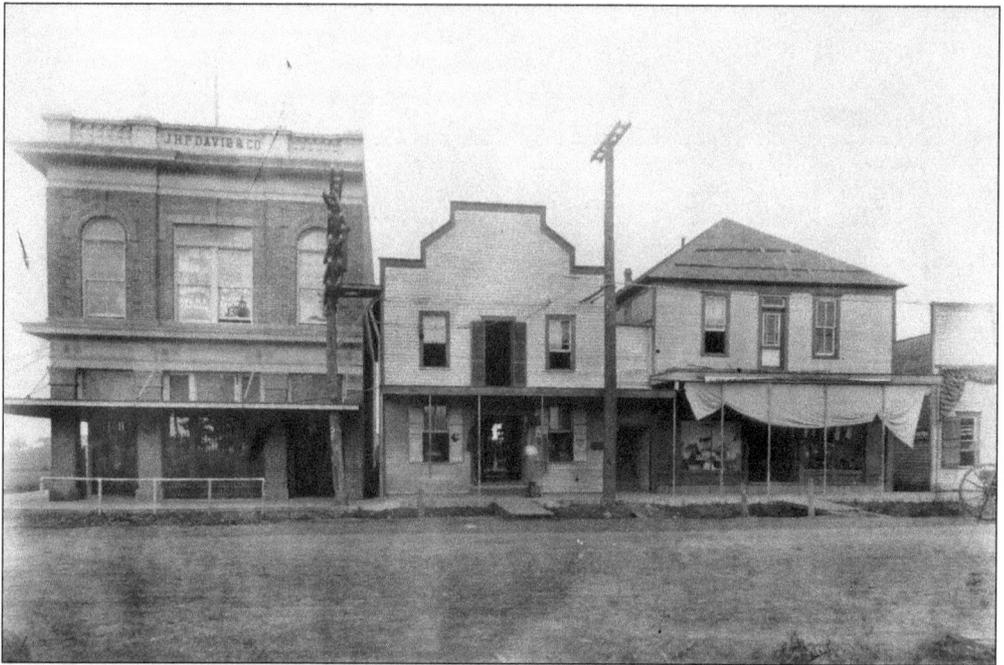

This 1910 photograph shows the brick J.H.P. Davis Bank (far left). The middle wooden building, at 828 Main Street, was the Racket Store. It, and the wooden building next to it, were replaced around 1930 by a single, larger brick building that would house Houston Lighting and Power.

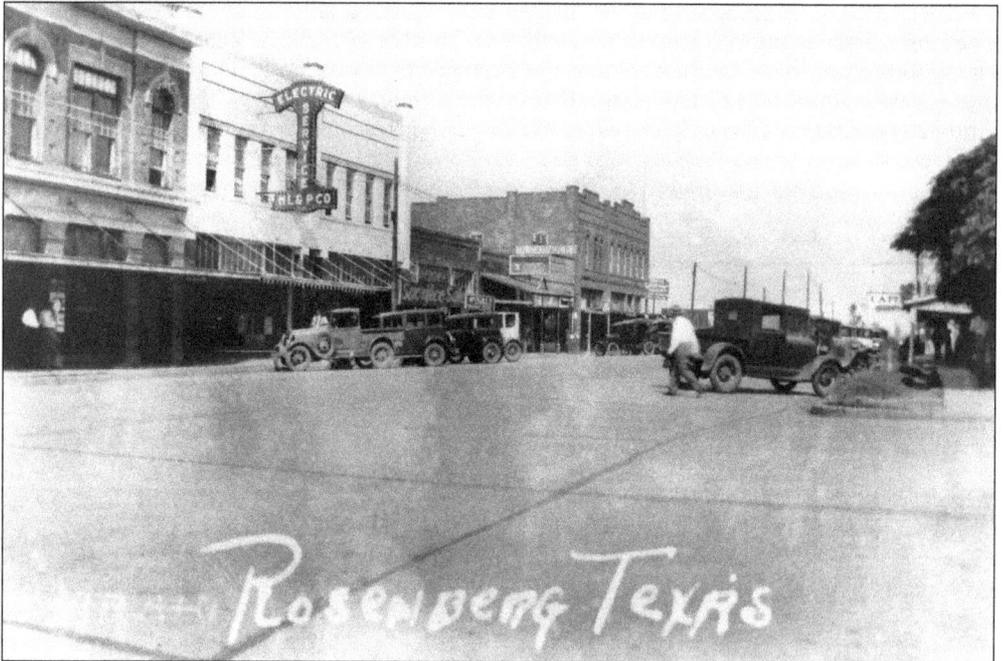

Shown here in the 1930s is the new Art Deco building at 828 Main Street occupied by the offices of Houston Lightning and Power (left of center).

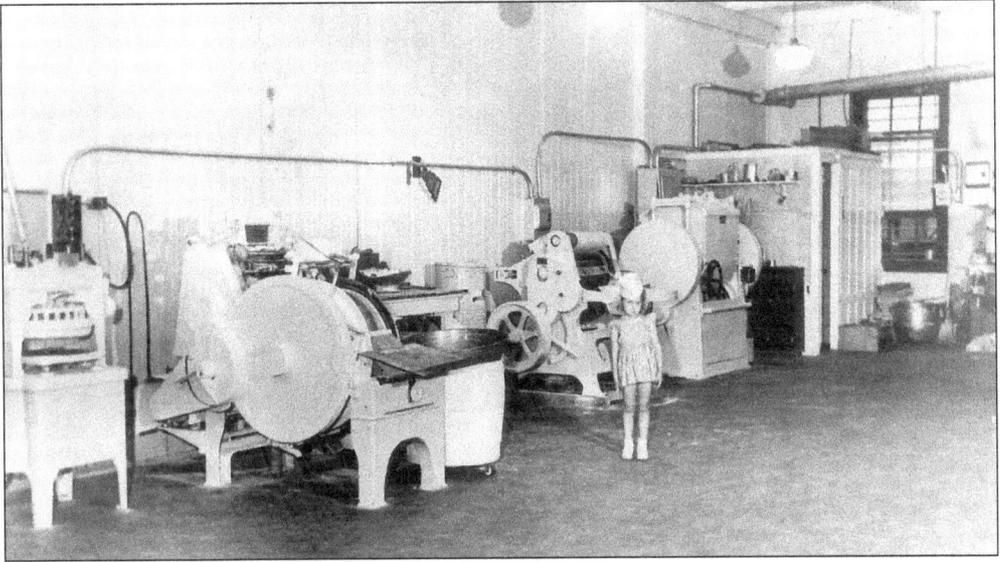

Baking equipment used by Schmidt Bakery at 828 Main Street is seen here in the late 1940s. Joe Schmidt's daughter, Mary Ann, poses in 1947 with the equipment. Joe Schmidt borrowed $3,000 from his grandfather to open a bakery and bought the building from the Moores. After quitting the bakery business, he renovated the store and had a dance studio upstairs and offices for an optometrist and attorneys Hardin and Brown. It has been home to Lack's Auto Associate Store (1951–1954), owned by Jack Forster; Bill's Dollar Store (1968–1980); K. Wolens (1982), where Charles Spate was manager; Kelly's Fine Fabrics (1984); and Olde Town Antiques (1994–2007), with Fletcher and Nancy Walker as owners. The building was remodeled between 2007 and 2012 and became Rocking Horse Antiques (2012–2013) and Rustic Kuts (2013–present). The upstairs houses Xtreme Danz Studio, owned by Juanita Velasquez, and offices of CPA Jeff McClellan, Brazos Bend Guardianship, and SierCam Health Care. Pictured below, at 828 Third Street today, is the Yellow Awning Building. (Courtesy of BAC Photography and Design.)

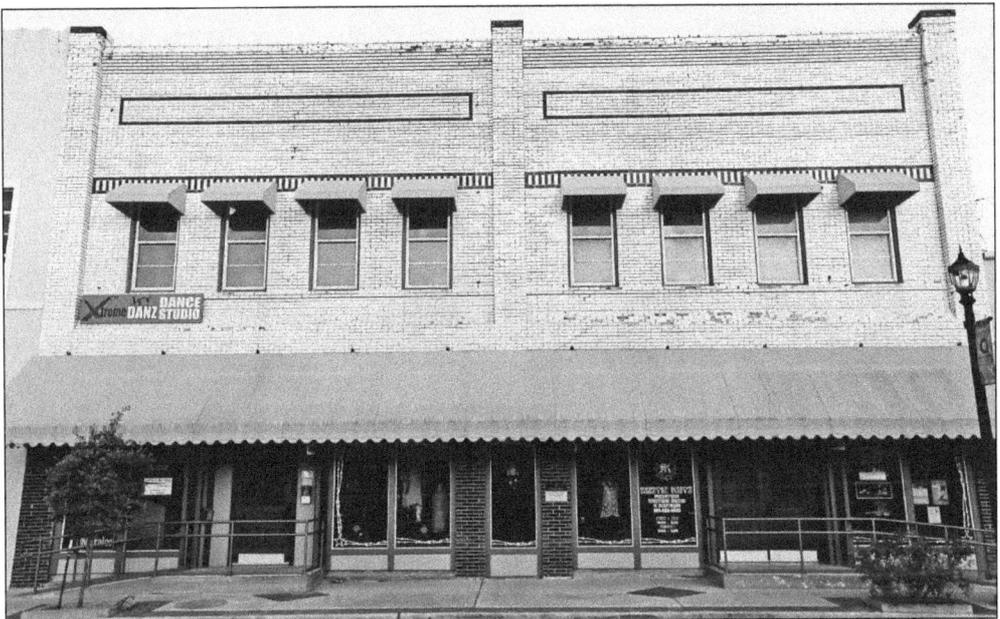

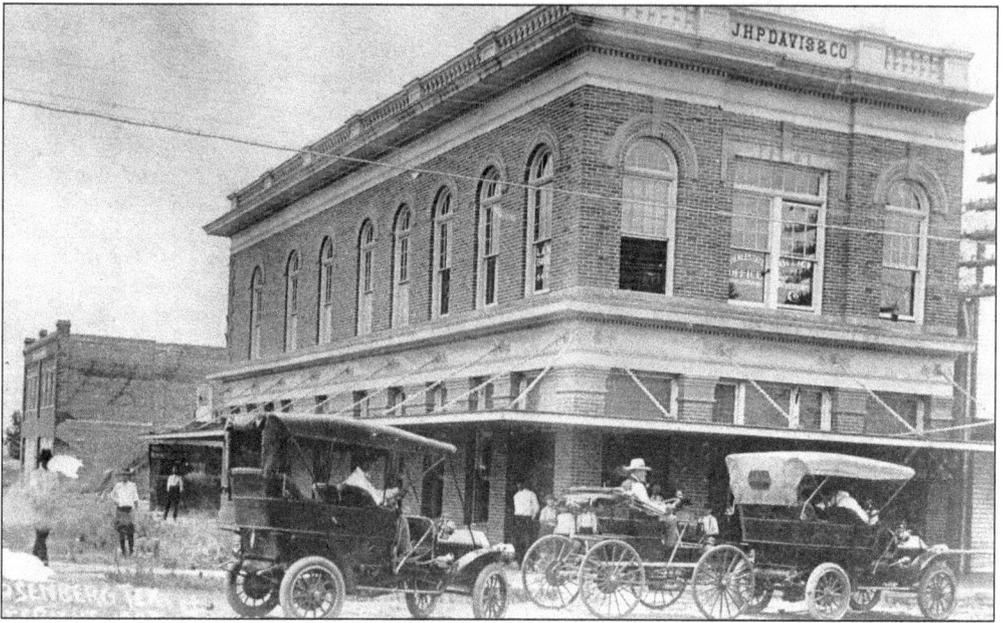

The J.H.P. Davis Bank Building was constructed in 1907. Located on the northwest corner of Avenue G and Main Street, this was Rosenberg's first brick building. The bank had many owners: J.H.P. Davis Bank (1907–1923), Farmers State Bank (1923–1925), and finally First National Bank (1925–1970), which moved to another location. There were several additional thriving businesses in the building, including the USDA and Dr. Emil Tejml, dentist (1929–1953). Upstairs housed Rosenberg Development Co. (a photography company) and a real estate office owned by Kinch Hillyer Sr. in 1907.

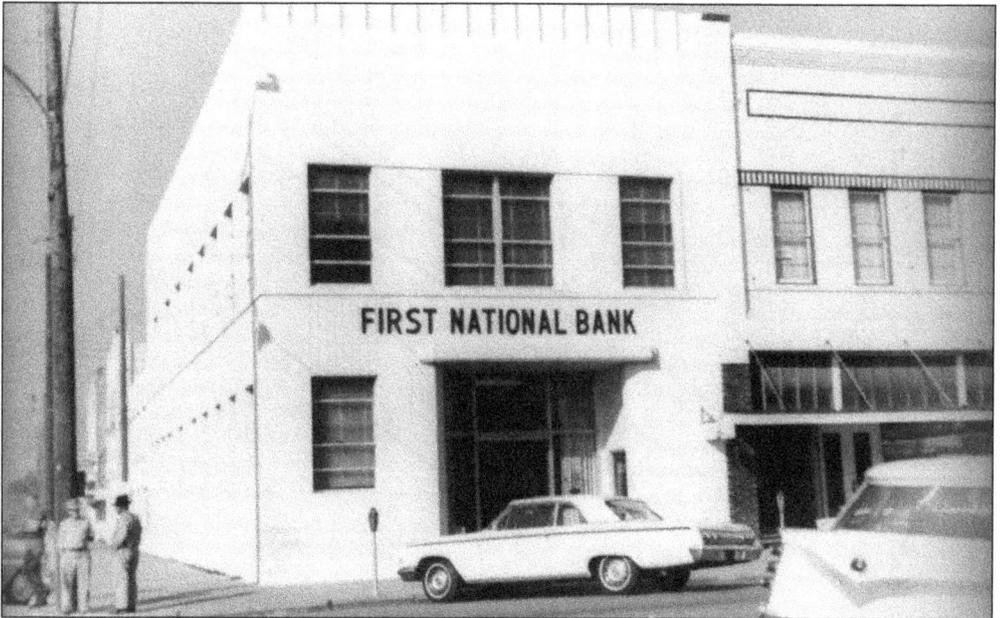

Rosenberg's first brick building, at 834 Main Street, was plastered over by First National Bank of Rosenberg to modernize it. Dr. Travis Reese of Reese Real Estate purchased the building in 1970 when the bank moved.

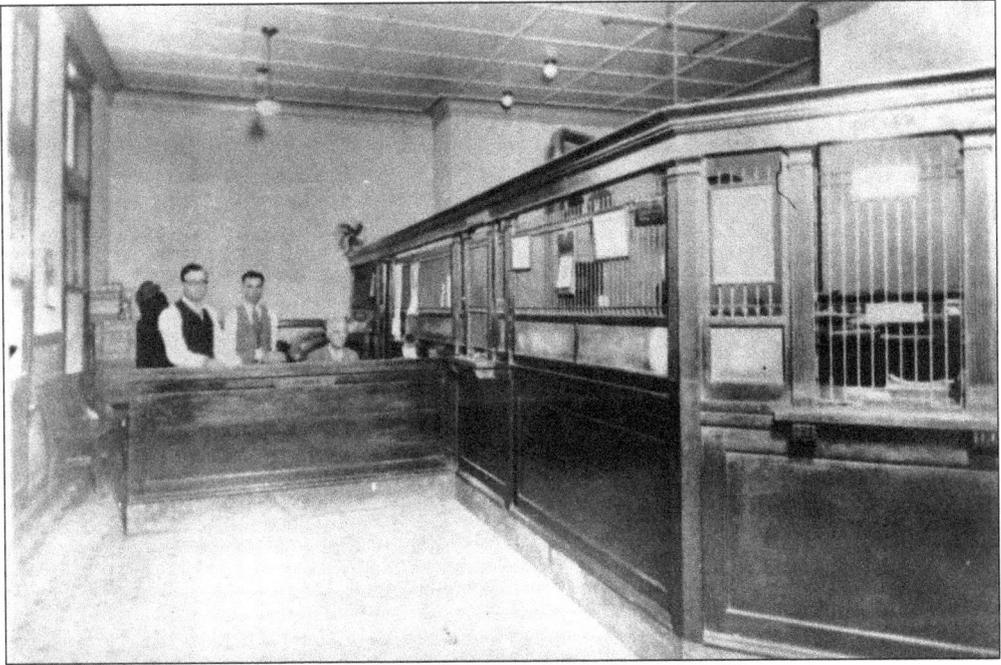

The above photograph shows the interior of J.H.P. Davis Bank in the 1930s. It is the Reese Building today (below) at 834 Third Street. (Below, courtesy of BAC Photography and Design.)

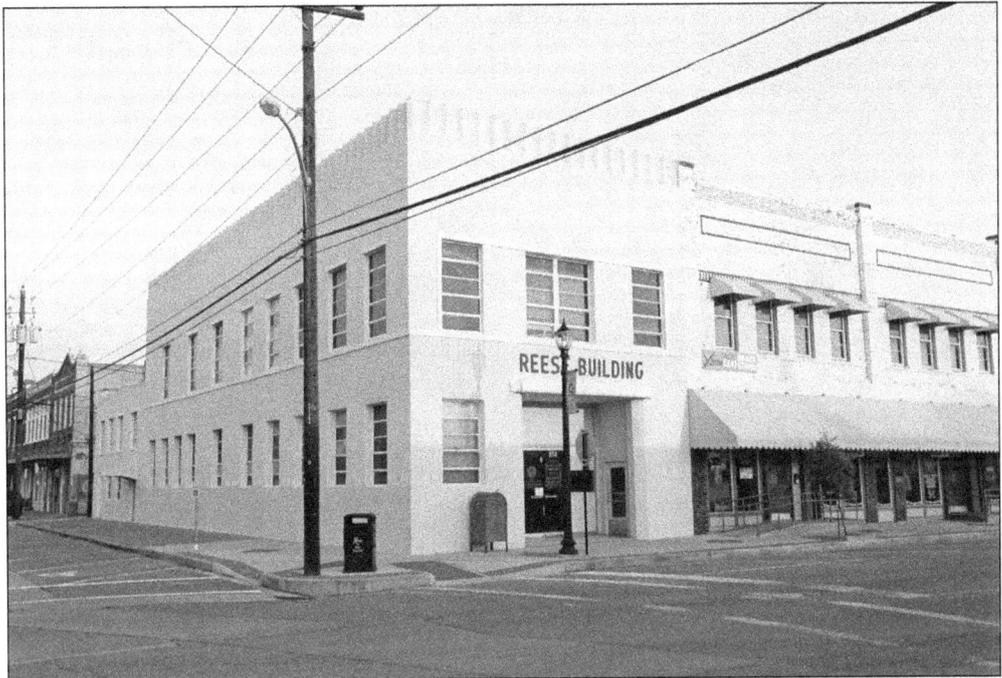

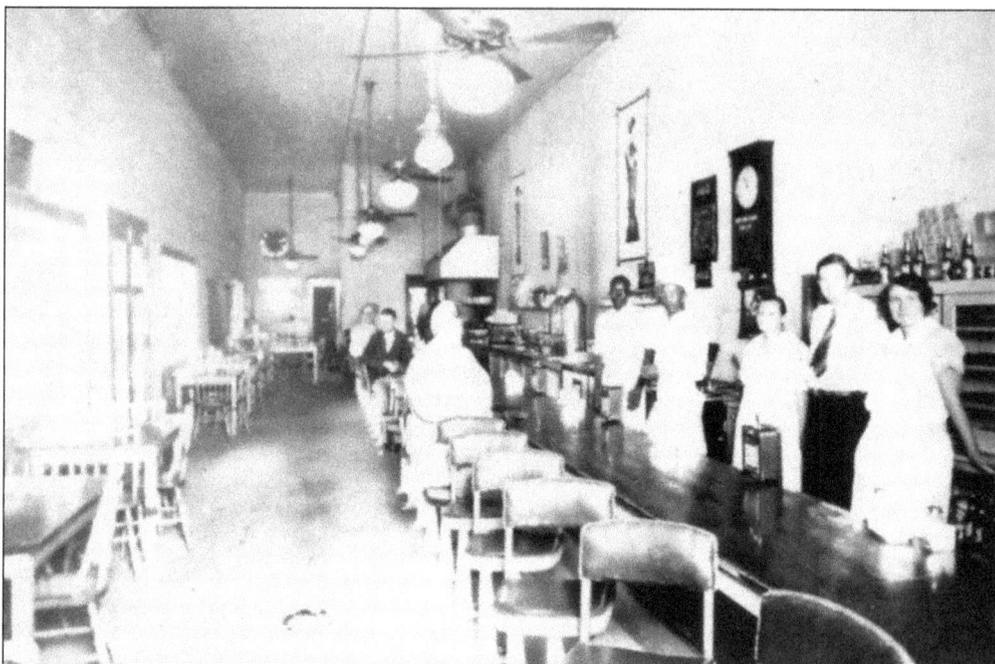

Shown here is the first location of the Eagle Café, on the corner of Main Street and Avenue F. Owner Anne Turicchi (third from right) poses with staff at the café.

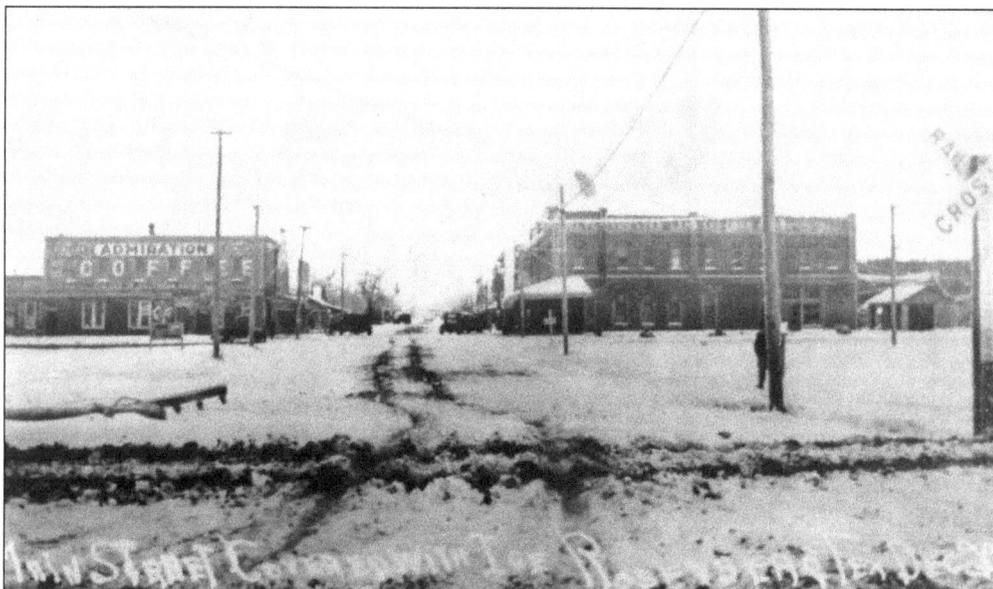

Admiration Coffee advertised on the railroad side of the Eagle Café Building, located on the corner of Avenue F and Main Street. This snowy scene was captured in the early 1920s.

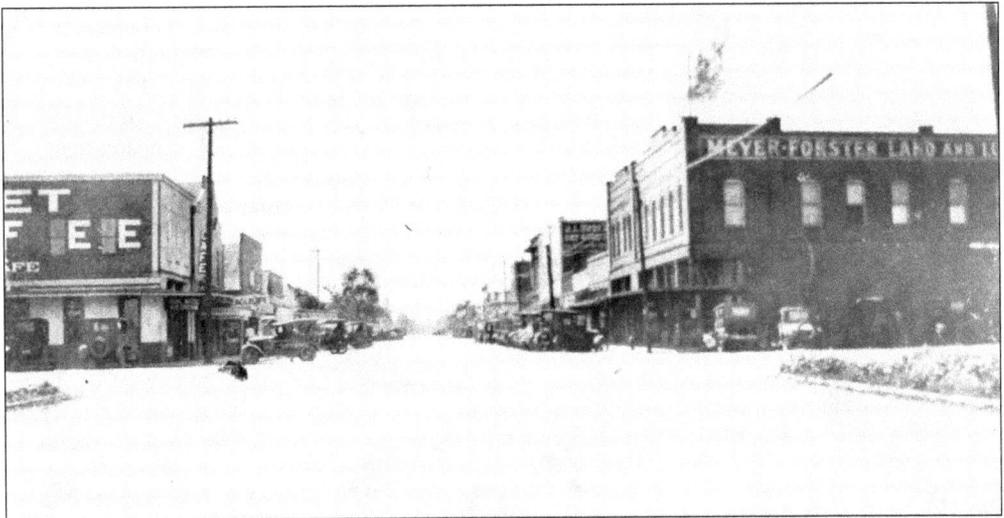

In the south-facing photograph above, the first building on the left is the Eagle Café at its first Rosenberg location, 801 Main Street, from 1924 to 1932. The other businesses in this location were Donley's Cleaners (1932–1972); Arredondo Showroom Furniture (1973–1984), owned by John Arredondo, who later made it into Arredondo Carpet Center; and Rose Buds, a florist (2004–2008). The building at 801 Third Street has housed Once Again Gifts and Collectibles since 2009. (Courtesy of BAC Photography and Design.)

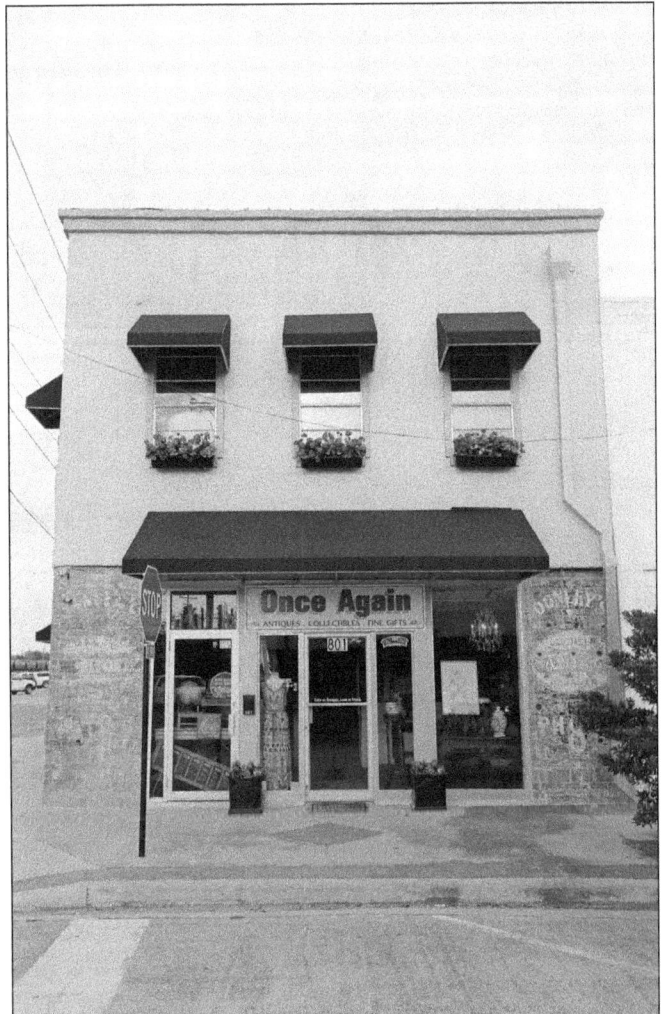

The State Theater, at 805–807 Main Street, was built in 1936. It was constructed, in part, while the Cole Theater down the street was undergoing major renovations. The State would later show Czech films and, more important, Spanish-language movies. It remained in operation until the late 1970s. The building's interior was used for location shots for the movie *Liar's Moon*, released in 1982. The film, starring Hoyt Axton and Yvonne De Carlo, was one of Matt Dillon's earliest movies. Karen Rosenbaum's Twirling School was located here in 1992. As pictured below, 805–807 Third Street is currently a vacant building. (Below, courtesy of BAC Photography and Design.)

John Splichal, a Czech immigrant (at right), poses in the late 1960s in front of his shoe repair shop, located in the 800 block of Main Street. There were three wooden houses here, each home to a family business. These were a cleaning and pressing shop owned by John Janca, who was Rosenberg mayor and a football coach and math teacher for Rosenberg High School; R.B. Covington Liquor (1945–1951); and Mr. Splichal's Shoe Repair Shop (1948–1968). The Splichals lived behind the shop. All the buildings at 809–811 Third Street were torn down and never rebuilt, becoming Third Street Park, as seen below. (Courtesy of BAC Photography and Design.)

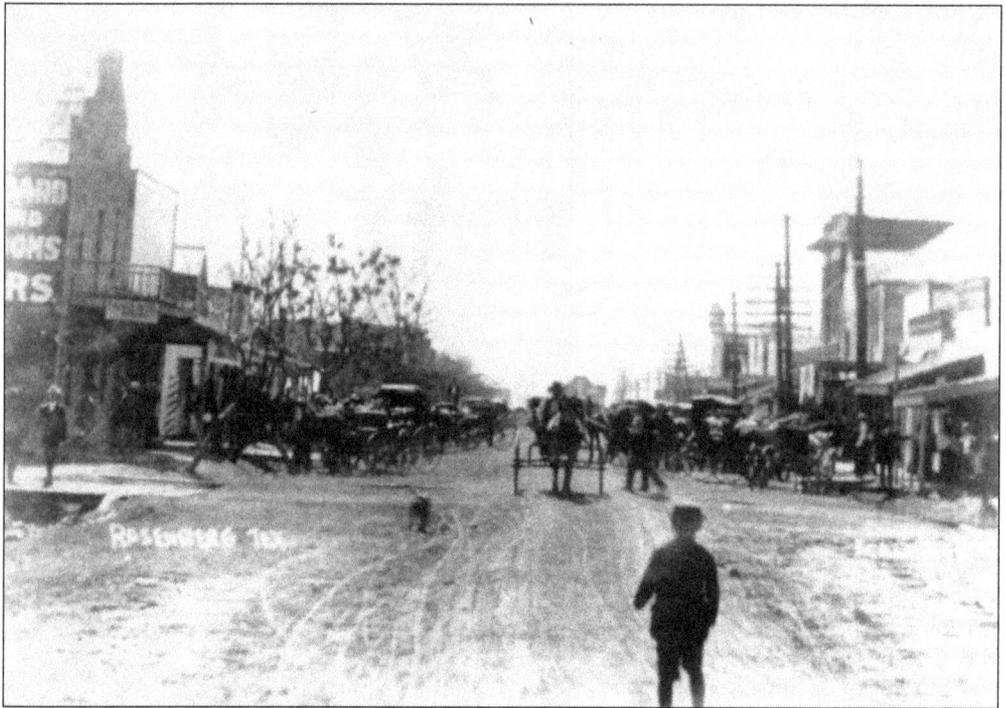

The tall building on the left in the above photograph is the Palace Hotel, located at 817 Main Street. The wooden structure was replaced with a brick one, and it housed several taverns until 2003, when the building was purchased and renovated to include businesses Deborah Designs, Self Made It, and Southern Sister Designs, which opened in 2010 and is seen below. (Below, courtesy of BAC Photography and Design.)

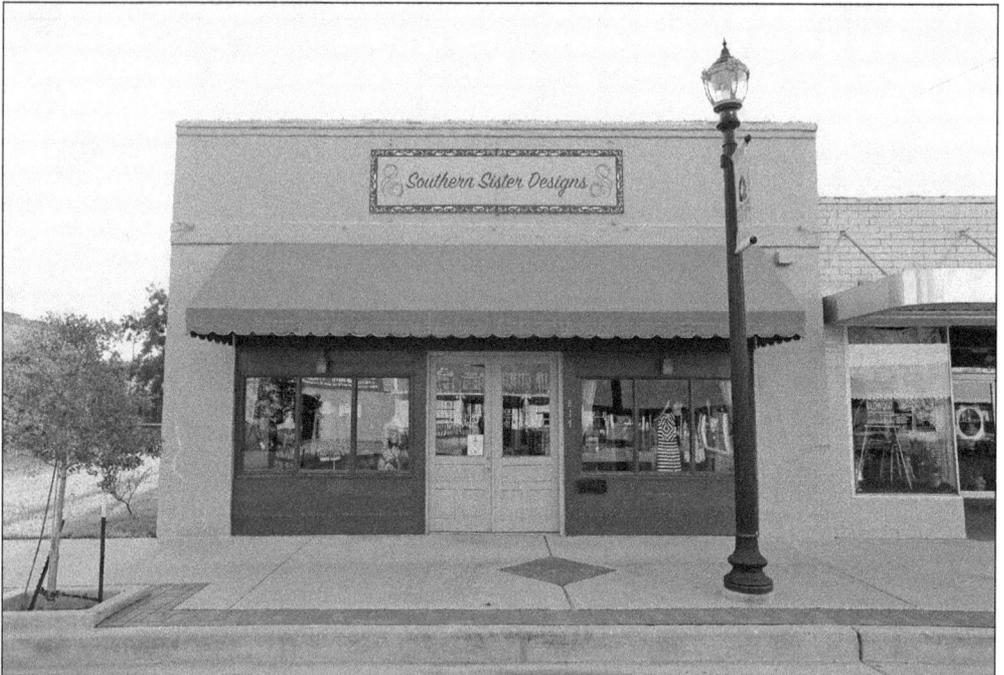

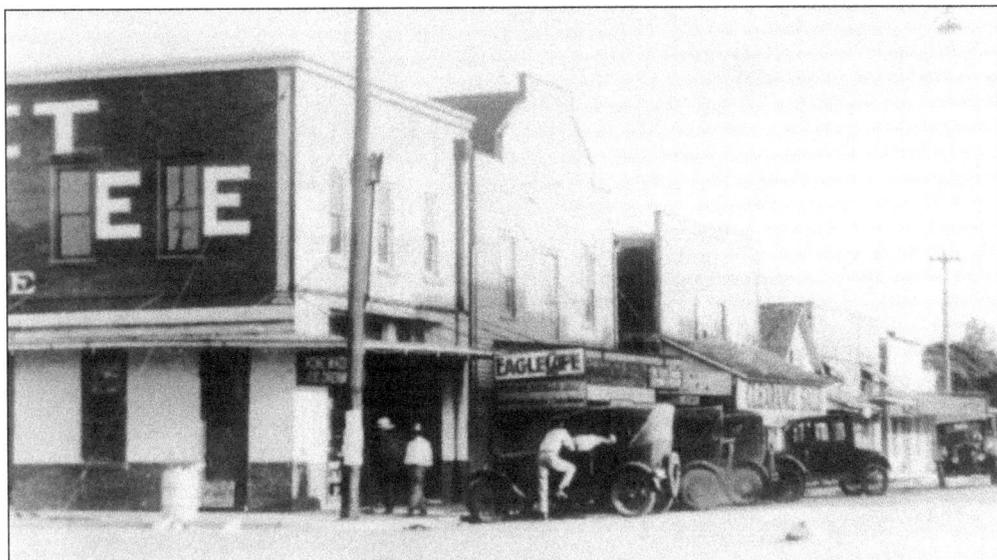

The east side of Main Street is shown in this south-facing photograph, taken in the late 1920s or early 1930s. A clearance sale sign advertises the Janack Brothers Men's Store. The Janack brothers, Vince and Arthur, were the salesmen, Vince's wife, Justina, was the bookkeeper and buyer, and Arthur's wife, Gladys, did alterations. Other businesses in the block were Attic Treasures (2002–2004), Honey's Fashions, owned by Sandra Toman (2004–2007), Helen Moon Mortgage Co. (2008–2011), and Sherwin Williams Paint (1962–1968). The buildings now house Downtown Studio, owned by Candice Beck, and Butler Waddell Interest.

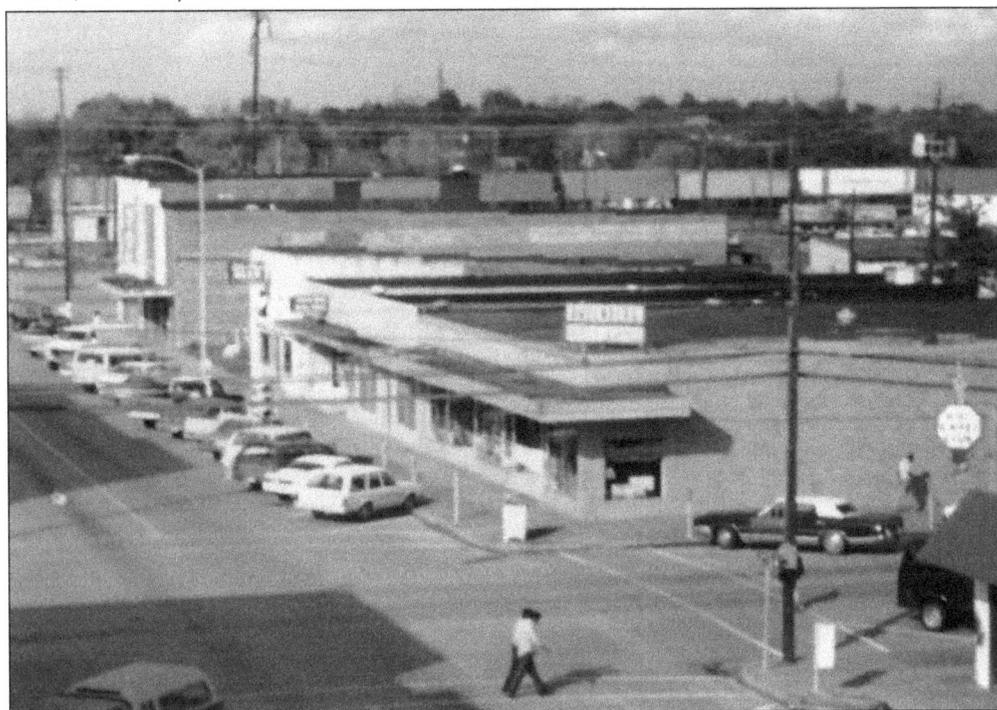

This is a 1983 photograph of the 800 block of Main Street at Avenue G. Rosenberg Office Supply was located here.

Pictured here are two present-day businesses. Above, at 819 Third Street, is Downtown Studio. Below, at 821 Third Street, is Butler Waddell Interest. (Both, courtesy of BAC Photography and Design.)

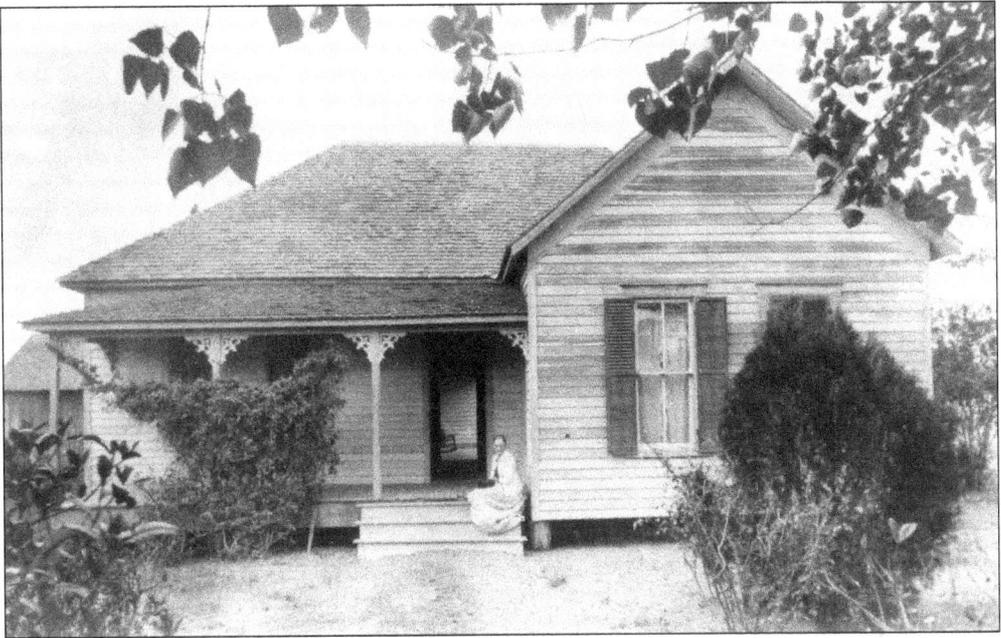

One of the first homes built in Rosenberg became known as the McNabb-Holliman house. Virginia Carrie McNabb and her widowed sister, Margaret Millie McNabb-Holliman, owned the white house with picket fence located on the northeast corner of Main Street and Avenue G. They were the granddaughters of Carrie Nation, the famous American temperance activist. Townspeople thought the ladies were mean as they did not socialize. Children would run sticks along the fence, making lots of noise. Virginia died in 1932 and Margaret in 1943. The house was torn down shortly after World War II.

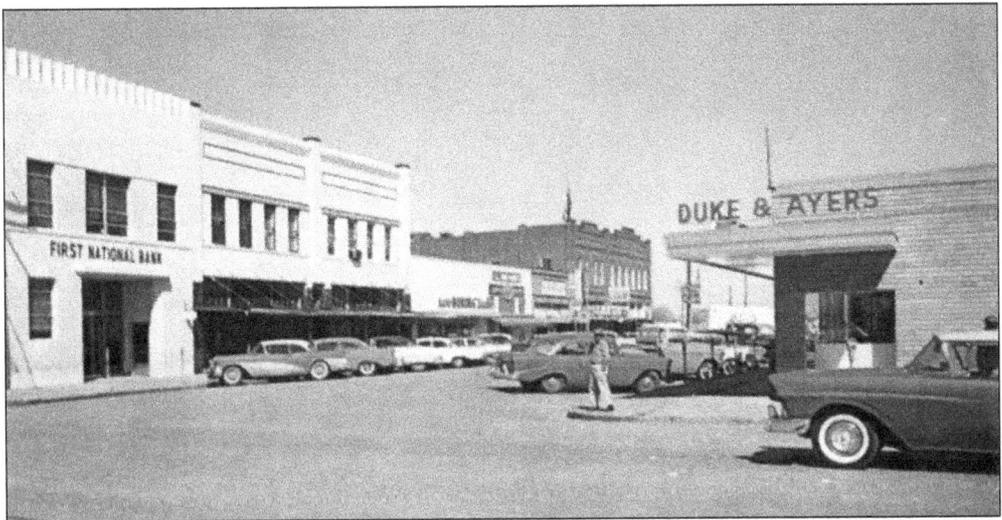

The Duke & Ayers Variety Store building was constructed in 1956 and was located on the northeast corner of Avenue G and Main Street. It replaced the McNabb-Holliman house. The variety store, at right in the above photograph, was replaced by Rosenberg Office Supply (1968–1990), the first real office supply store in town. Among other services, it repaired office typewriters. Other businesses at this location included Twin City Business Machines (1990–1991); BM Discount Grocery (2002–2003); Butler and Sons' Bookstore (2003–2010).

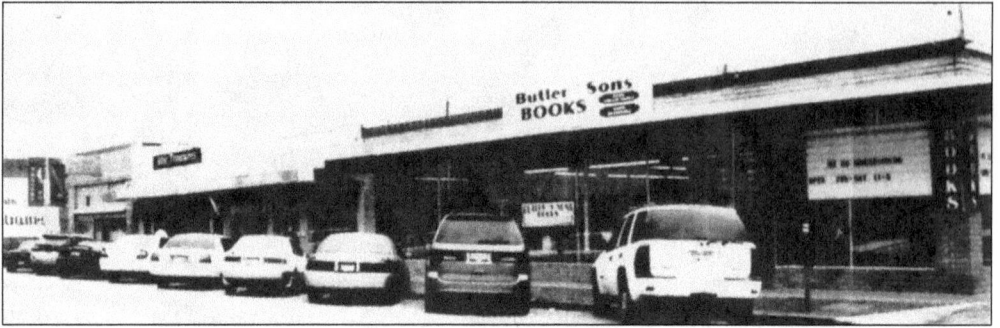

Butler and Sons' Books was located on the corner of Main Street and Avenue G in the early 2000s, and, shown below, Center for the Arts (2010–2013) was located at 823 Third Street.

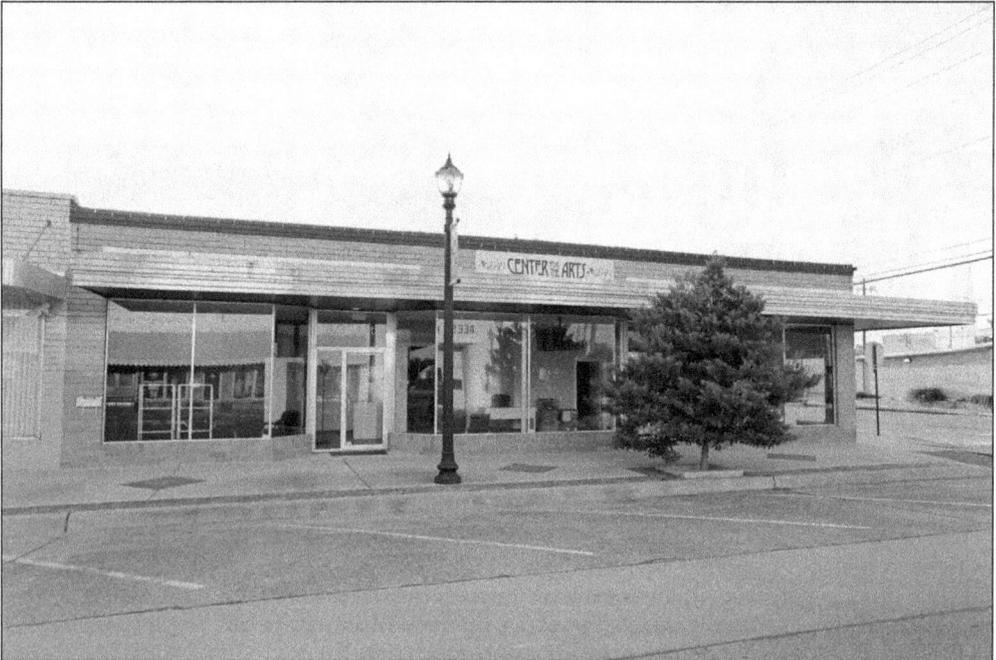

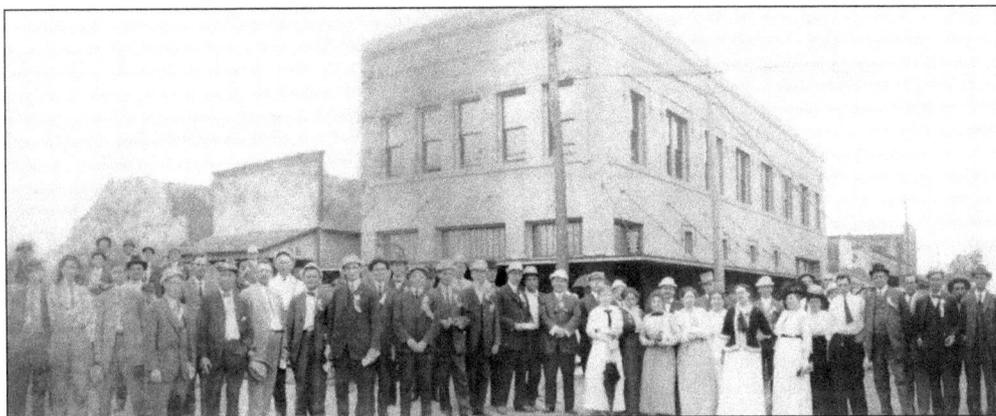

The Houston Boosters' 14th annual trade trip to Rosenberg took place on April 17, 1914. The organization was the forerunner of the chamber of commerce.

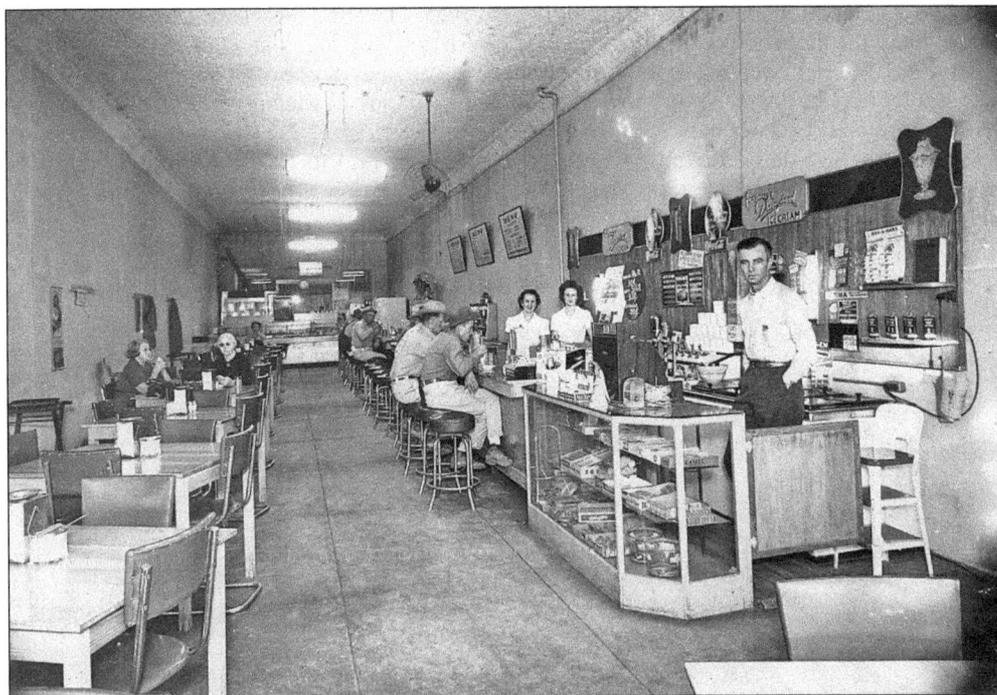

In the late 1940s, the Lehmann family owned a restaurant where Red Queens Attic is today. Mrs. Lehmann made the pies, and there was a steam table in the back.

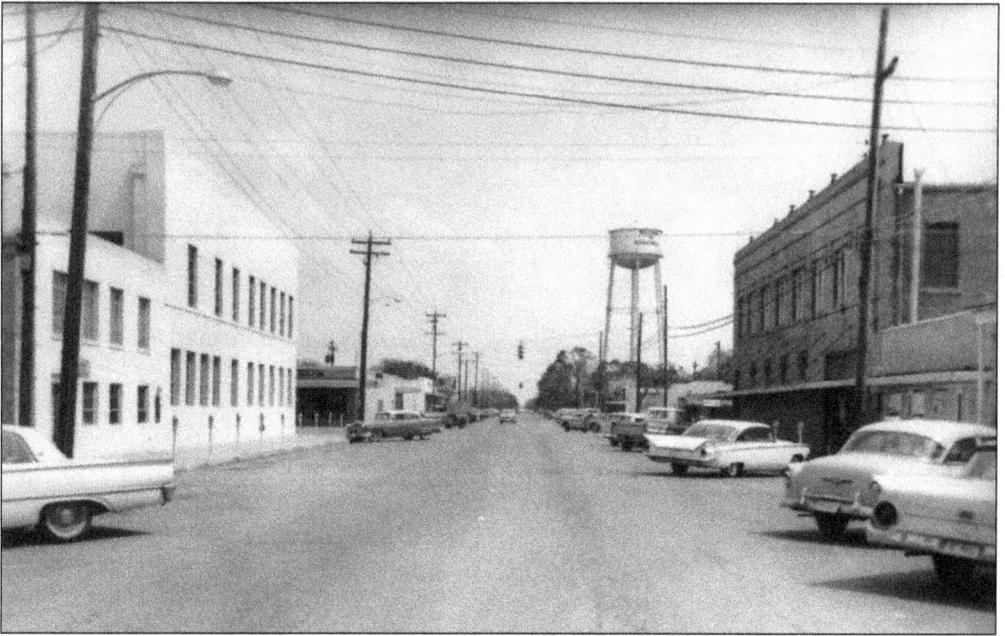

The above photograph, taken in the 1950s, looks east on Avenue G. The taller building on the right now houses Red Queens Attic (below) at 900–912 Third Street. However, before Red Queens, this building housed many very important businesses. Daily Mercantile, which had dry goods from the 1920s to 1954, sold the business to M&M Department Store with owners Mary Mills and R.M. Brown, brother and sister, and Elsie Daily as manager. Butler and Grimes Company also had a variety store business there from 1948 to 1955. They sold nickel and dime candy by the scoop. Later the business became Ben Franklin's Variety (1960–1978), and it had a photographer to take pictures right before school started. This was the sales pitch to get people to buy school supplies there. The supplies were the cheapest in town. Guy L. McNutt started his insurance business upstairs and later moved a block over. From 1998 to 2004, New Life Ministries Church was housed here. One of the most memorable places from 1914 to 1944 was Slovaks Sandwich and Ice Cream with 5¢ hamburgers, the cheapest in town. (Below, courtesy of BAC Photography and Design.)

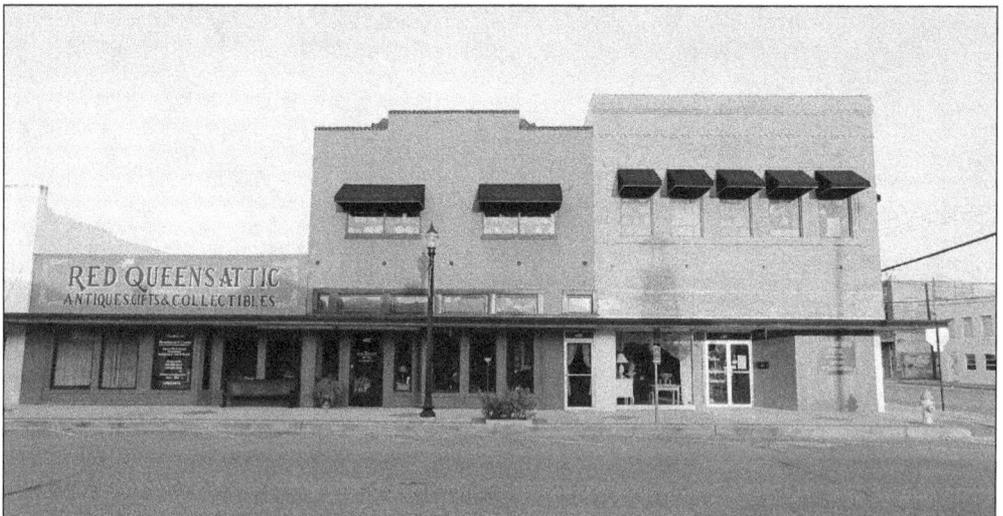

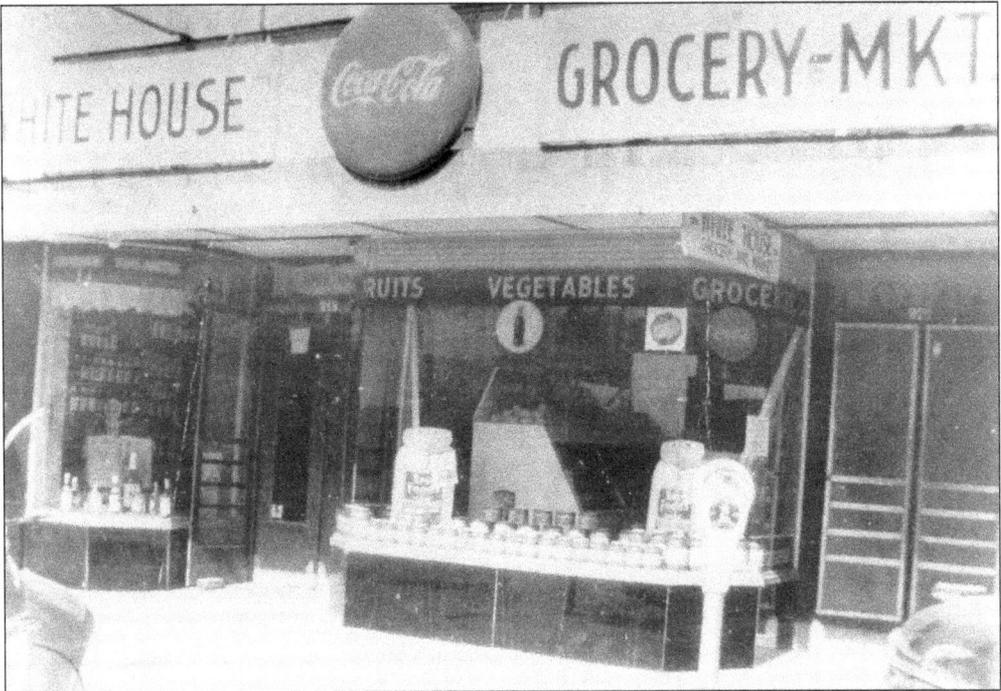

The above photograph, taken in the late 1940s, shows the White House Grocery Market, located at 916 Main Street. The business was originally owned by Herman Gold from 1935 to 1946. He sold the business to brothers Teddy, Johnnie, and Freddie Stavinoha at the end of World War II. They also purchased the building at the same time from Mr. Turrichi. They moved the business to First Street in 1949. The building also housed D.G. Oshman & Co. dry goods from 1950 to the early 1970s. Now it houses Video Sol, as seen at 916 Third Street below. (Below, courtesy of BAC Photography and Design.)

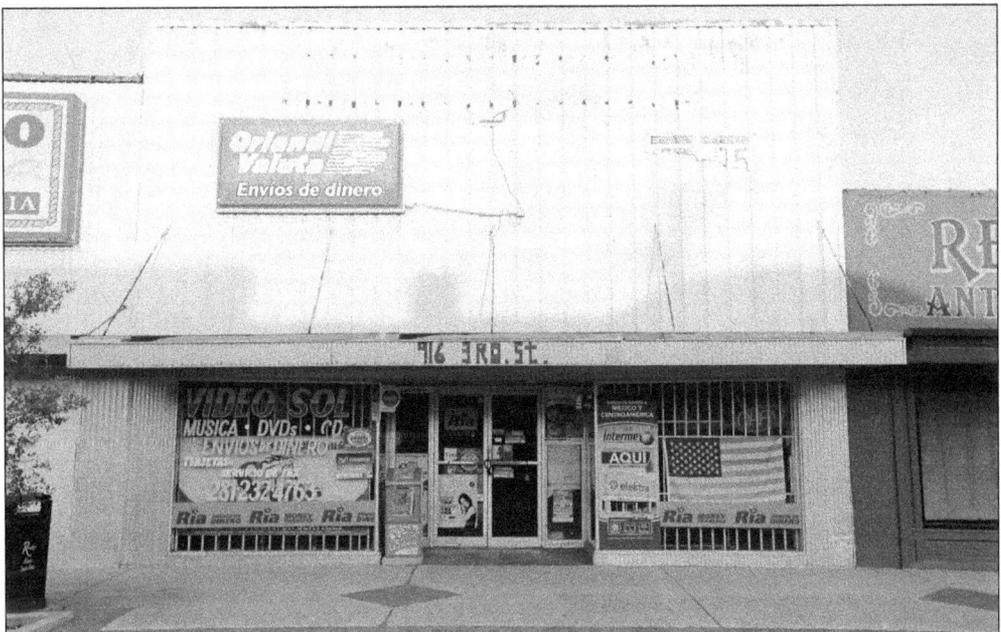

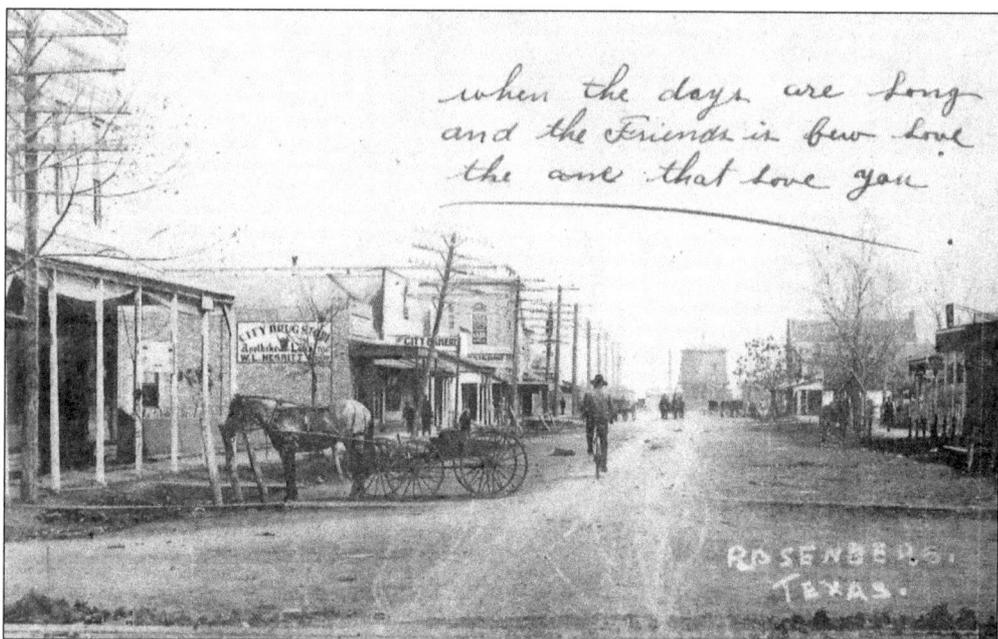

when the days are long
and the friends is few love
the one that love you

ROSENBERG,
TEXAS.

In the early 1900s, the City Bakery was located in a wooden building at 920 Main Street. It is shown here on the left, just beyond the horse and buggy. This building was later replaced with a brick structure. The bakery moved on to other locations in downtown Rosenberg.

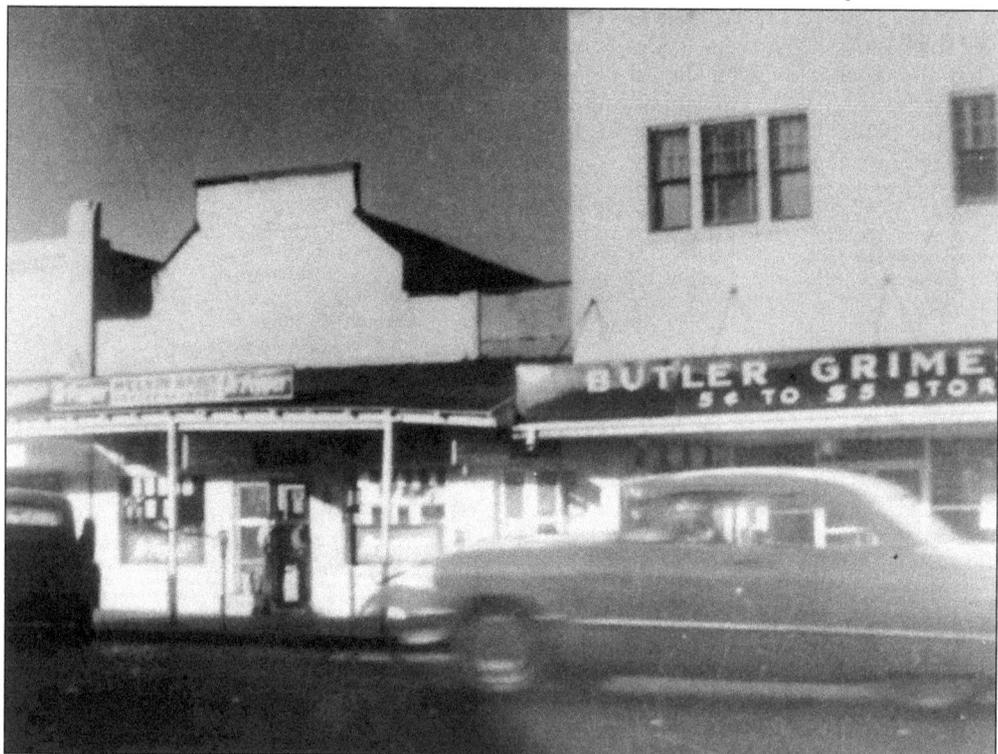

Daily's Grocery Store (left) was located at 920 Main Street. It is seen here in the late 1940s or early 1950s. Next door was Butler and Grimes variety store.

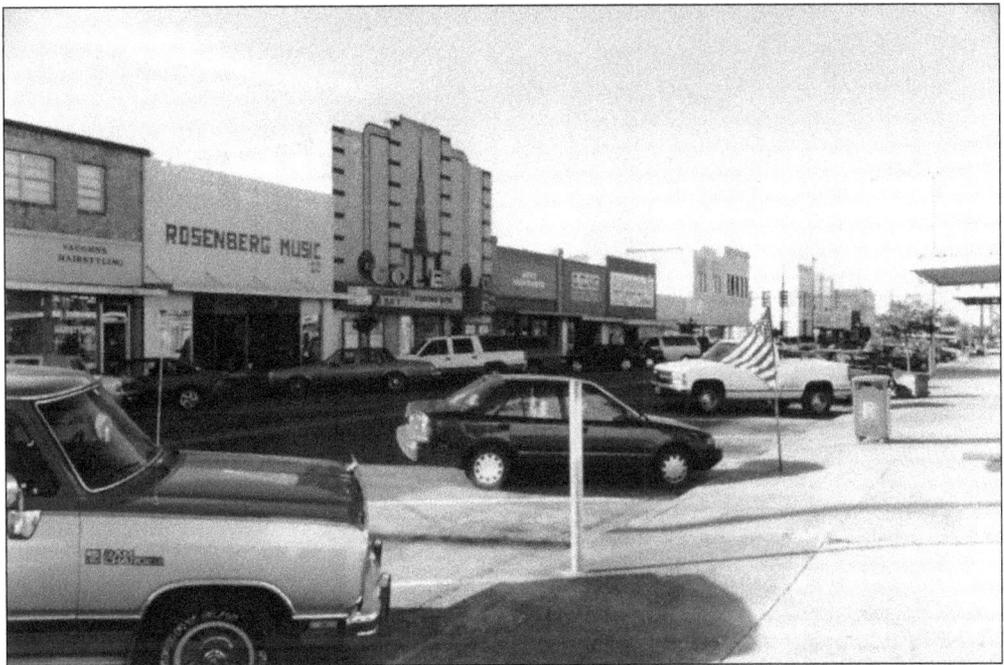

In this photograph, the second building past the Cole Theater on the left is 920 Main Street, which housed the City Drug Store (1915–1923) and Daily's Grocery Store in the 1940s with brother and sister Melvin and Elsie Daily as owners. Melvin never got married, but Elsie did at 70 years of age. Howard and Willie Mae Schwarting bought the store from the Dailys and ran it from 1944 to 1948 and then began Main Cafeteria (1948–1951). After that, they opened Budget Shop (1951–1966). This building at 920 Third Street has housed El Tejano Meat Market since 1984. (Right, courtesy of BAC Photography and Design.)

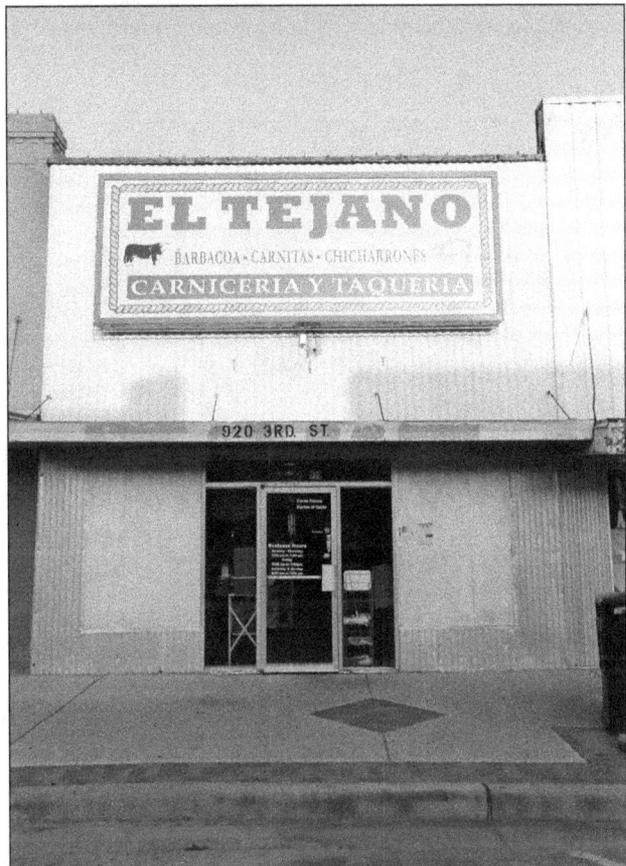

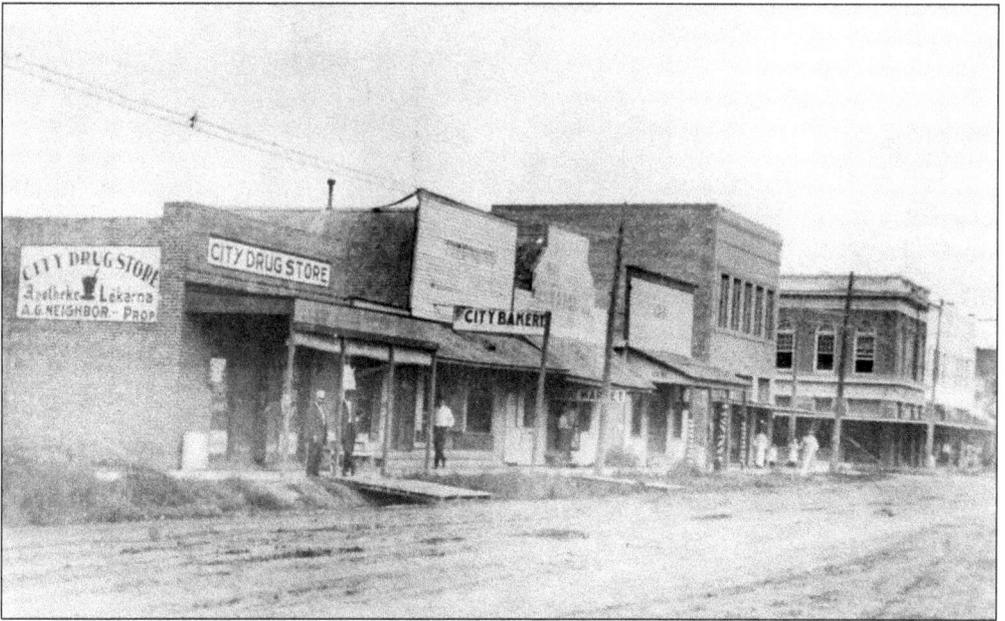

In the 1930s, Rosenzweig's Dry Good Store had its business at 924 Main Street. Later, City Drug Store occupied the building. The sign on the side of the building indicates that the pharmacy served a diverse clientele, including Anglos, Germans, and Czechs.

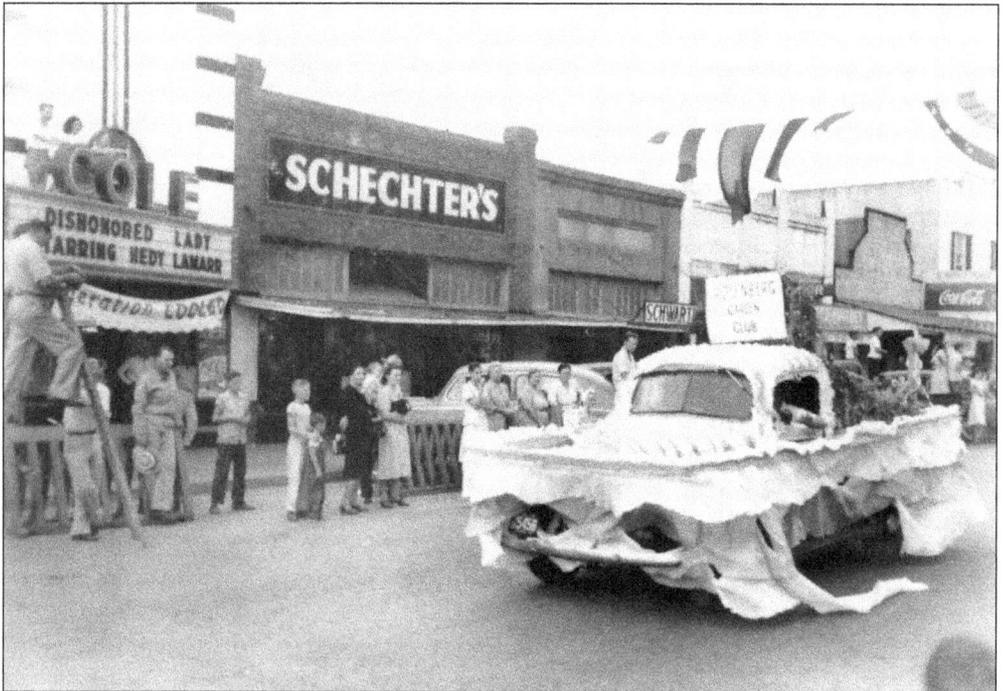

Schechter's Department Store was a great place to watch a parade in the late 1940s. The store was owned by Butch Schechter and primarily had men's clothing from 1948 to 1955.

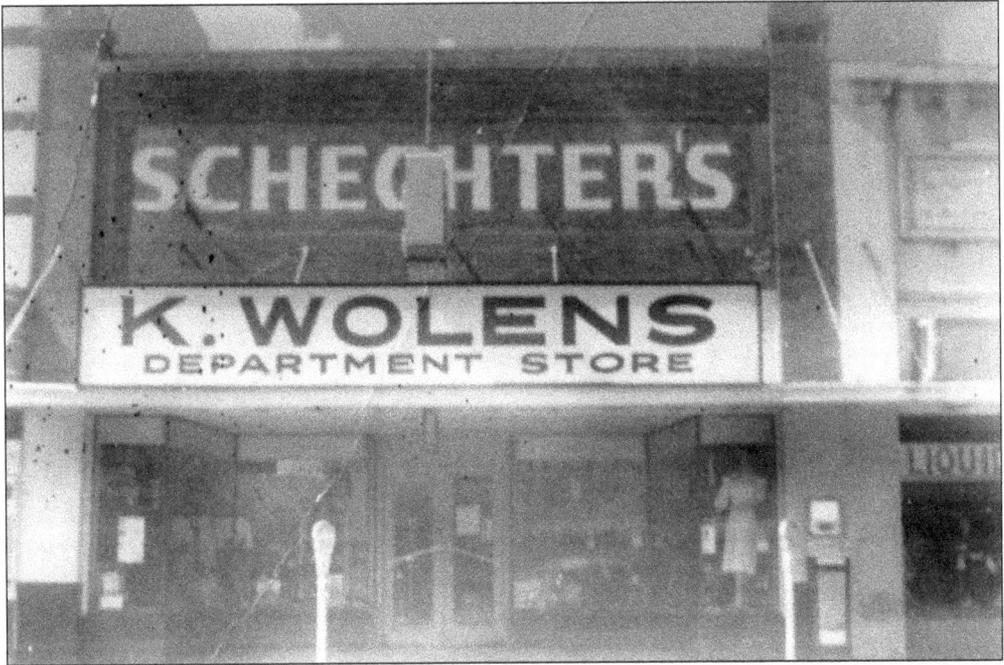

Schechter's Department Store became K. Wolens Department Store in the early 1960s. It was located at 924 Main Street. This was Rosenberg Music Company's first downtown location (1973–1984). The building has several occupants today, including building owner Danziger Investments, Jay and Barb's Antiques, Simply Artistic, and Juan's Music. Pictured below, at 924 Third Street, is the Danziger Building today. (Below, courtesy of BAC Photography and Design.)

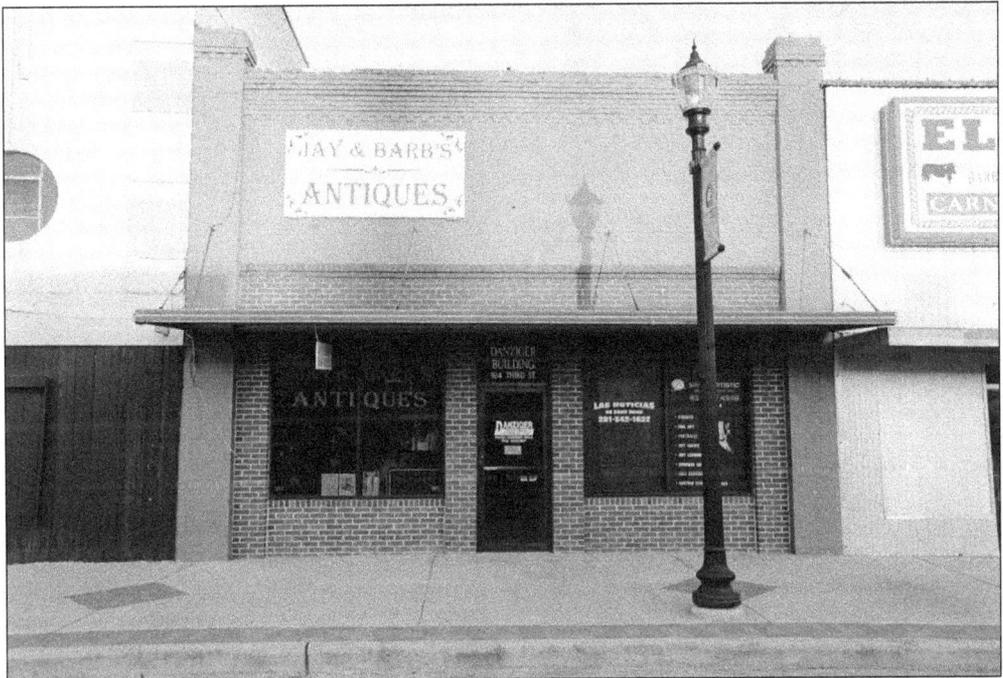

The Picture You've Waited to See

Liberty Theatre
Rosenberg, Texas

WEDNESDAY – THURSDAY – FRIDAY
January 7, 8 and 9

"NORTH OF 36"

Also 2-Reel Comedy

Show Starts Promptly at
8:00 p. m.

Matinees Each Day
at 2:30

Admission 25c and 50c

The Liberty Theatre, built in 1919, was located at 930 Main Street. It was named in honor of the nation's participation in World War I, which had ended less than a year before. The theater was renovated in 1936 and reopened as the Cole Theater, named after its new owner, Mart Cole Sr. Within the theater was Guarantee Jewelry Store, which was owned by Miles Podlipny Sr. and Fred Felcman Sr. They constructed the building that housed both businesses. It was located to the left of the structure.

Portions of the movie *North of 36* were filmed in Fort Bend County in 1922. The movie was shown at the Liberty Theatre.

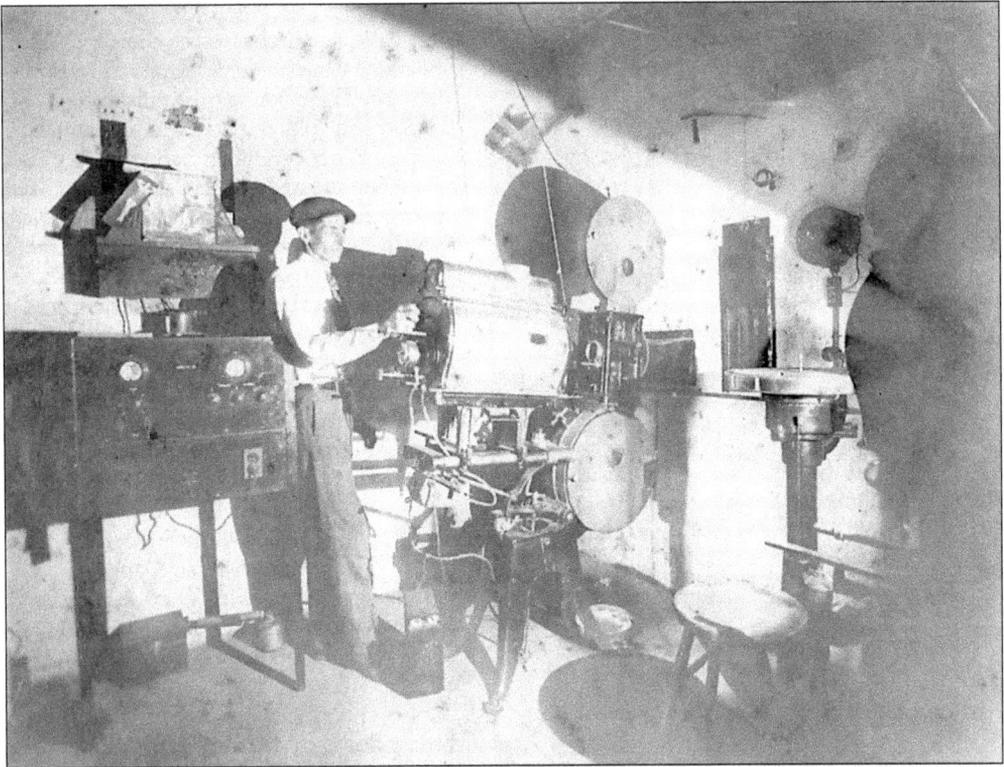

Louis Kocurek stands at the projector in the Cole Theater in the 1940s. To counteract the introduction of television into American homes, Hollywood started a program called "Stars Across Texas." Many famous actors came to the Cole Theater, including Shirley Temple, Roy Rogers, Clark Gable, Gene Autry, and Jeff Chandler. Gayle Storm sold war bonds here.

This is a flyer from the Cole Theater from May 1946. Such movie schedules were mailed and hand-delivered throughout the community.

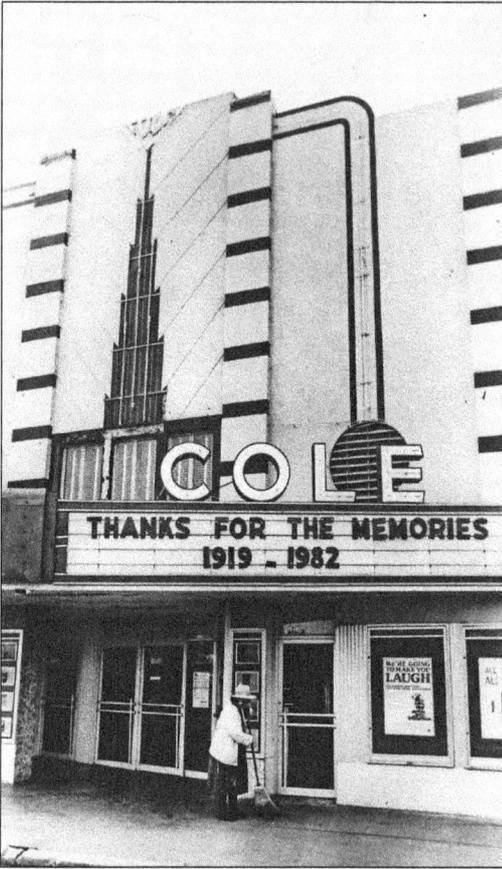

Mart Cole Sr. purchased the theater in 1936. The name was changed during renovation that year. The colors for the curtains, maroon and gold, were chosen to match the colors of Rosenberg High School. Alphonse J. Schubert created the Art Deco front and the interior decorations. Black residents had a segregated entrance and were required to sit in the balcony. Hispanics could go in the front door, but they had to sit in the balcony. During Christmastime, Santa would ride on a fire truck from the train station to the theater, where everyone would gather and sing Christmas carols. Then everyone would see a movie for free. From the 1940s to 1956, the theater had a wheel that was spun for door prizes on Wednesday nights. Estel Roesler, the last winner, received $360. The pot was progressive, and one had to be present to win. The theater was the babysitter for the town. In the 1940s, a ticket was 5¢, then was raised to 10¢. In the 1950s, a ticket cost 25¢, then was raised to 75¢. Rosenberg Opry took over when the theater closed in the early 1980s. Singer Leann Rimes sang on the stage before she became a star. Pictured here, at 930 Third Street, is the vacant theater today. (Below, courtesy of BAC Photography and Design.)

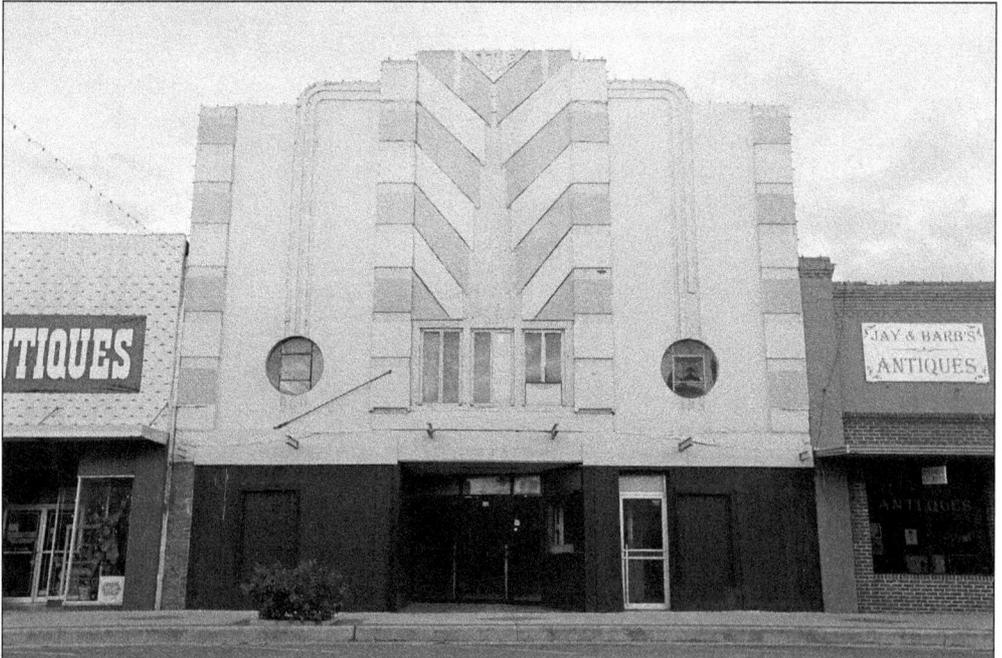

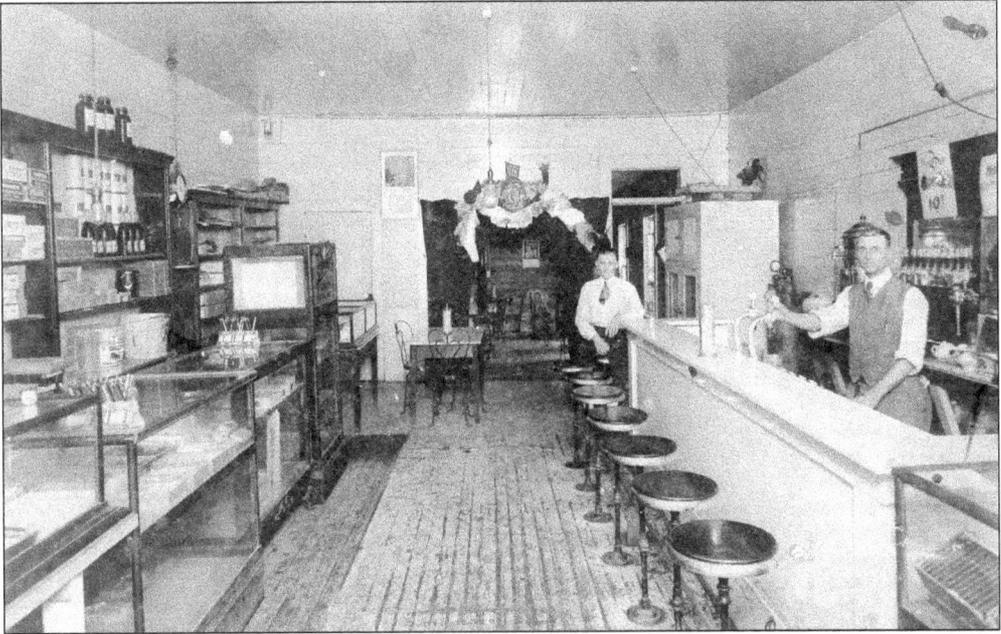

Rosenberg's very first soda fountain was located in the Palace of Sweets at 934 Main Street. Shown here in 1916 are C.H. Boring Sr. (left), the owner, and Clemmie.

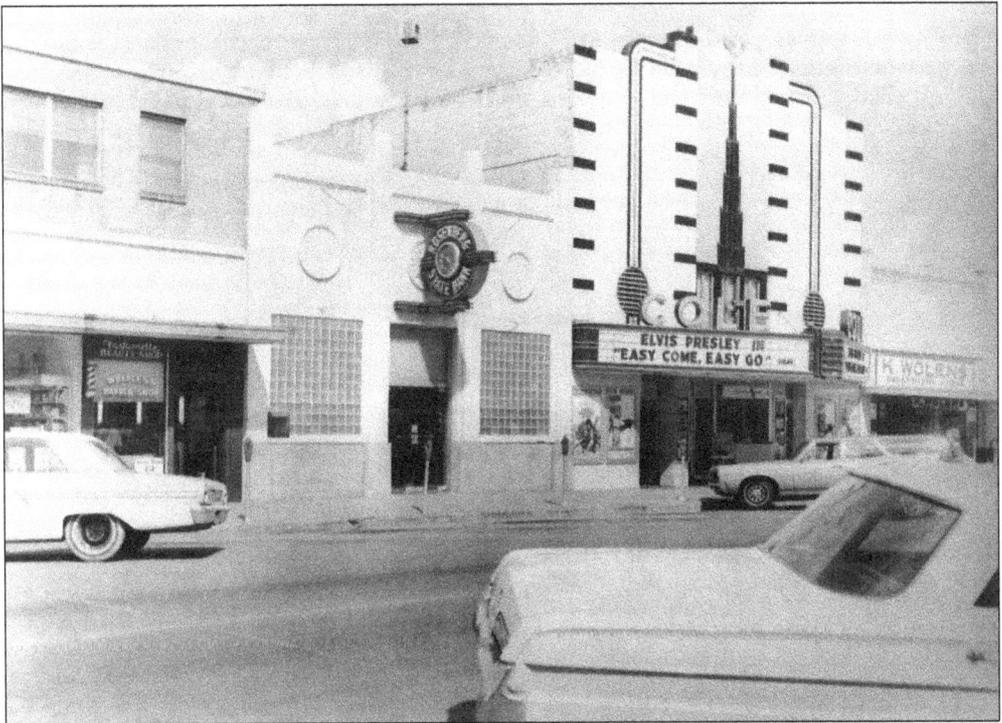

In 1967, the Rosenberg State Bank was located at 934 Main Street. It had been at this location since 1935. Other businesses were Mode O' Day women's store (1971–1976), Guys and Dolls (1978–1984), and Rosenberg Music Company's second location (1986–2014). The building now houses Barn Door Antiques.

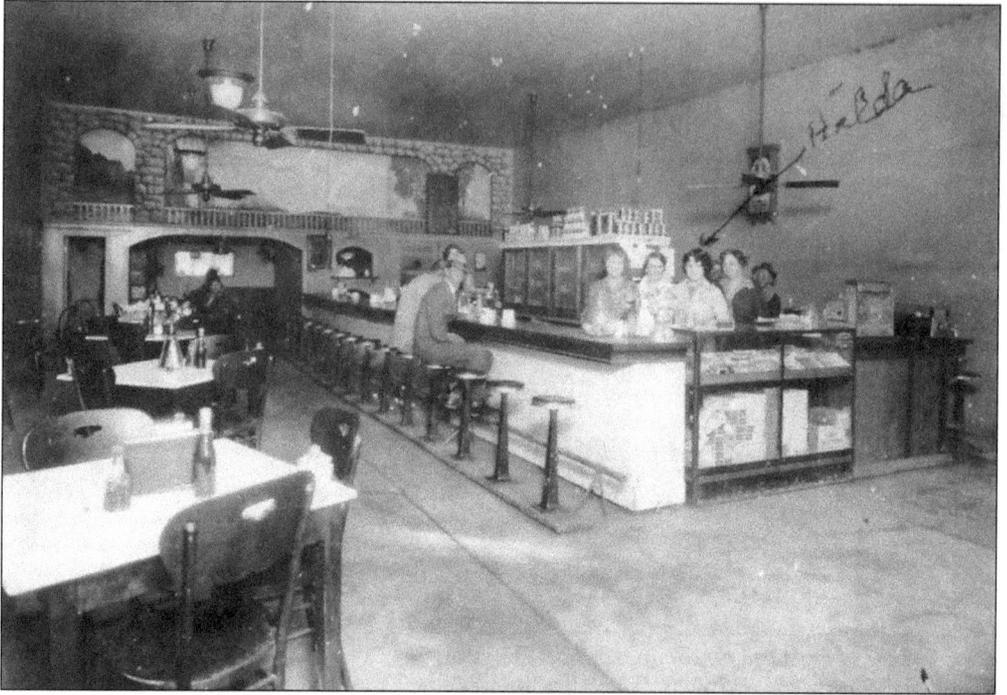

The Palace Café was located in downtown Rosenberg. Pictured above in 1929 behind the counter are, from left to right, Lilly Bezecny, Laura Gasch, Hilda Luedeke Blahuta, and manager Mrs. Hillard Allison. Today, the building houses Barn Door Antiques (below) at 934 Third Street. (Below, courtesy of BAC Photography and Design.)

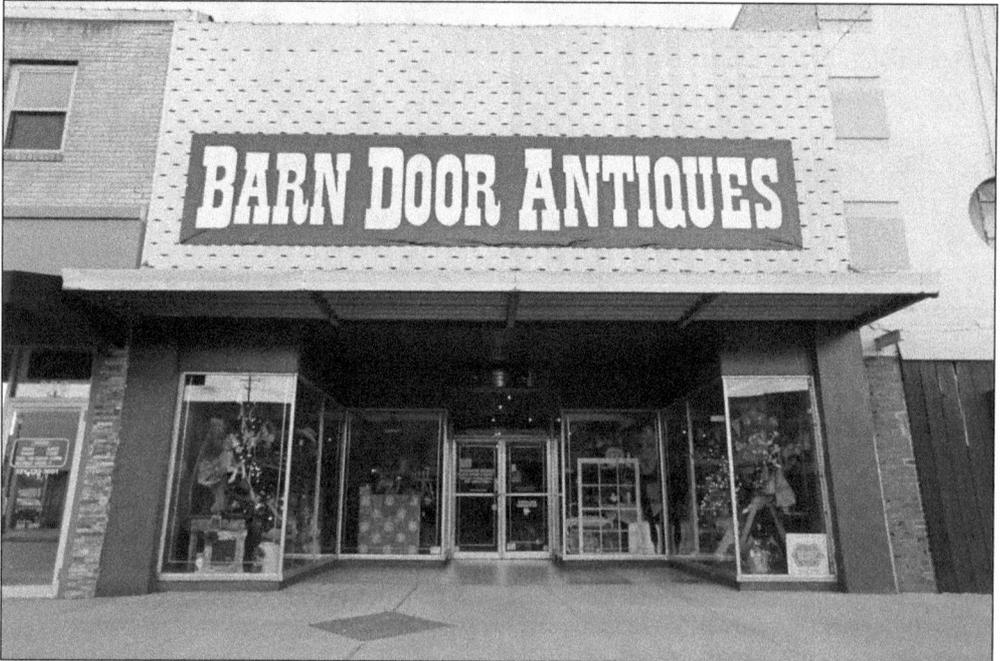

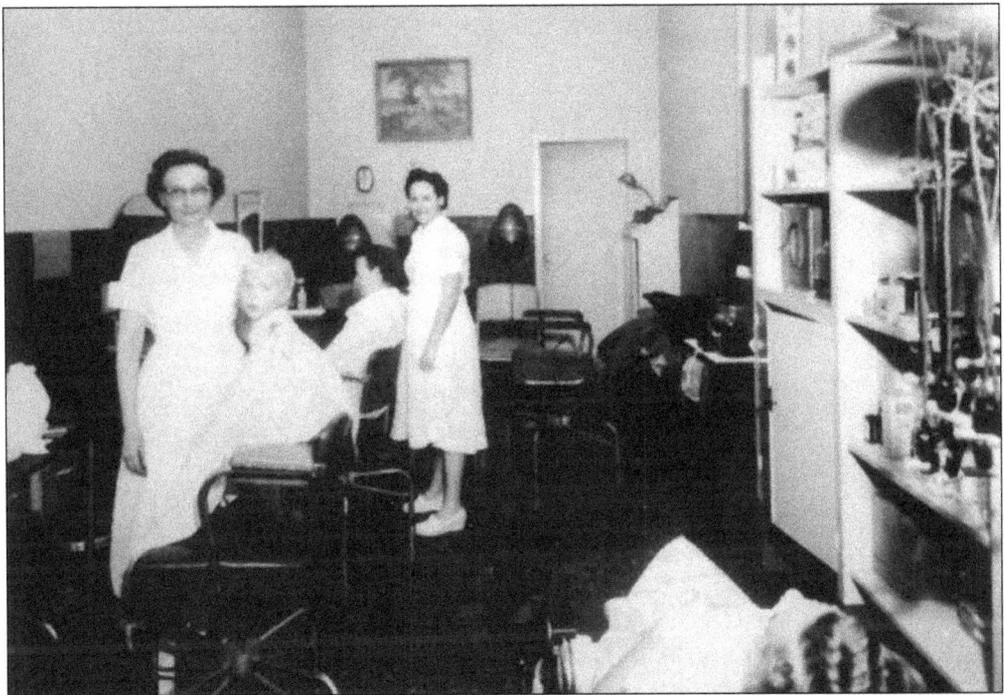

The Fashionette Beauty Salon began in 1948 and was located in the back of Wheeless Barber Shop, begun in 1926. Shown in the above photograph are owner Elsie McFarland (left), Margie Danhaus's son (in chair), Elizabeth Fisk (standing in back), and Dannhaus (in chair at lower right). Pictured below, at 936 Third Street today, is Cindy's Cut 'N Corral. (Below, courtesy of BAC Photography and Design.)

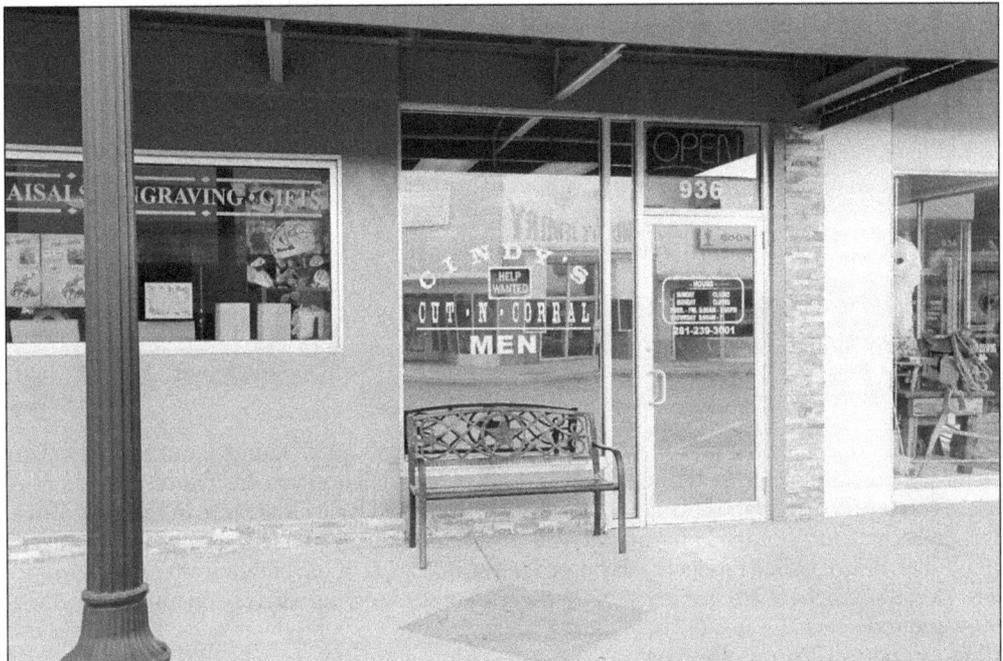

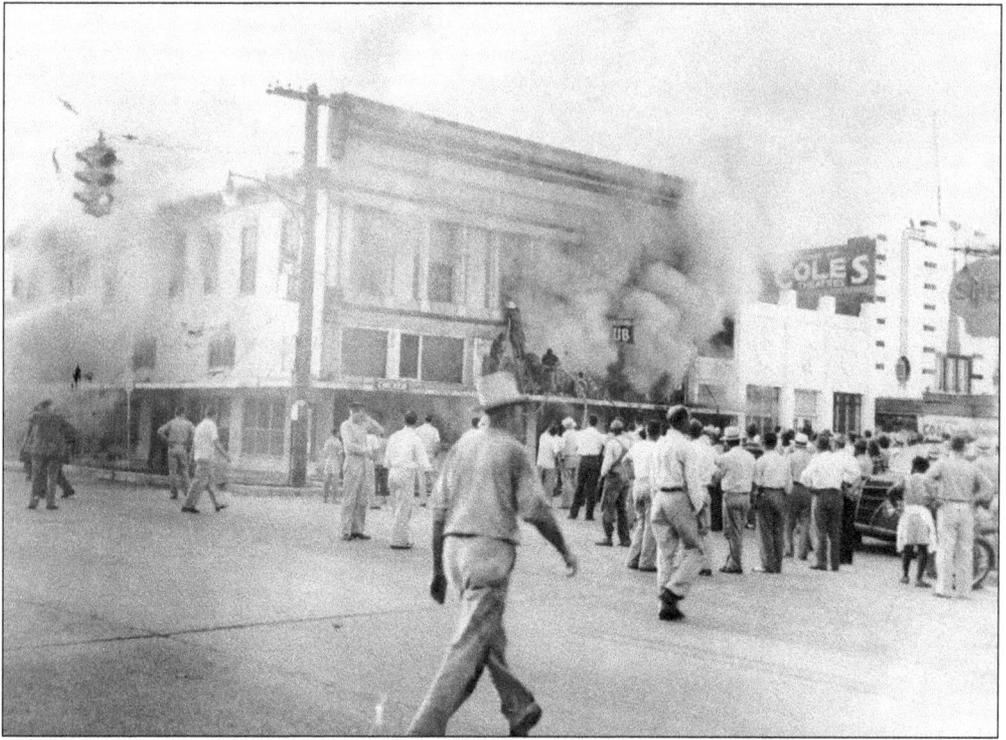

On September 10, 1946, the Eagle Café and Hotel, along with Howard's Drug Store and Green's Recreation Hall, burned down in one of Rosenberg's worst fires. Customers of the bank next door were afraid their money would burn if the fire was not put out quickly. The customers were assured that the bank had a vault and that their money was safe. In 1934, Bonnie Parker and Clyde Barrow parked their car and came into the café. Carl Turicchi, who is Lydia Turicchi Mahlmann's dad, waited on them. They sat down, ordered their food, and ate, never looking up. The outlaws had left their car running. No one was hurt, and no one confronted the gangsters. They were killed shortly after that in Louisiana on May 23, 1934.

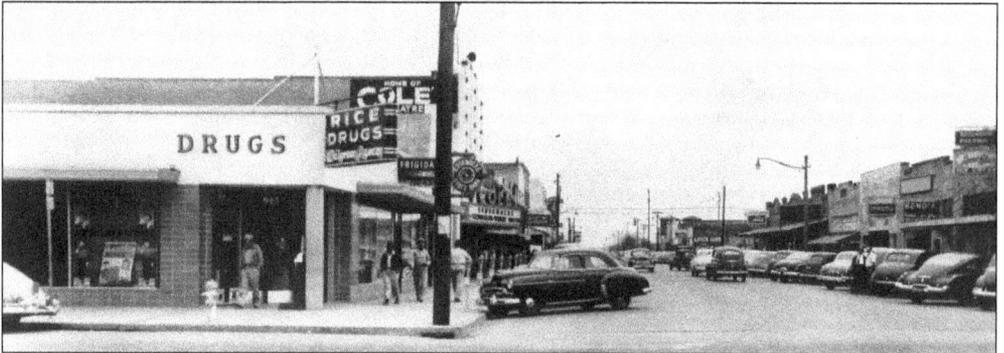

After the previous structure burned down in 1946, a new building was erected on the corner of Main Street and Old Spanish Trail (Highway 90A). It housed Rice Drug Store in the early 1950s. It then became Jim Gordan's Pharmacy (1950–1968) and Miller Pharmacy, owned by pharmacist Jim Miller. Brazos Office Products was housed in the front part of the building after the pharmacy left; Dostal's Designs (1940–present) was in the back of the building with the opening to Highway 90A and took over the rest of the building when Brazos Office Products moved. This was the third location for Dostal's Designs.

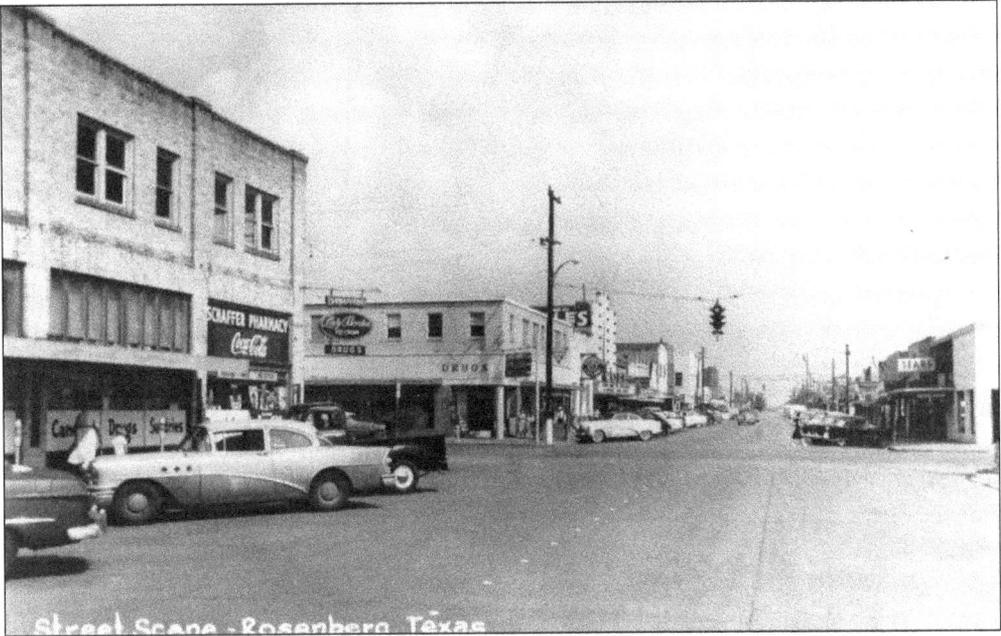

The new building at Main Street and OST is seen here in the 1950s. At this time, the building had a second story, which housed Lamar Meadows Sr., DDS, and Will E. Scott, MD, who was known for the bow ties he wore, the Selective Service Office, and Greenlawn Cemetery office from 1950 to 1970. Pictured below, at 940 Third Street today, is Dostal's Designs.. (Below, courtesy of BAC Photography and Design.)

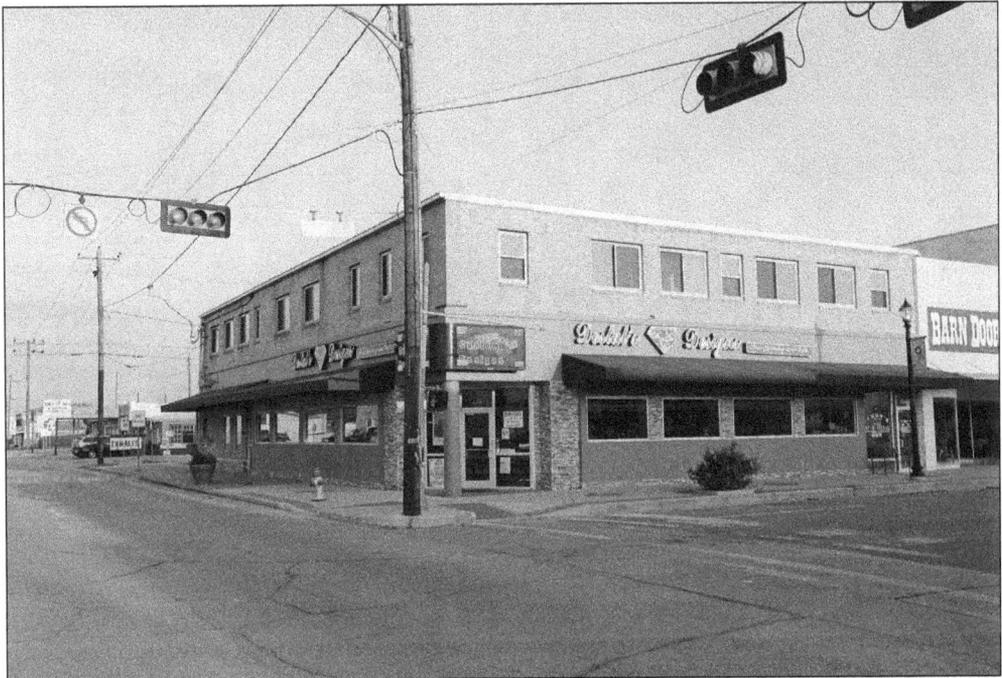

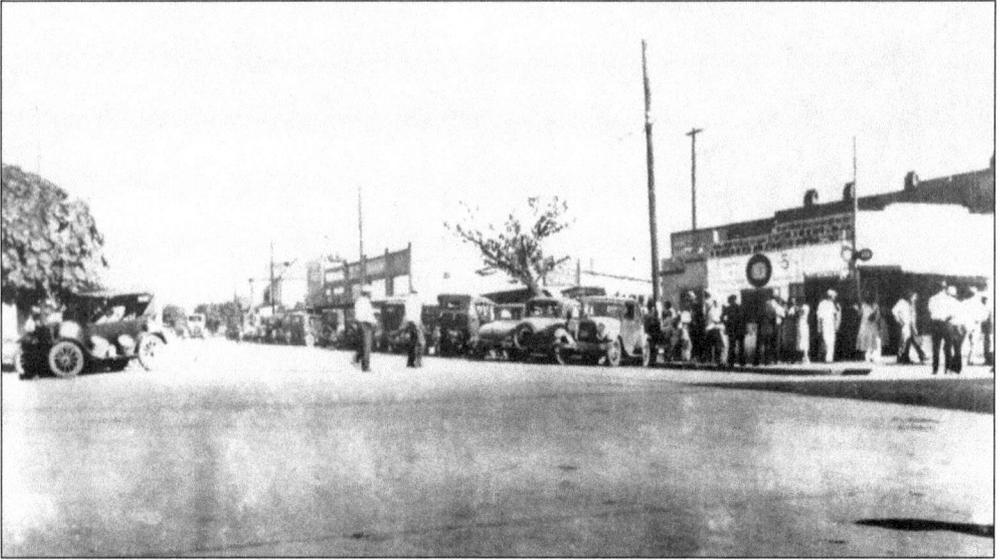

The red cinder block building on the southeast corner of Main Street and Avenue G housed Bill's Place in the early 1930s. It is believed that the building, which had an ornate mirror, was a saloon before it became Bill's Place (1938–1962). Bill and Mary Bezecny owned the café and beer joint. There was a long counter, and latticework divided the food-preparation area from the customers. The establishment had two domino tables by the window. It served breakfast and lunch for locals and for railroad workers. During World War II, Bill's sister-in-law Lula set up a booth in the alley to take photographs, after which she colored them.

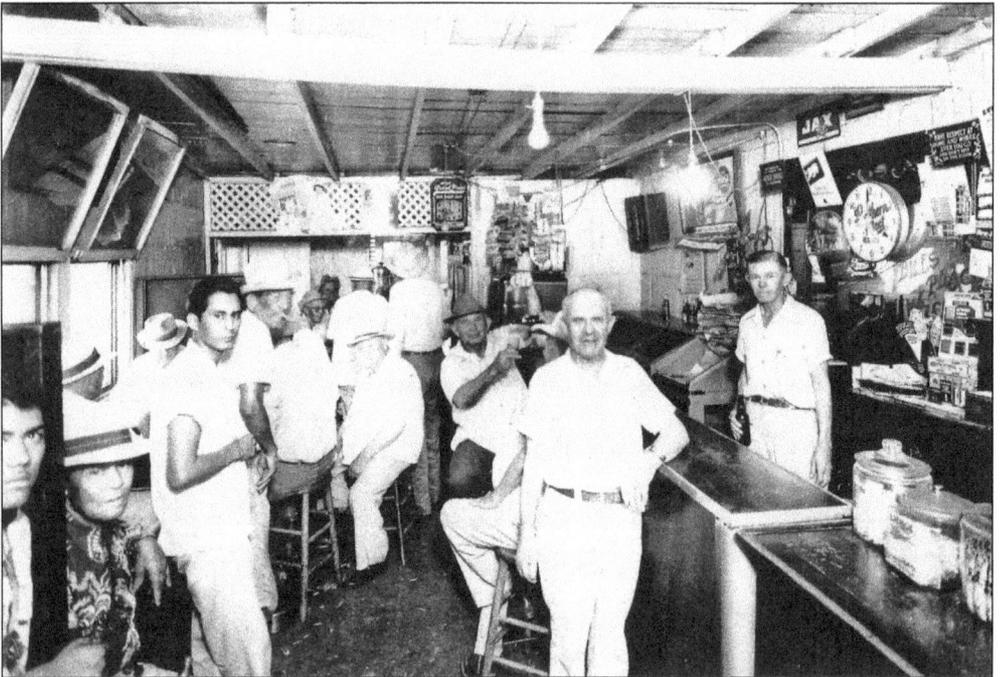

This interior picture of Bill's Place shows several locals, including Lou Kinney (seated center), Adolf Kelm (fourth from right), and George Hochman (second from right, owner of the fruit stand next door). Behind the bar is owner Bill Bezecny.

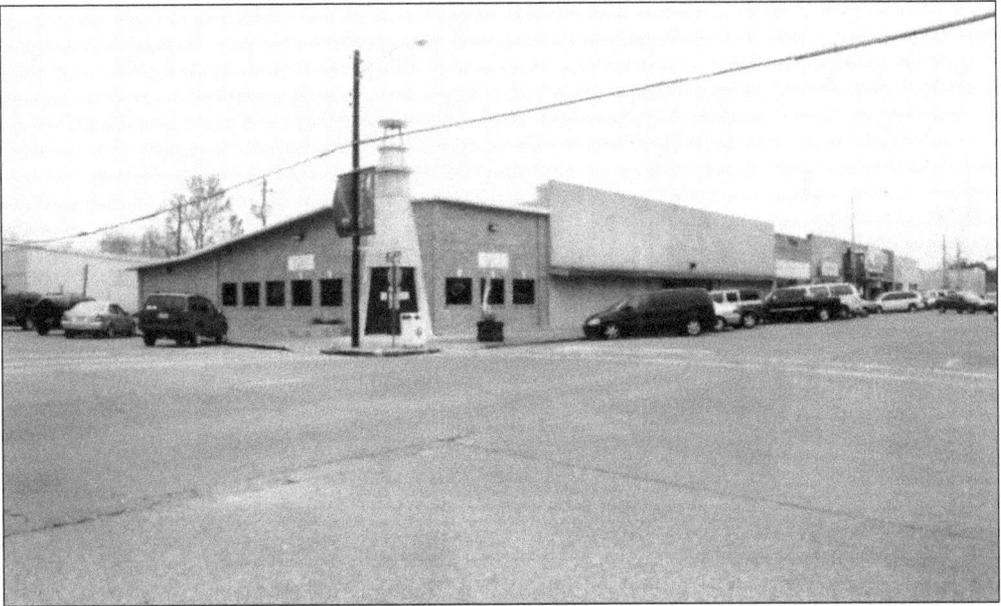

This "lighthouse" building at the corner of Avenue G and Main Street was intended to be a restaurant for the New Life Ministries Church, which at the time was housed directly across the street. The project never happened. The building was erected in 2002 on the former site of the Red Dog Saloon, which opened in 1988 and burned down in 1998. In 2003, Another Time Soda Fountain & Café was temporarily housed there during the renovation of the original building at 800 Third Street. Fancy's Antiques (2004–2006) was housed there once the café moved. Petromax Resources was housed there from 2007 to 2009, and now Fort Bend Chiropractic Center is there, as seen below at 901 Third Street. (Below, courtesy of BAC Photography and Design.)

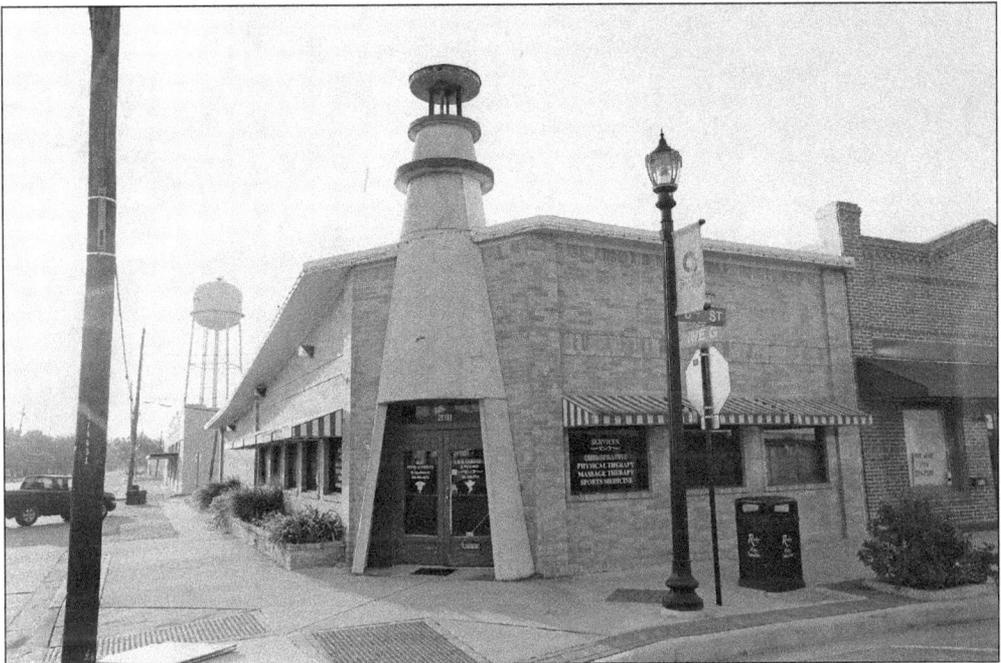

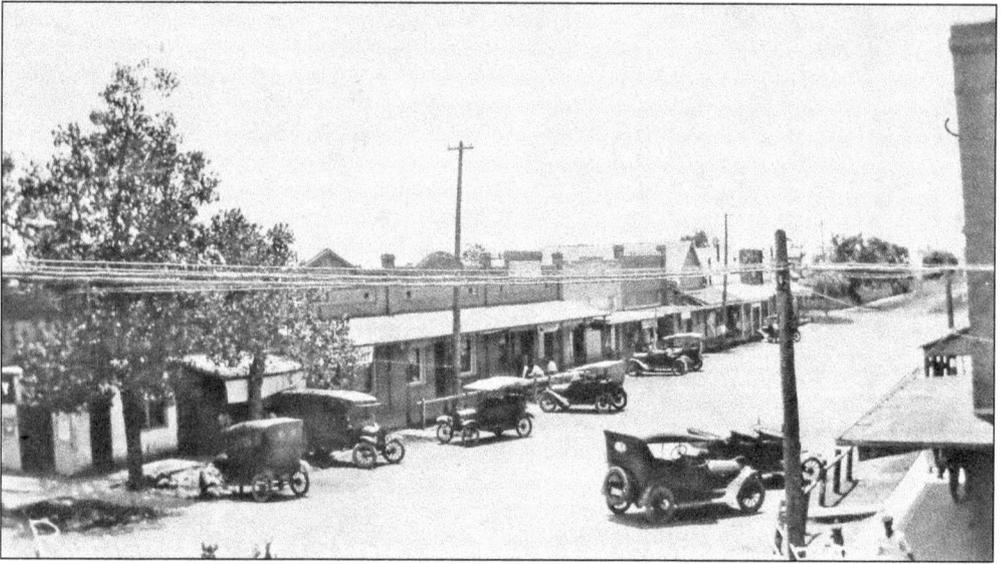

This photograph, taken in 1926, depicts the east side of the 900 block of Main Street. Left of the brick buildings is 903 Main Street, which no longer exists. The Hochman fruit stand, from 1948 to 1955, was an outdoor area covered with a tarp. Customers could buy sugarcane in pieces to chew. Rudy Celman's Saw and Lock Shop took over the area and framed it out and made it into a wooden building. Rudy would charge $1.25 to make new keys, saying it was "a quarter for the key and a dollar for the know-how." He was a very religious man and helped to build the Jehovah's Witness Kingdom Hall on Eighth Street. He sold ice cream from his bicycle and peanuts at football games. He emigrated from Europe when he was four and never was able to speak well because of an accident he had when getting off the boat on arrival in the United States. He walked funny, was well liked, and was considered a very smart and a hard-working man.

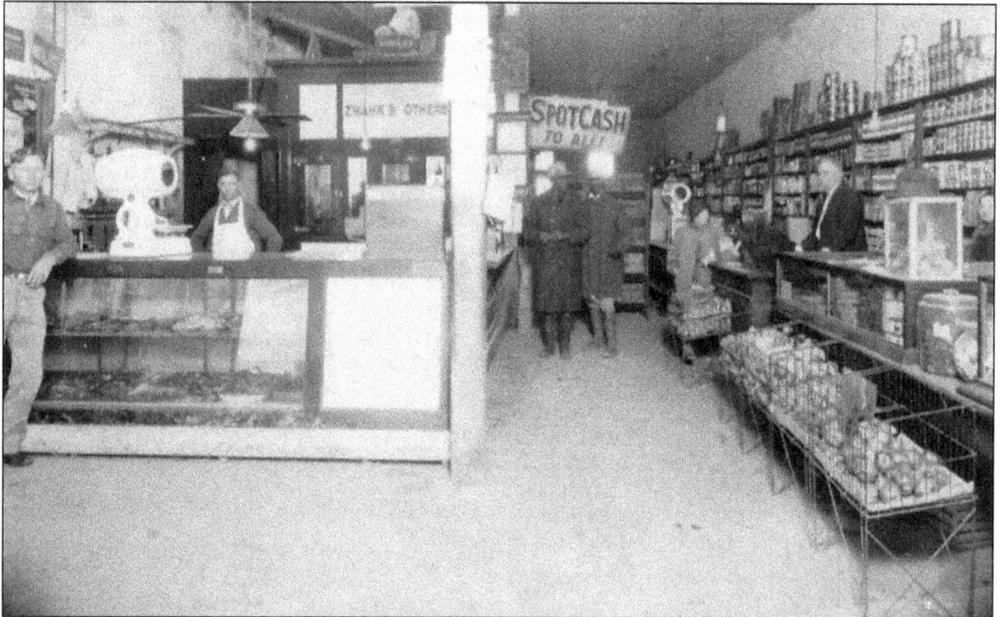

The building at 905–907 Main Street, erected around 1920, housed the City Meat Market and J.T. Barnes Grocery. The interior of the building is seen here.

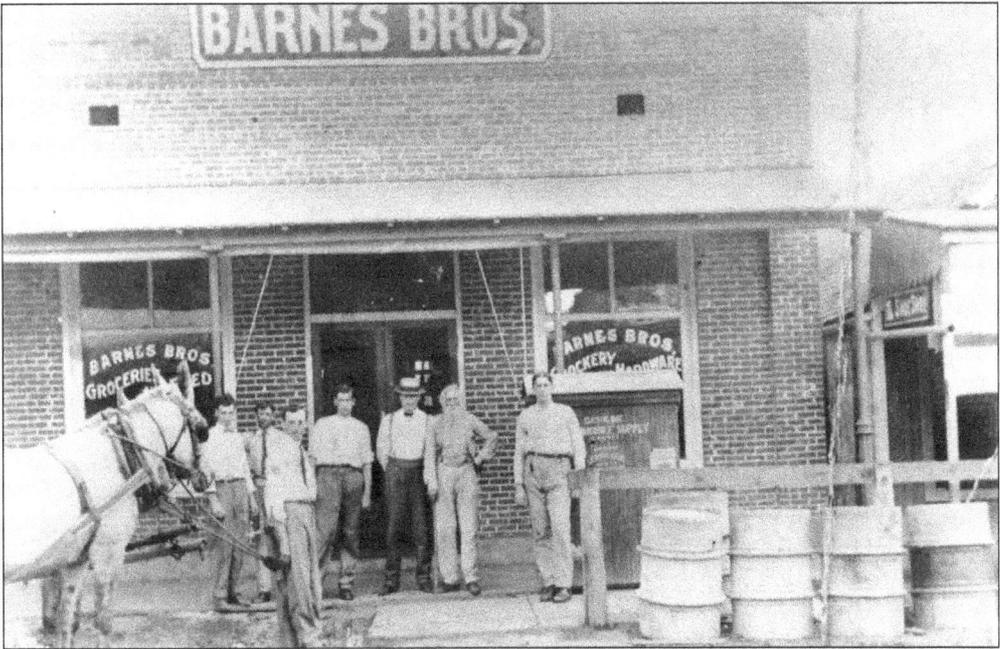

In 1911, the Barnes Bros. store was located at 905–907 Main Street. Shown here are, from left to right, Elton Barnes, Jim Barnes, George Thomas Barnes, Max Lewis, Morris Lewis, Mr. Barnes, and P.K. Rude Sr., who first operated the Barnes Bros. establishment.

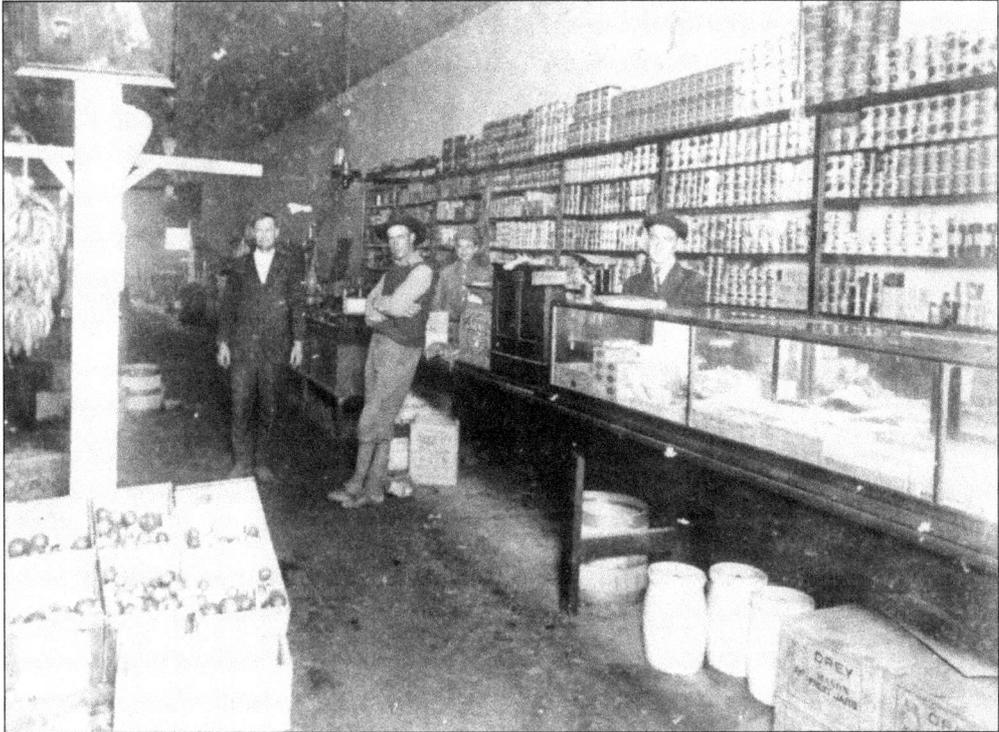

Shown here is the inside of J.T. Barnes Grocery, located at 913 Main Street. Posing here are, from left to right, Charles Seydler, Jolin Gray, an unidentified person, and Arnold Seydler.

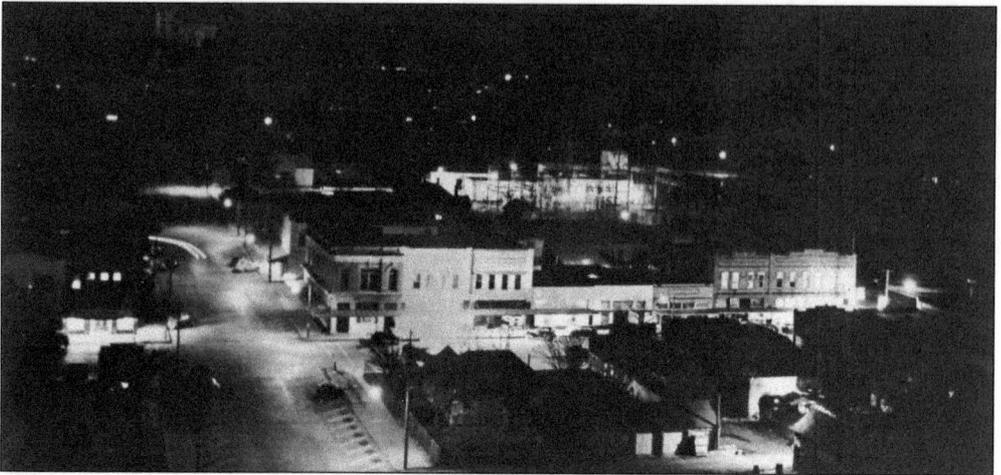

This is a 1942 view of Third Street during a World War II night air raid practice.

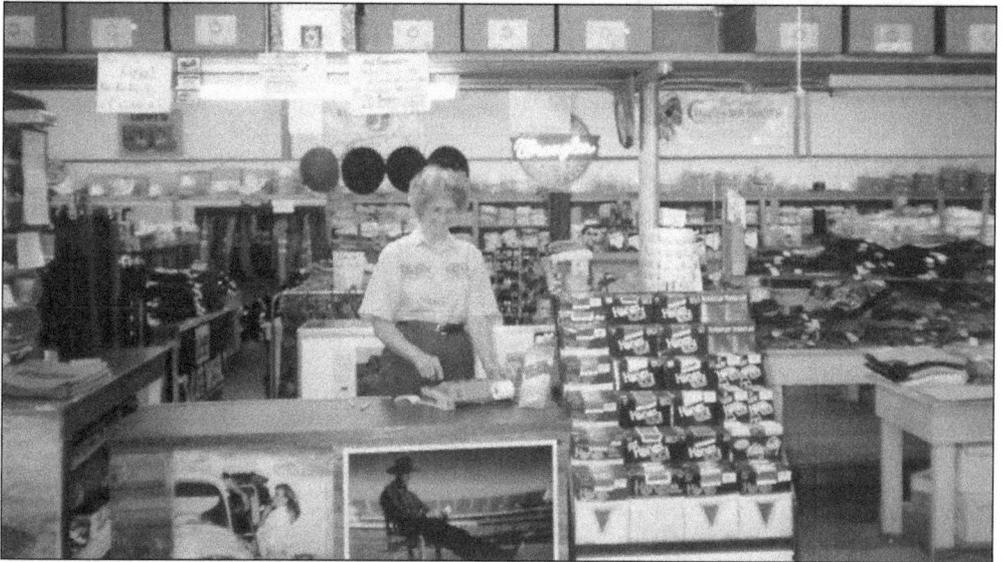

Blase Dry Goods (1948–1995) was known for its extensive inventory of merchandise. Virginia Verm, who worked for the store for 48 years, is shown here behind the register in the 1980s. Ricky and Lois Blase, brother and sister, ran it after their parents died. There was 50 years' worth of merchandise in the place. Once an item was marked with a price, it was never changed. Piles of clothes were stacked so high that parents were afraid to let their kids run around, fearing the stacks might fall on them. The schools would shop there for costumes for drama and choir productions. Residents would go there to get the latest style of blue jeans or a costume dating to the 1940s. The store was the first to get the Husky brand of clothing. The workers knew exactly where everything was. Sometimes, when customers were looking for clothes, they would find a bottle of whiskey that Mr. Blase had hid from his wife. The store's slogan was "If you can't find it anyplace else, go to Blase's." The Blase family turned it into an antique store in 1997–1998, and they then sold the property to William Butler. Kelm's Grocery Store (1930s) sold to A.W. Fahrenthold, and he changed the name to Fahrenthold Grocery. Other businesses in this location were Clayton's Home and Auto Supply (1948–1949); Firestone Tire and Appliance Store, owned by Jack Forster (1949–1954); and Anderson Home and Auto Store (1954–1955); then it became part of Blase Dry Goods.

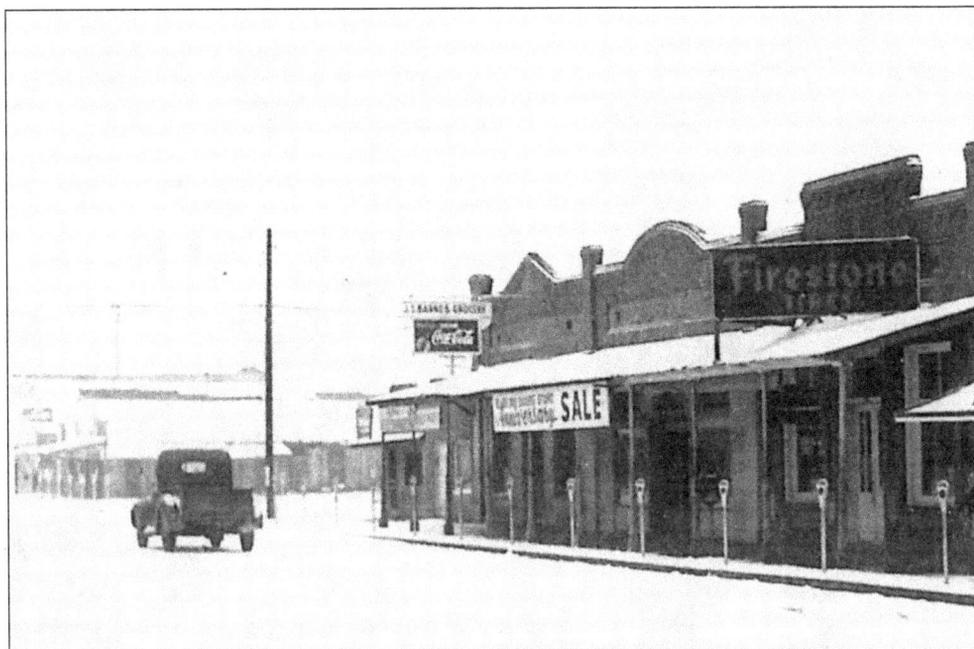

Seen here in the early 1950s are J.T. Barnes Grocery (center), Blase Dry Goods (right of center), and Firestone Tires and Appliance Store. Later, Blase Dry Goods occupied all three stores. These buildings now house Third Street Emporium, Good Things, and A Tropical Haven, respectively.

The Blase Dry Goods building is seen here in 1980. Originally, three buildings made up the establishment. The Blase family applied a stucco facade to give the appearance of one building.

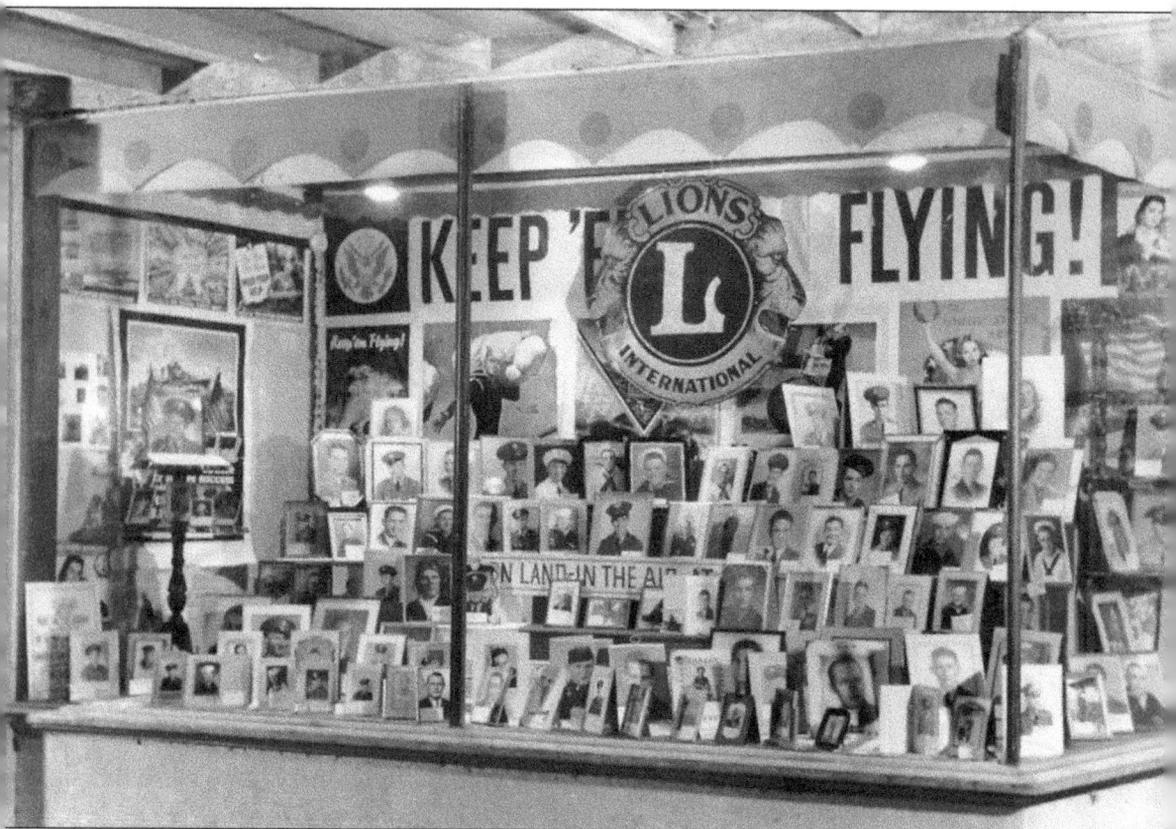

In a show of patriotism during World War II, Blase Dry Goods and Schechter's Dry Goods posted photographs of local service personnel in their front windows.

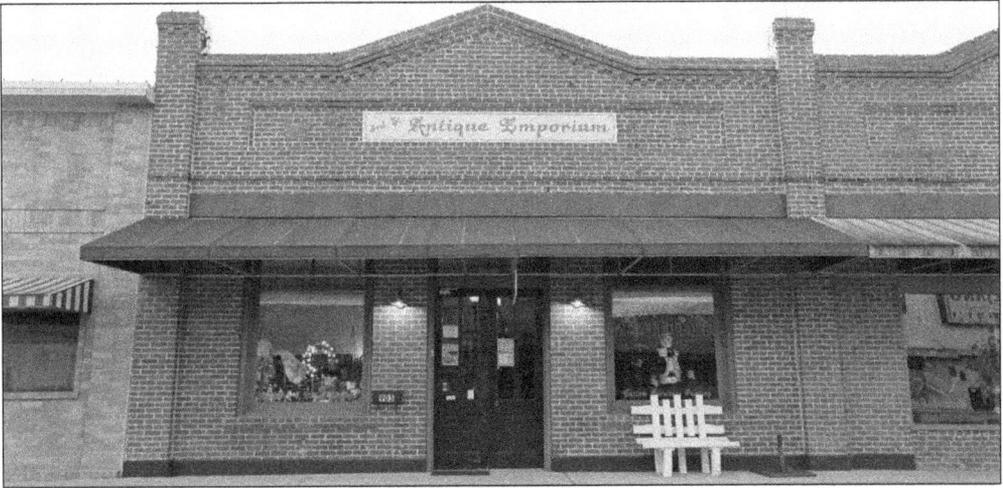

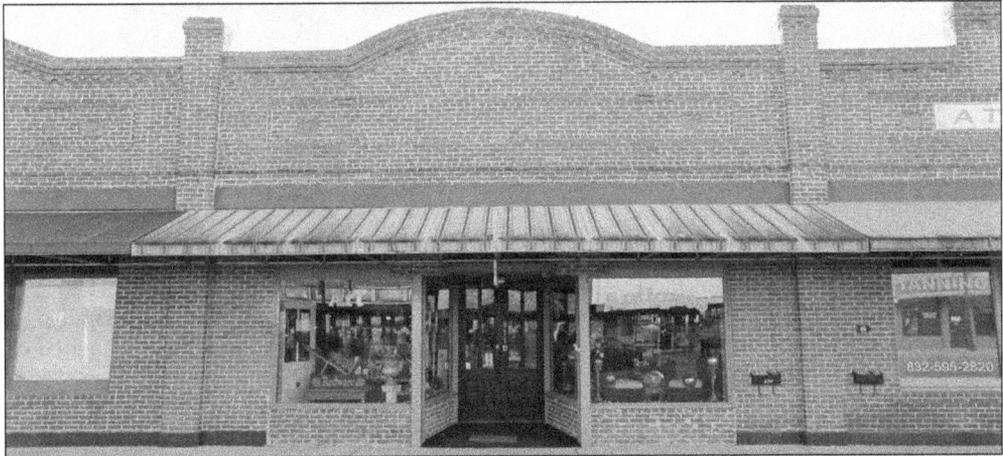

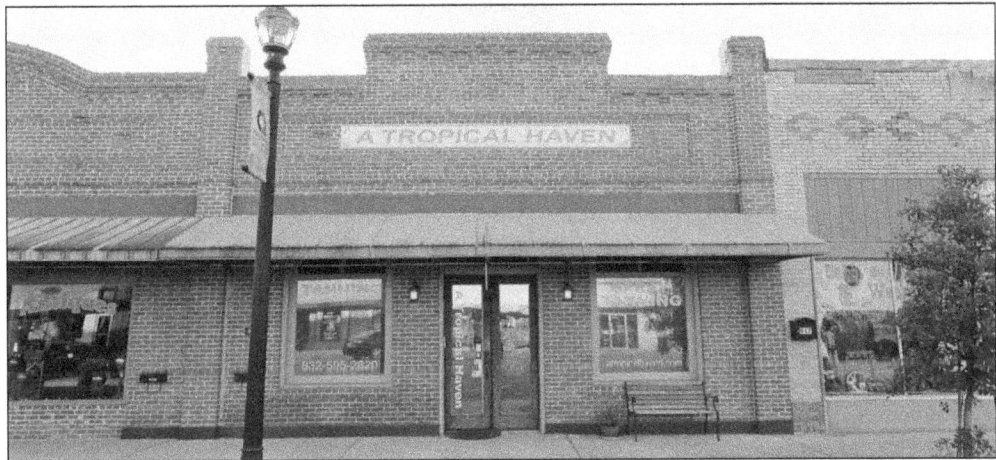

This site was the location of J.J. Newman & Co. from 1926 to 1938. The store sold dry goods and dress goods. Kaplan's Dry Goods occupied the site from 1938 to 1948. Today, it houses Antique Emporium at 905 Third Street (top), Art & Antiques at 911 Third Street (middle), and A Tropical Haven at 913 Third Street (bottom). (All, courtesy of BAC Photography and Design.)

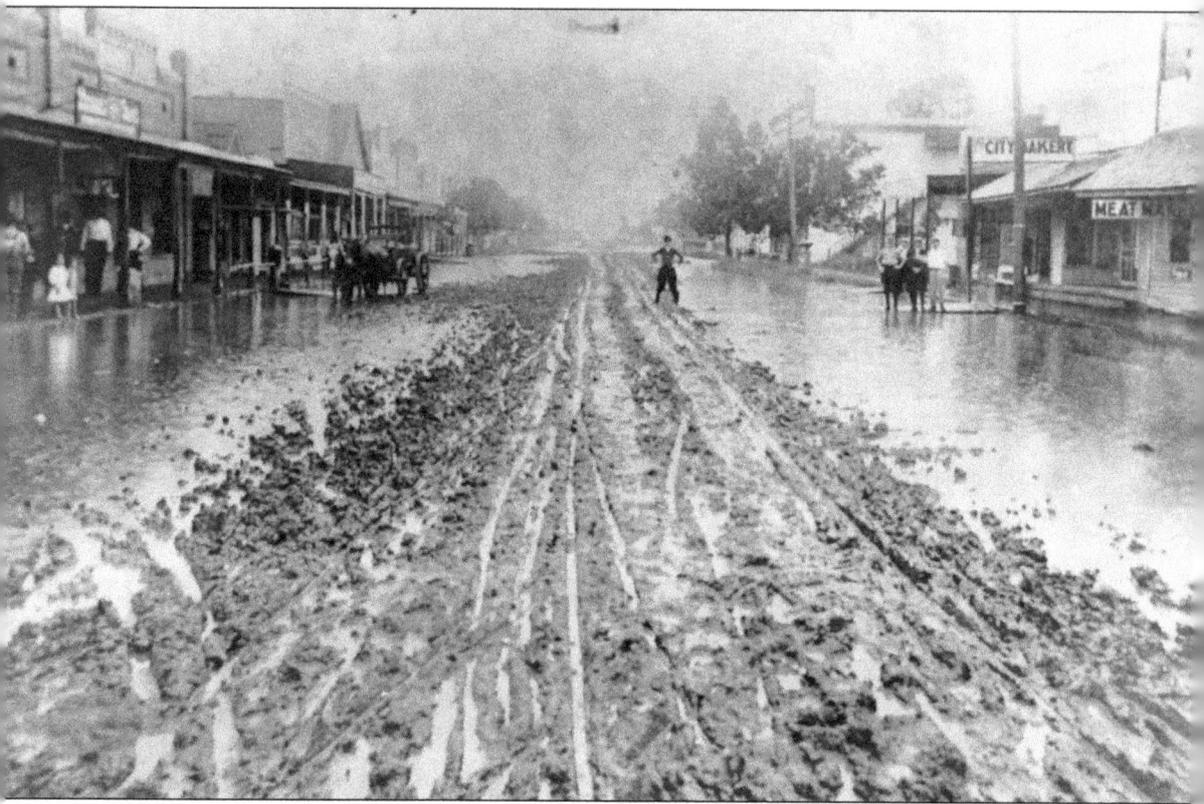

This classic photograph, used to illustrate Rosenberg's nickname "Mud City," was taken around 1912. A horse-drawn wagon stands in front of the site of the future Stach building, erected in 1917.

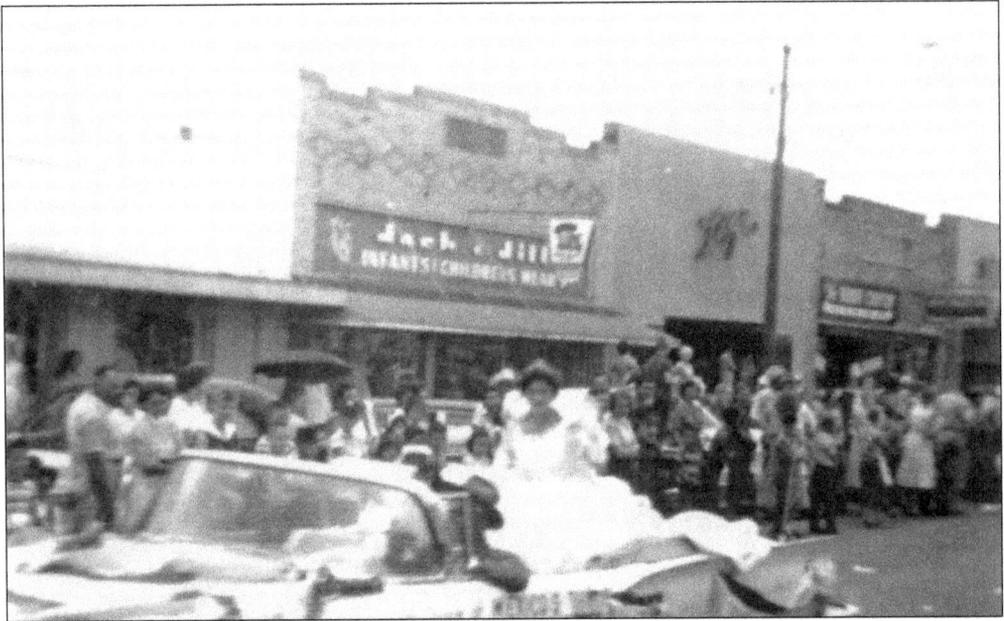

Above, the 1960 Fort Bend County Fair Parade passes the Jack & Jill children's store in the 900 block of Main Street. The Stach building, built in 1917, housed the Jack & Jill Shop from 1946 to 1973. Owner J.B. Sagor had Buster Brown shoes and a measurer that would x-ray the feet to find the size. Women would come and look at the store windows to see the children's clothing styles and go home and make them because clothes were too expensive to buy. In 1951, she sold the business to Doris Erwin, who sold it to Annabelle Geick in the late 1960s. Pictured below, at 921 Third Street today, is Gabby's Western Wear. (Below, courtesy of BAC Photography and Design.)

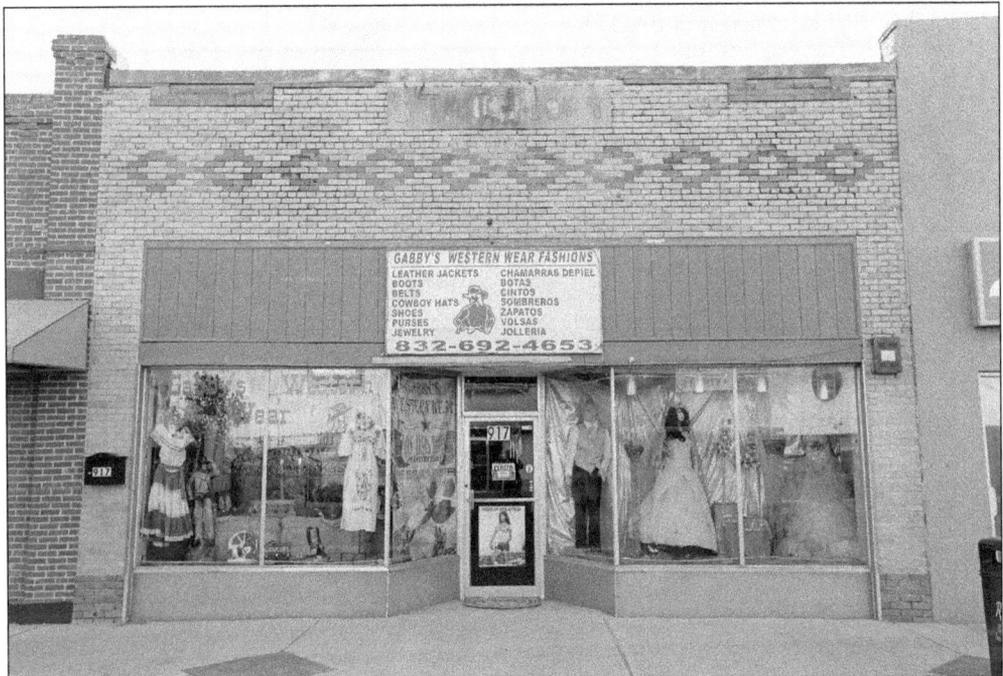

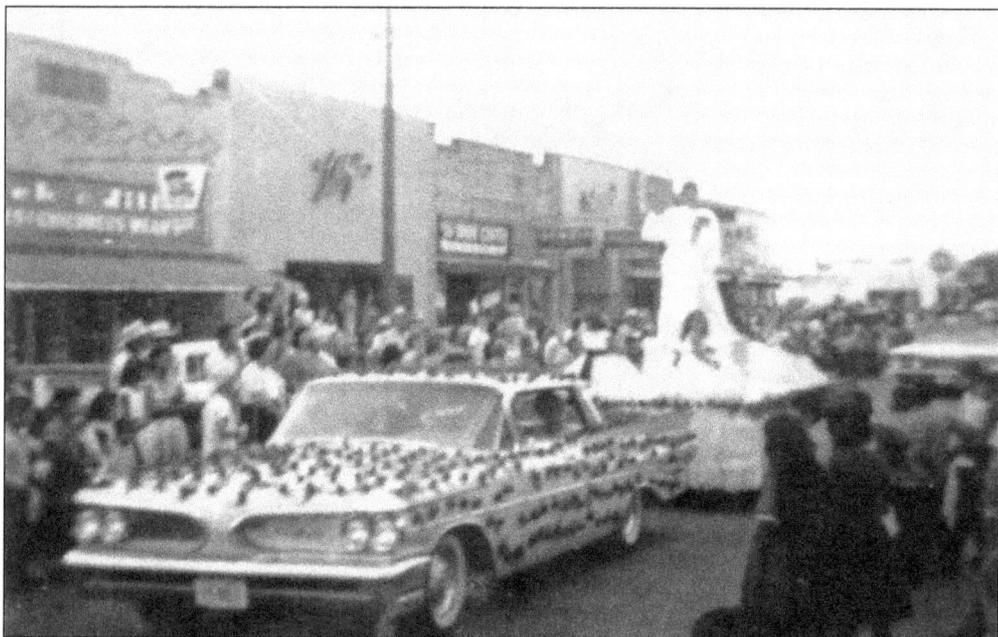

A 1959 Pontiac Bonneville pulls a float in the 1960 Fort Bend County Fair Parade. In the background is Libby's, which was started by Libby Robinowitz Oshman and was in business from 1948 to 1966. In 1966, Leon Danziger expanded his Shoe Center to include this building. He displayed shoes in the window, and if people stopped to look, he would meet them outside and make them come in to try the shoes. Danziger retired in 1980, and Hartfield's TV & Electronics operated there from 1982 to 1986. Pavlock's TV & Electronics took over and added to its other building next door. In 1994, Kellie Carden Hubbell opened Grand Design, an antique and interior design center. She sold it in 2008 to Calla Lilies. Pictured below, at 923 Third Street today, is Calla Lilies. (Below, courtesy of BAC Photography and Design.)

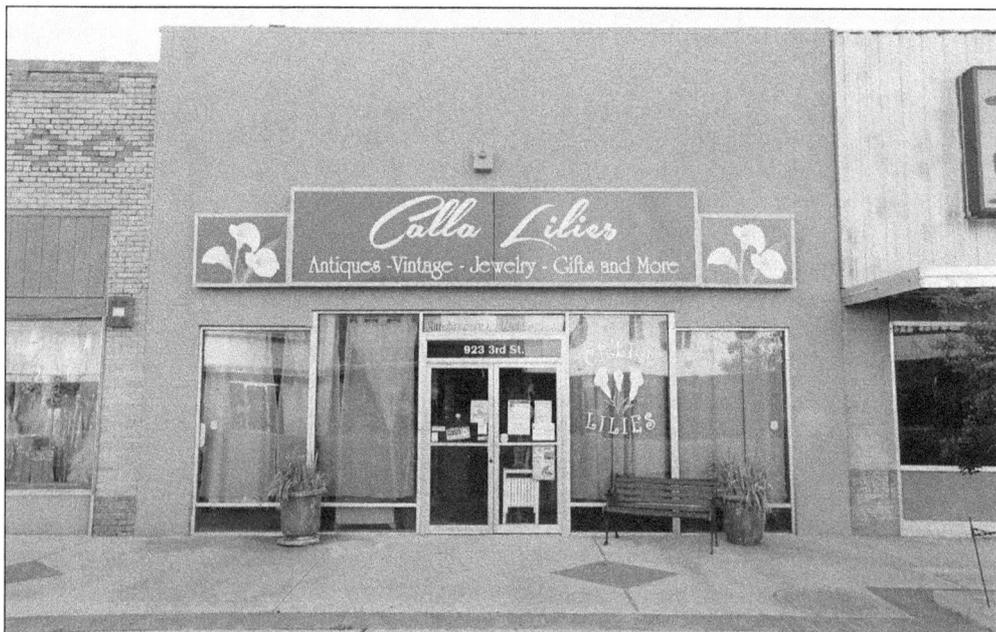

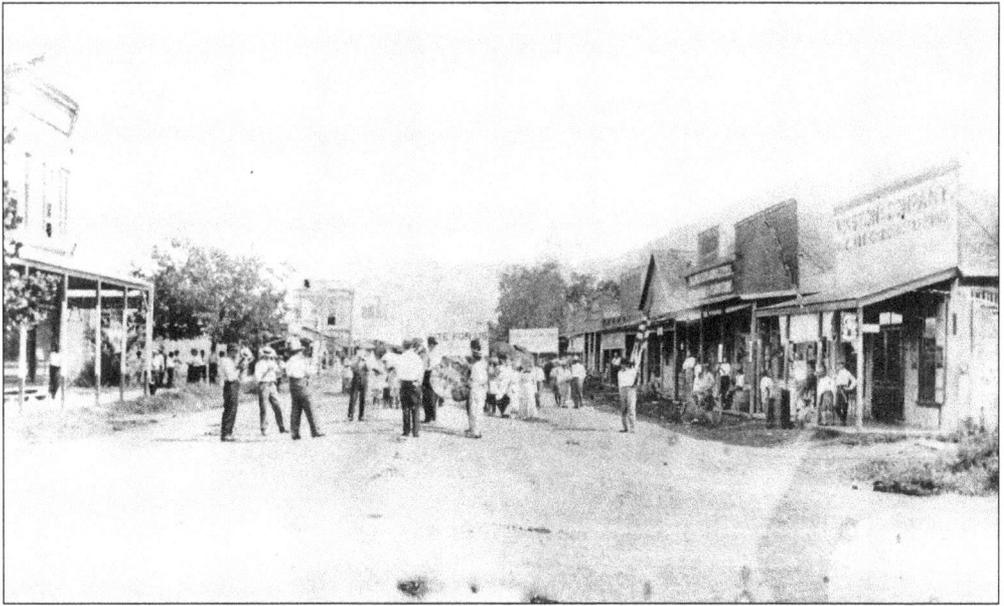

A parade on Main Street in the early 1900s is led by the Texas Cowboy Band. The banners read "vote for the [school] bonds." The building second from the right was the future location of Humpola Radio & Appliances Services.

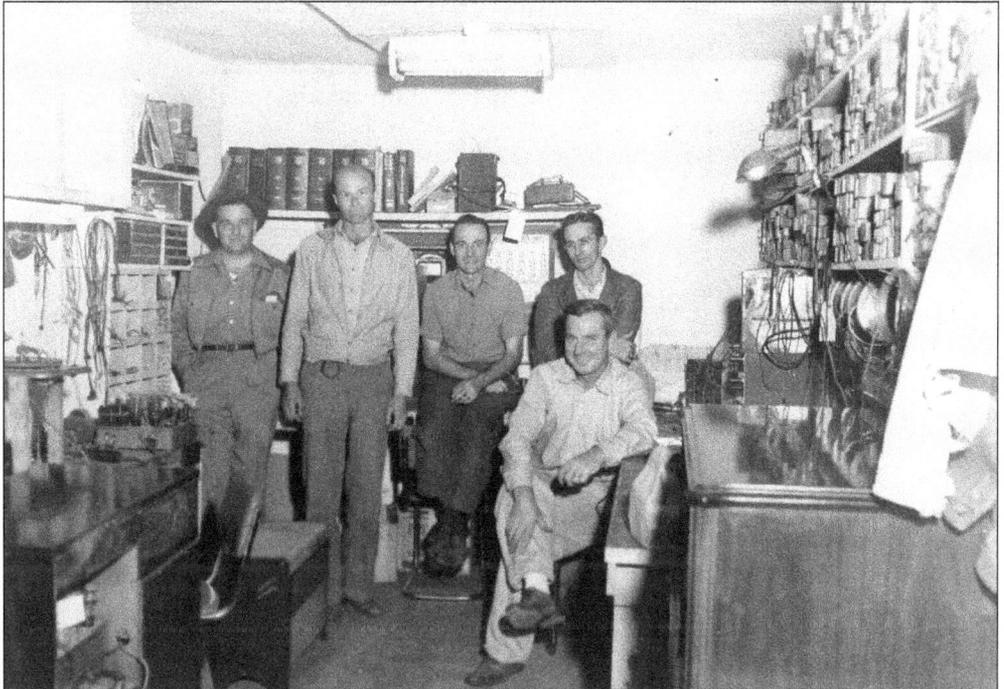

Cyril Humpola (background, far right) poses inside of his shop at 935 Main Street. Humpola Radio & Appliance (1950s–1974) had the first electric washing machine in town. In the 1950s, it had the first television, and everyone would go there to watch. Jerry Sindel watched wrestling matches there. The store was replaced by Hartsfield TV & Appliance (1976–1980) and, later, La Tiendita (1986–present).

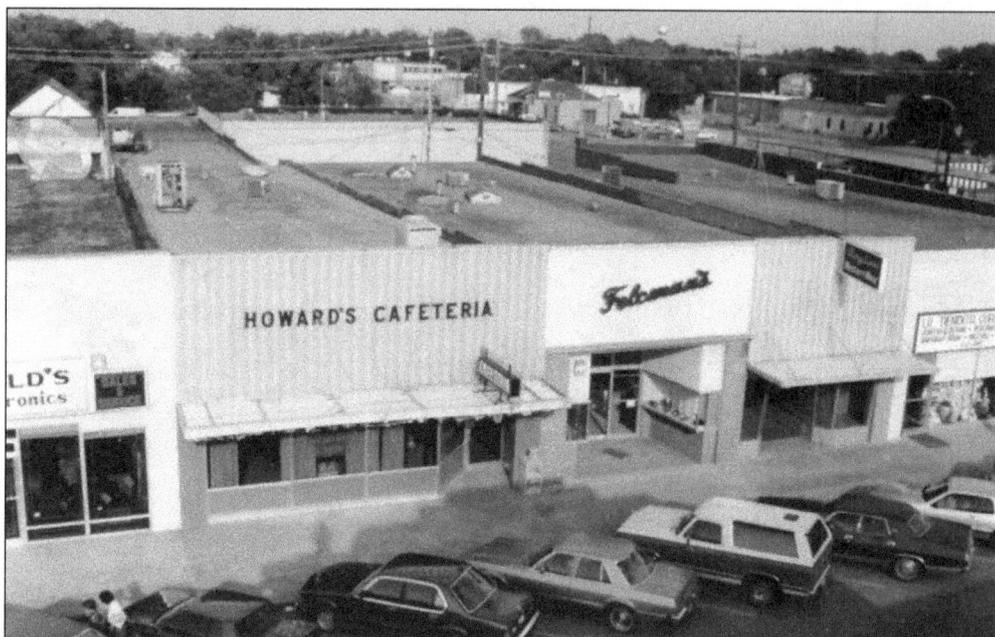

Here is a bird's-eye view of Howard's Cafeteria, located at 927 Main Street, in the 1990s. The establishment operated from 1967 to 1988 with Howard "Tuttle" and Willie Mae Schwarting as owners. They had moved Main Cafeteria from across the street to this location and changed the name. Tuttle was a character. In the late 1940s, a customer came in and purchased a 10¢ Coke with a large bill. Schwarting went out the back door, walked to the bank, and exchanged the bill for coins to give the customer as change. Prior to Howard's Cafeteria was Humpola's Appliance Radio Sales and Photo Studio (1932–1961). Pictured below is the vacant building today at 927 Third Street. (Below, courtesy of BAC Photography and Design.)

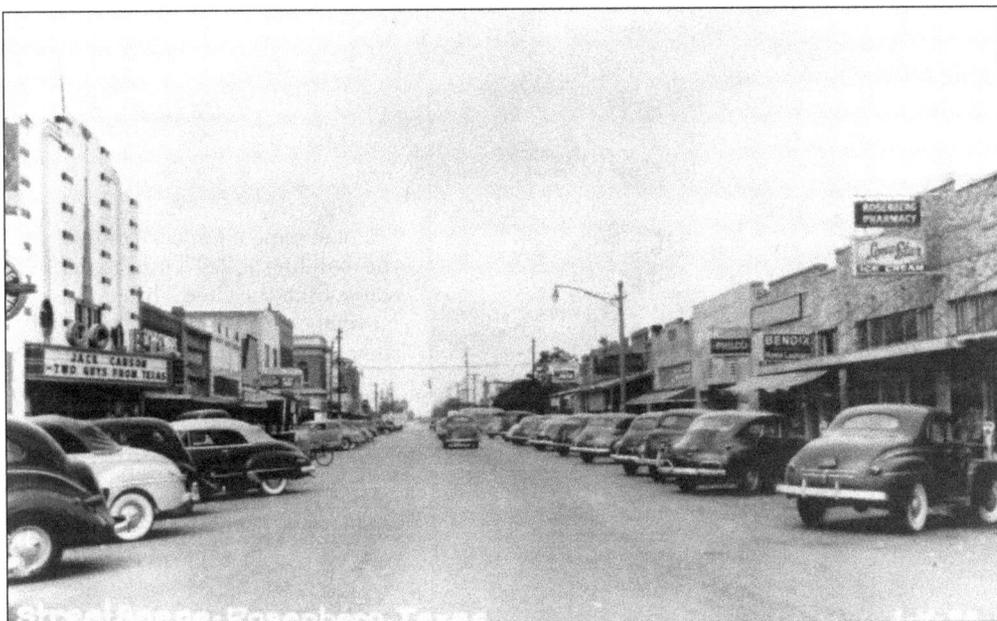

Located at 929 Main Street was Noska Brothers' Café from 1942 to 1948. This photograph, taken in 1948, shows the Rosenberg Pharmacy, which took over the café. In 1950, Fatjo Furniture had a satellite store in this location.

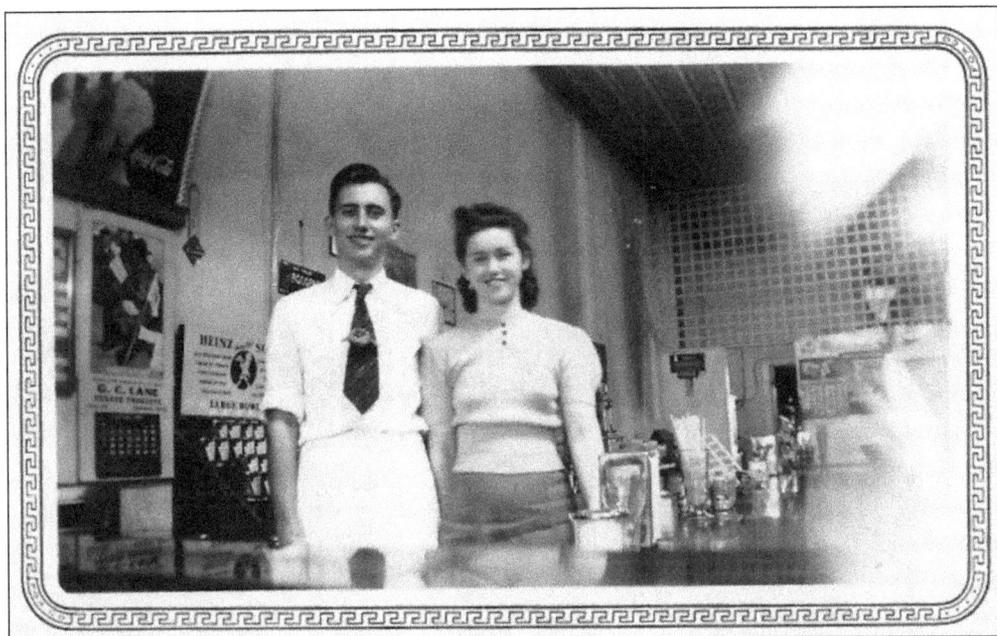

The interior of Noska Brothers' Café is seen here in 1942. Employees Edwin Ubernosky and Margaret Palmer pose for a photographer.

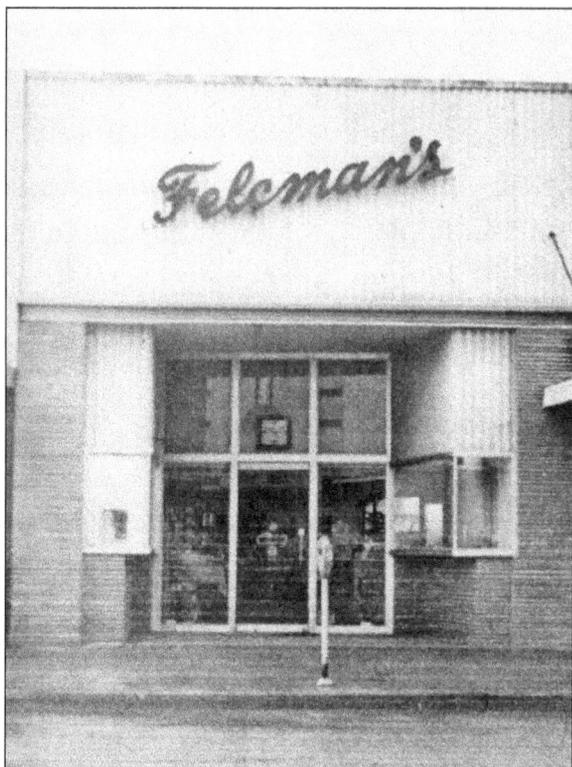

Felcman's Jewelry relocated to this building at 929 Third Street, across from the Cole Theater, in November 1952. The store featured show windows at the front door and a pink facade, adding color to the downtown area. Owners Jimmy Felcman and Bessie Felcman Elder were brother and sister. They were robbed several times because thieves could climb the roof and go through the skylight. Once, Joan Reese was visiting Bessie and thieves came into the store, opened the cases, and stole all of the men's diamond rings. The cases were never locked. Now Mondragon Jewelry is housed in this location. (Below, courtesy of BAC Photography and Design.)

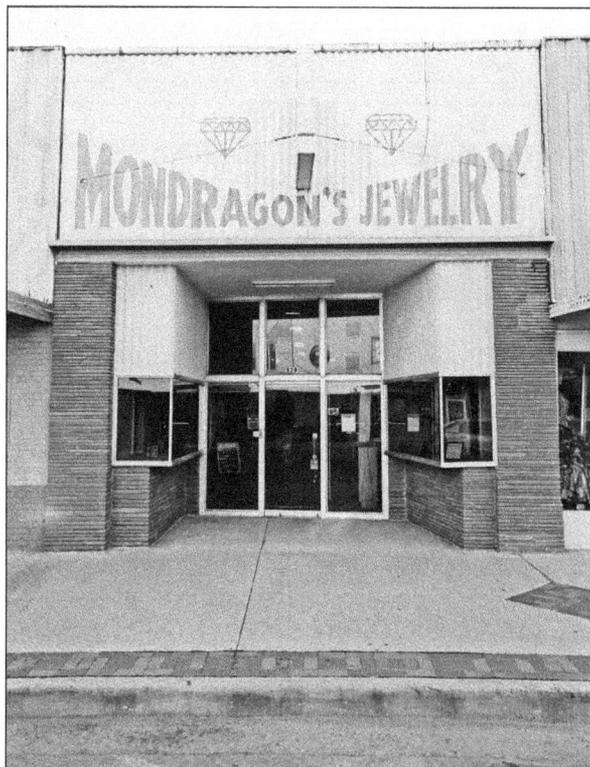

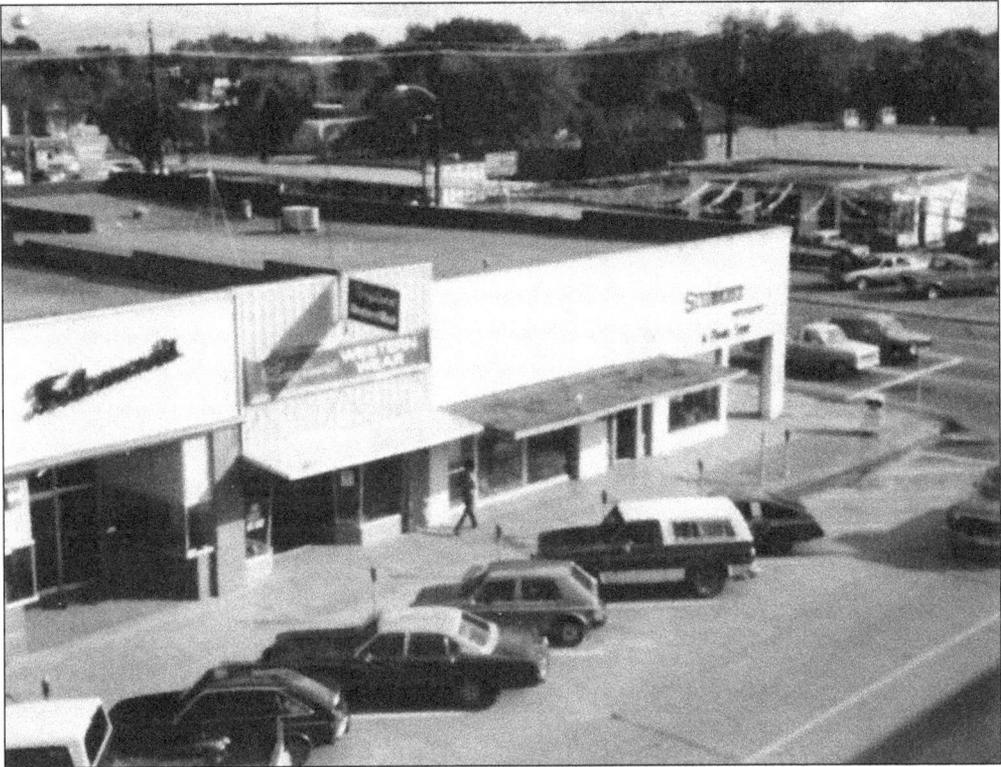

Shown at center in the 1980s photograph above is Larry Davis Western Wear, located at 931 Main Street. It stood between Felcman's Jewelry (left) and La Tiendita Curio Shop. From 1962 to 1969, Ann's Dress Shop, owned by Anna Weitz and Anna Novasad, was located in this building. His Closet, owned by Gary Geick, leased the building in 1973, as did Dixie Joann's Florist (1988–1990) and later Memory Shoppe (1996–1998). It has been occupied by Fashion La Joya (right), at 931 Third Street, since 1998. (Right, courtesy of BAC Photography and Design.)

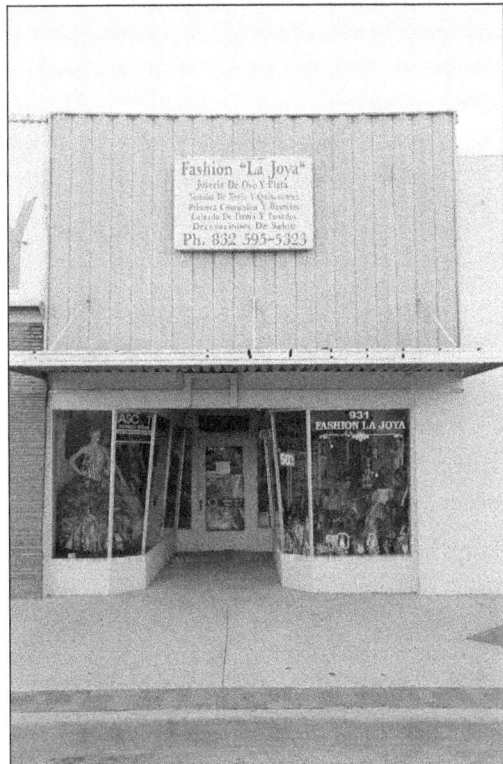

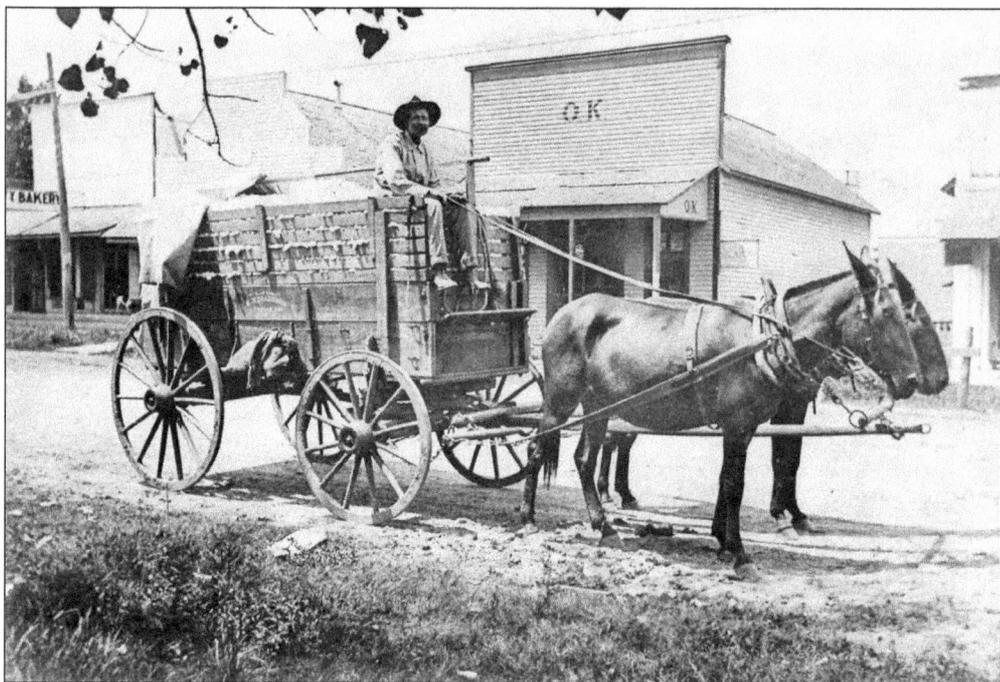

This picture, taken in 1911, shows P.W. Sims and his team of horses delivering cotton.

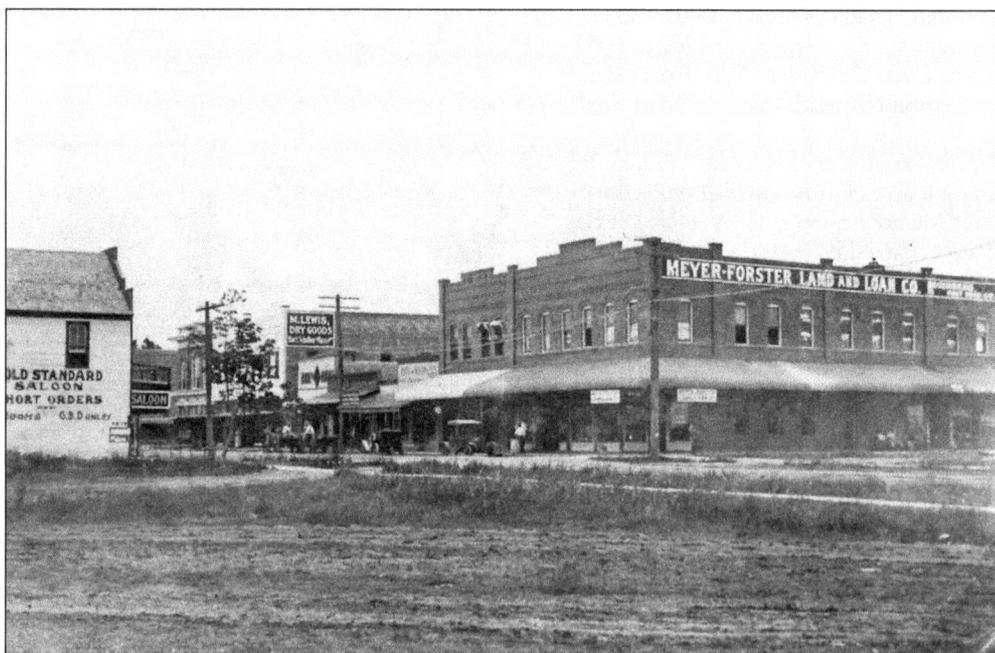

Pictured here is a south-facing view of Third Street in the early 1920s.

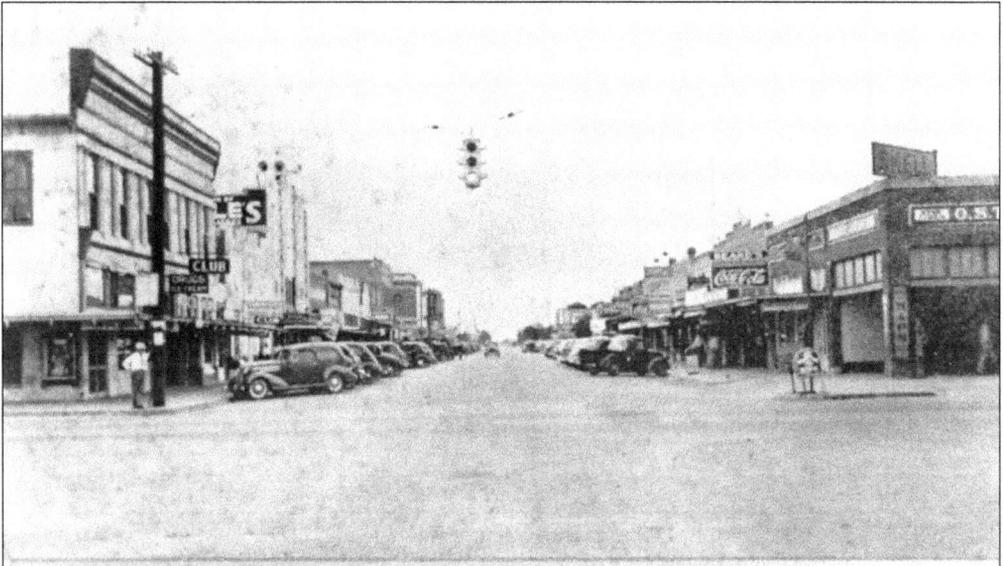

TH STREET LOOKING NORTH TOWARD MAIN BUSINESS SECTION. ROSENBERG. TEXAS G-22

This photograph looks north on Main Street in the 1930s. The OST Garage is at right, with the OST Barbershop next door.

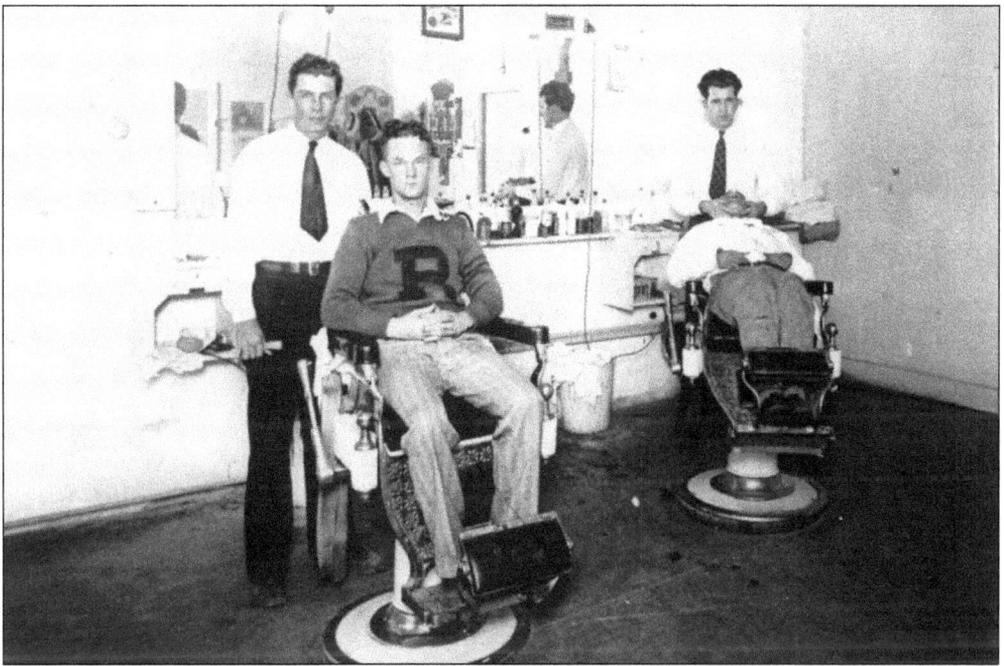

The barber on the left is Emil Bezecny, who worked in OST Barbershop in the 1930s.

This north-facing photograph, taken in the 1940s, shows the 900 block of Main Street. On the left is the renovated Cole Theater; at right is the OST Garage.

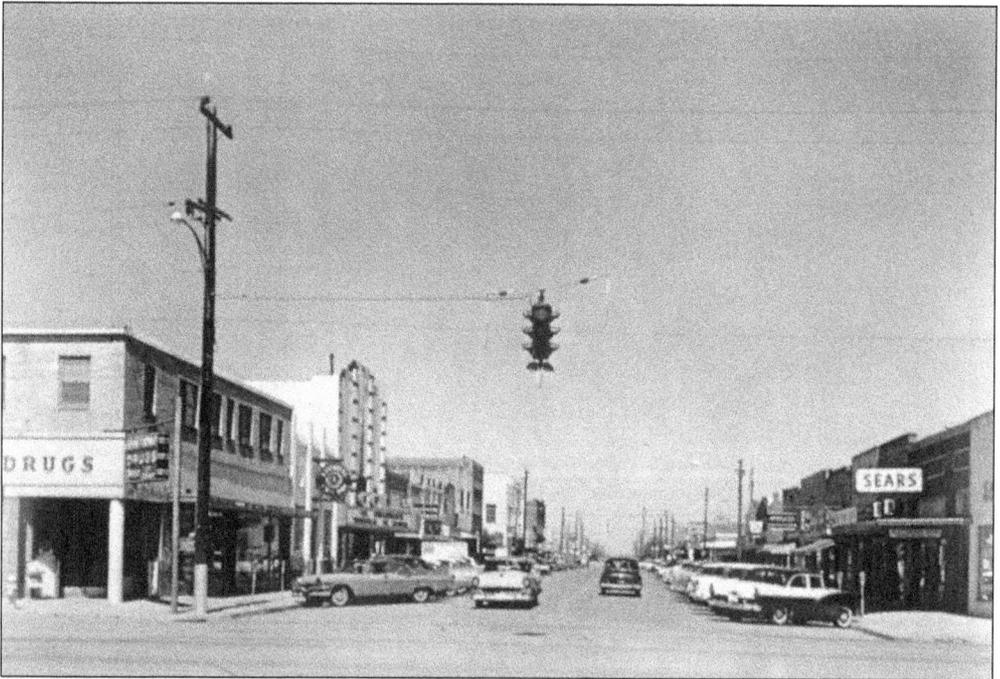

This mid-1950s photograph shows the Sears store (right) at 935 Main Street.

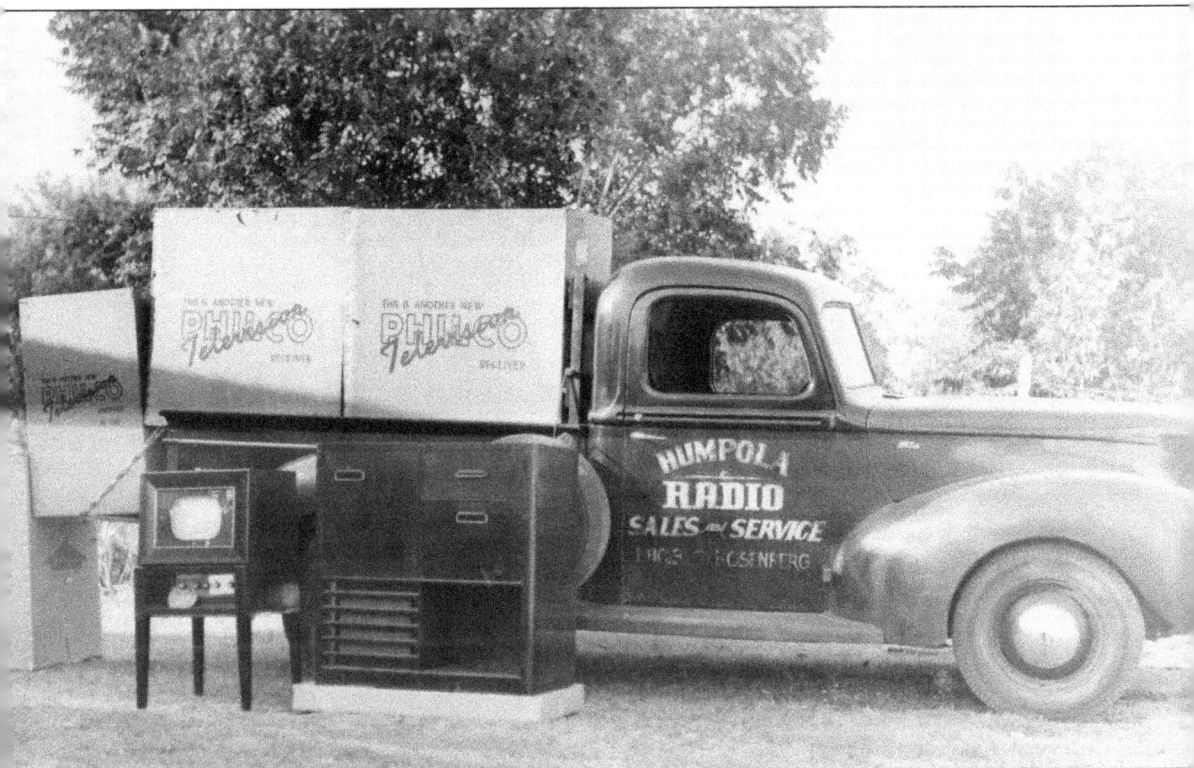

This was the delivery truck for Humpola's Radio Sales and Service during the 1950s.

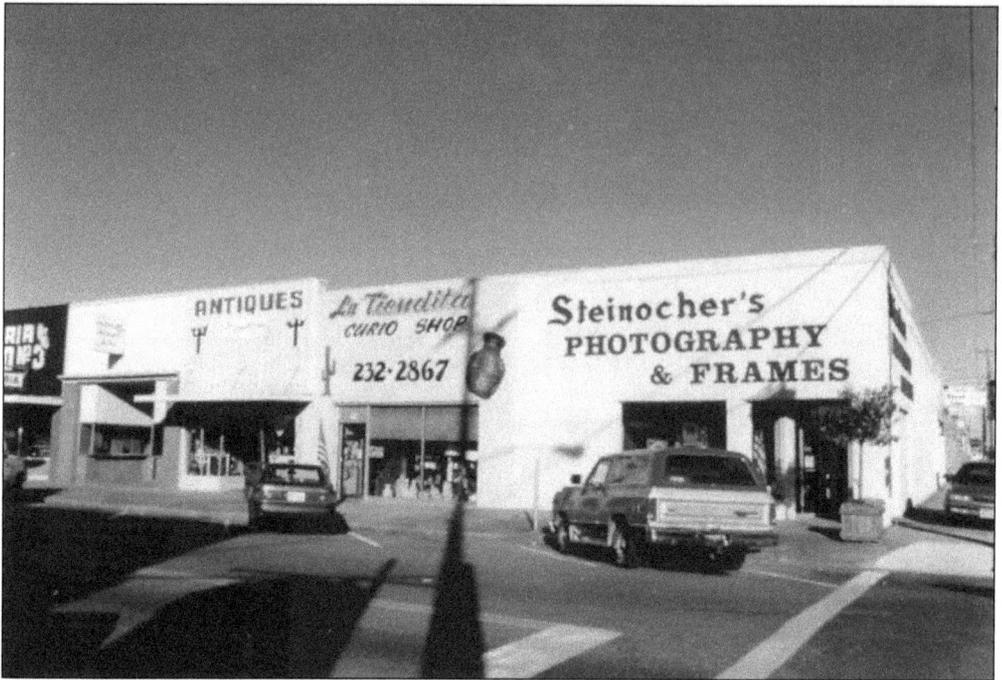

After OST Garage left this location, it became Etta Mae's Dress shop from 1950 to 1964. Steinocher's Photography and Frames took over the building in 1971. It remained there until 1998 and is shown in this photograph taken in the early 1990s. Other businesses in this location were Fancy's Antiques (its first location), Fish Ranch, and Rustic Kuts (its first location from 2010 to 2013). Chapperall Antiques was the last business prior to Eclectic Clutter taking over. Pictured below, at 939 Third Street today, is Eclectic Clutter. (Below, courtesy of BAC Photography and Design.)

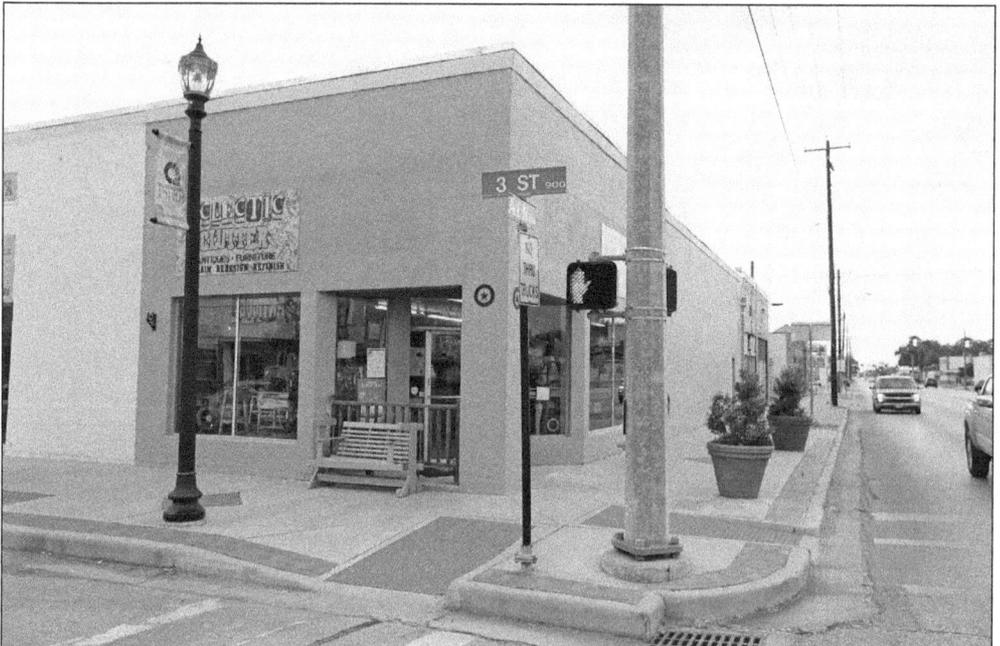

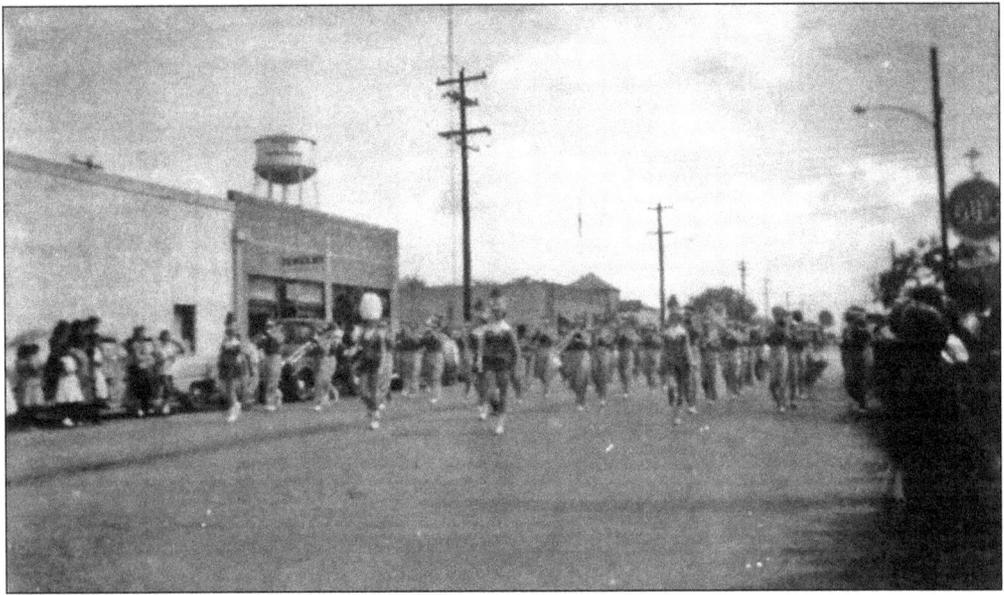

This 1936 picture shows Straznicky Jewelry Store and Royal Beauty Shop, located at the rear of the OST Garage. In 1964, the jewelry store was sold to Miles Podlipny Jr., and he renamed it Podlipny-Straznicky Jewelry Store. Miles later removed the Staznicky name, calling it Podlipny Jewelry Store until he closed the business, retiring in 1995. Gabby's Western Wear had its first location here in 2000. Royal Beauty Shop, owned by Rose Trest, was located next to the alley from the 1930s to the 1950s. Rose had the first local Merle Norman Cosmetics business at the location. Marietta Beauty Shop replaced Rose when she relocated. (Below, courtesy of BAC Photography and Design.)

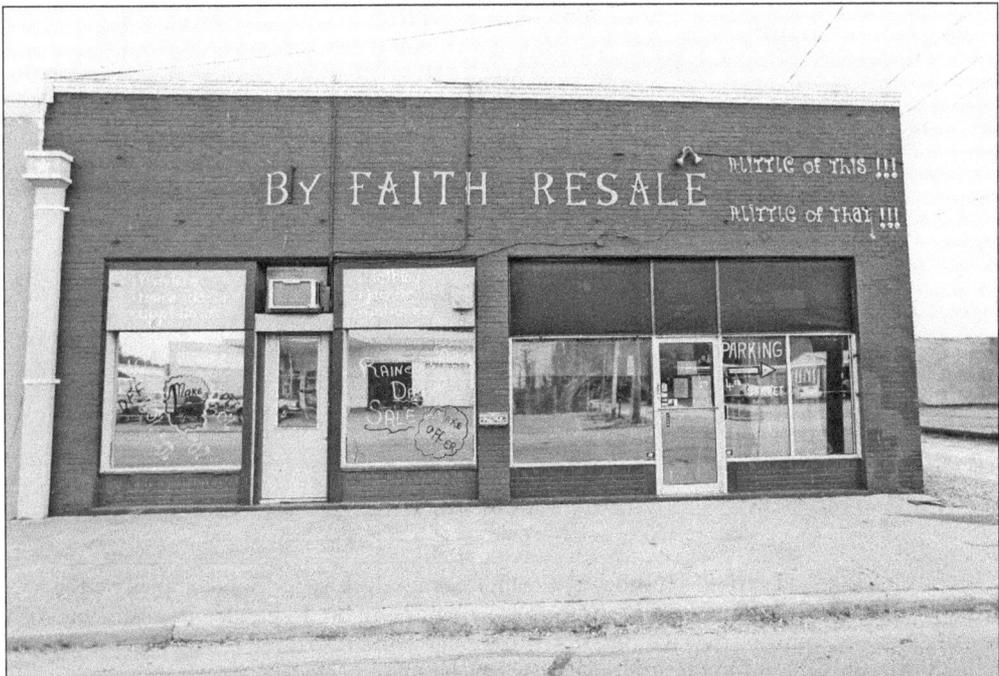

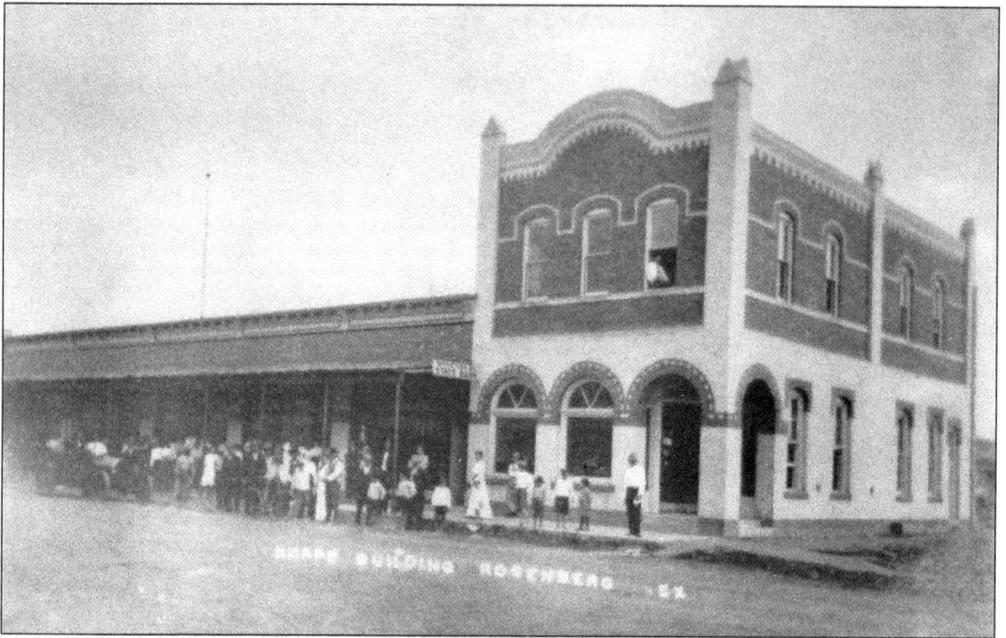

Rosenberg State Bank was located on the corner of Avenue G and Second Street in the early 1900s.

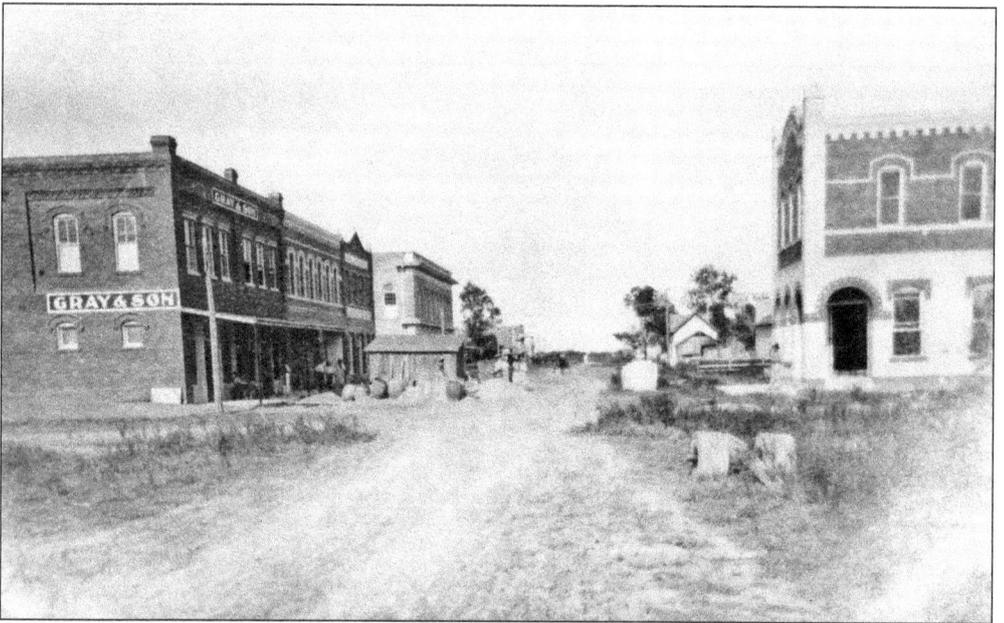

This picture, taken in early 1910, shows the completion of the Gray & Son complex on the left. Rosenberg State Bank is shown under construction on the right. To provide its customers with the most convenient banking facilities, Rosenberg State Bank instructed the contractor to build a hitching post and watering trough outside its new building in 1910.

Two

HUB OF ACTIVITY

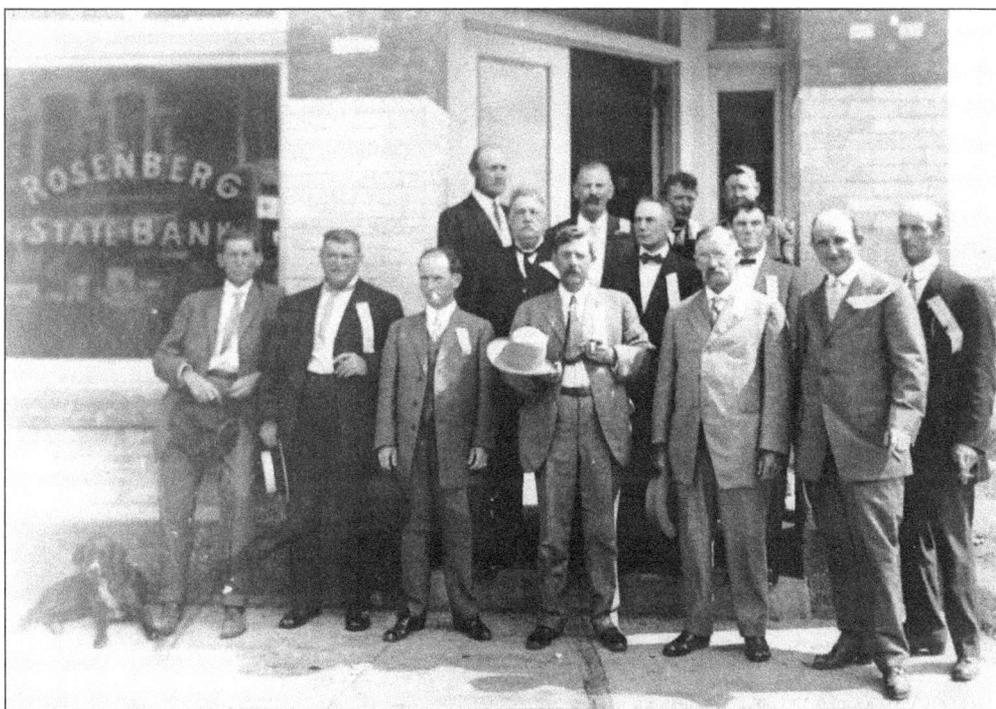

This group in front of the Rosenberg State Bank at 1900 Avenue G (1910 to 1935) gathered for the visit of William Jennings Bryan, spokesman for the Democratic Party in the early 1900s. This building also housed R.L. Ullrich Grocery and Market (1940–1951). Kubena Boot Shop was housed in part of the building from 1943 to 1960, and when the grocery moved, Kubena took that part too. In 1958, Simon Galicia, who worked for Kubena, bought the business and renamed it Galicia Boot Shop. Another business in the building was Antiques on the Corner (2001–2005), and shortly after Antiques on the Corner left, Janice Vyoral State Farm Insurance moved in.

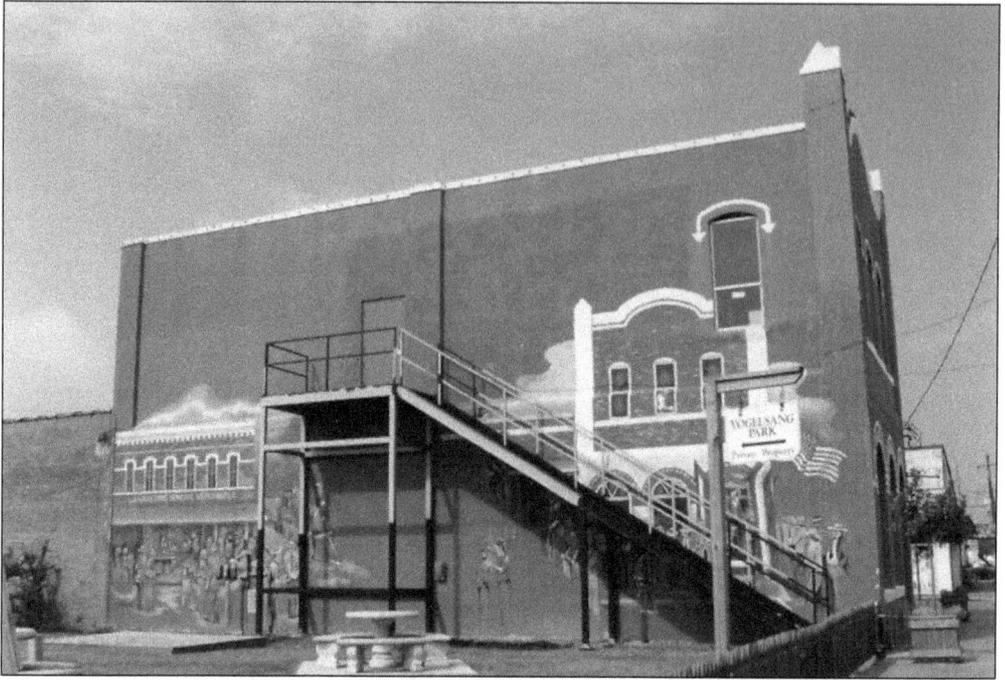

Murals of the Vogelsang Building and the original Rosenberg State Bank are depicted in Vogelsang Park on Avenue G in 1995. Pictured below, at 1900 Avenue G today, is Janice Vyoral State Farm Insurance. (Below, courtesy of BAC Photography and Design.)

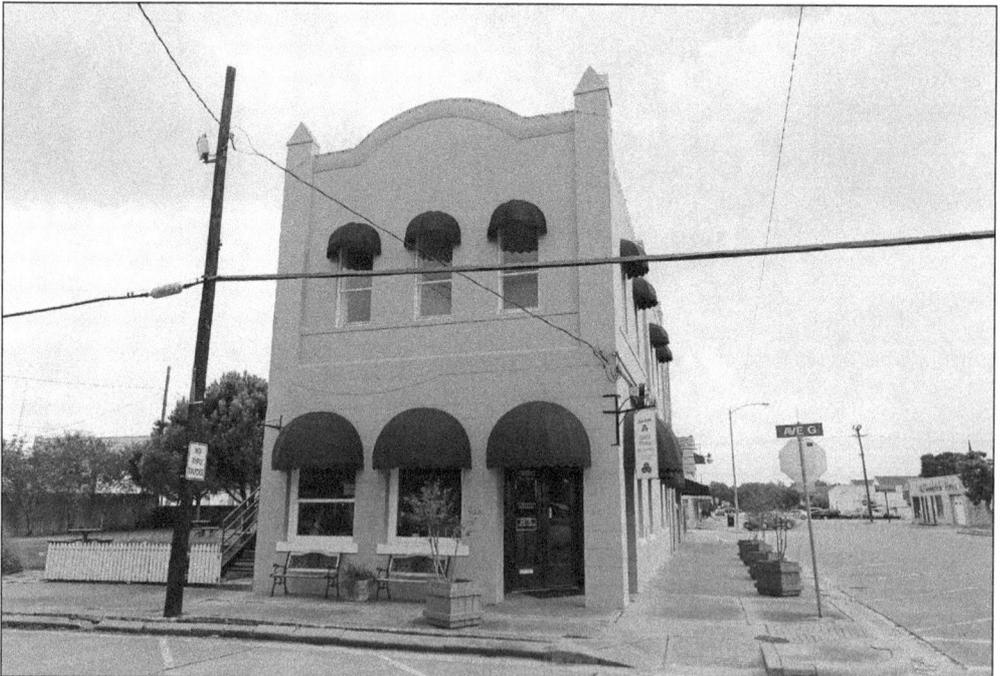

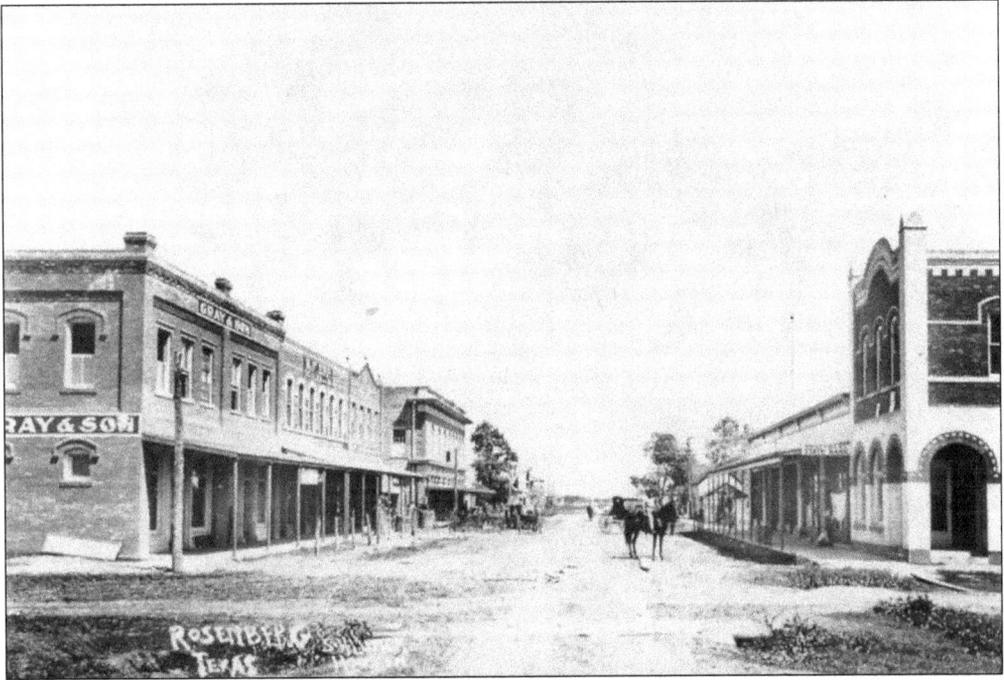

In this photograph, looking east on Avenue G, a lone cowboy poses during the World War I era.

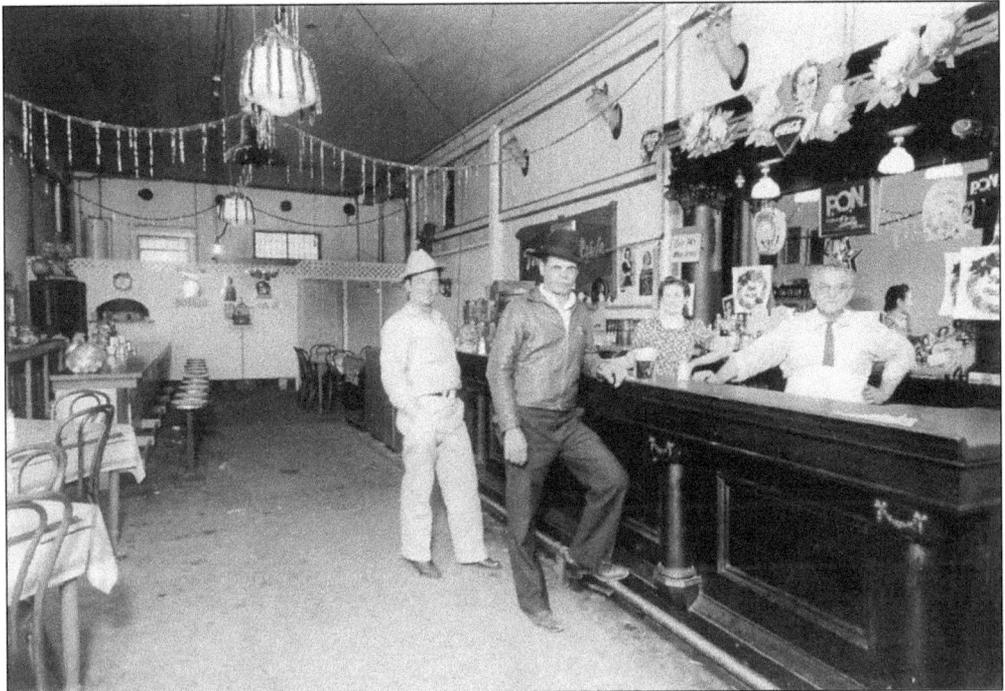

Vogelsang Café & Tavern stood on Avenue G, near the original Rosenberg State Bank. Shown here in 1938 are, from left to right, the Kubena brothers, Marie Sebesta Zatyka, and owner L.A. Vogelsang.

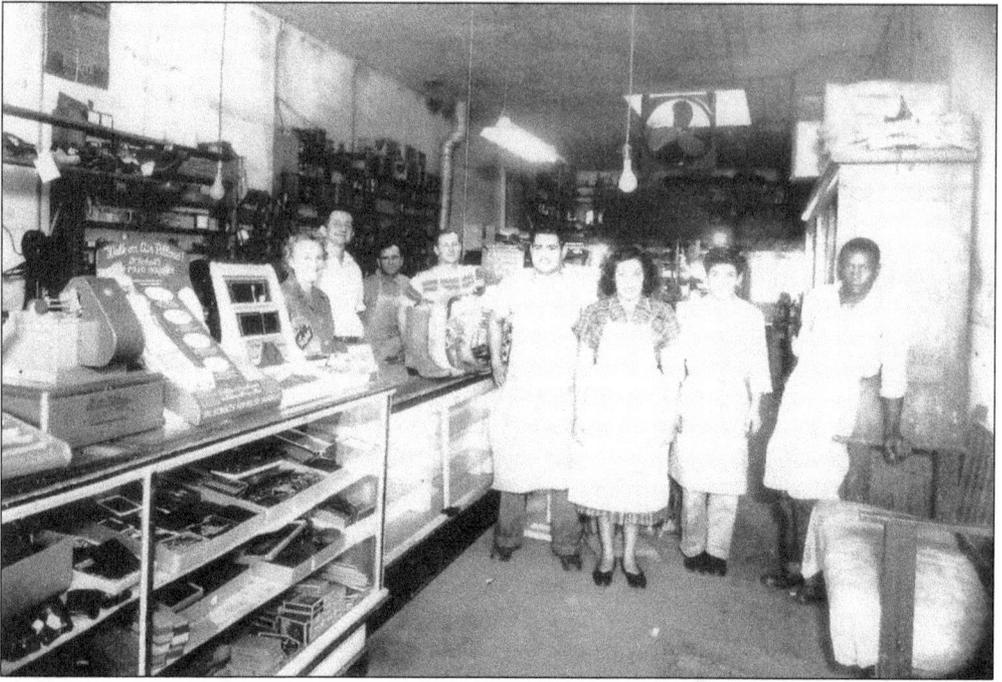

This is Kubena Boot and Shoe Shop's first location on Avenue G. Pictured here are, from left to right, owners Mary and August Kubena, an unidentified person, Alec Urbanski, Martin Ybarra and his wife, Simon Galicia (owner after August Kubena), and James Mitchell.

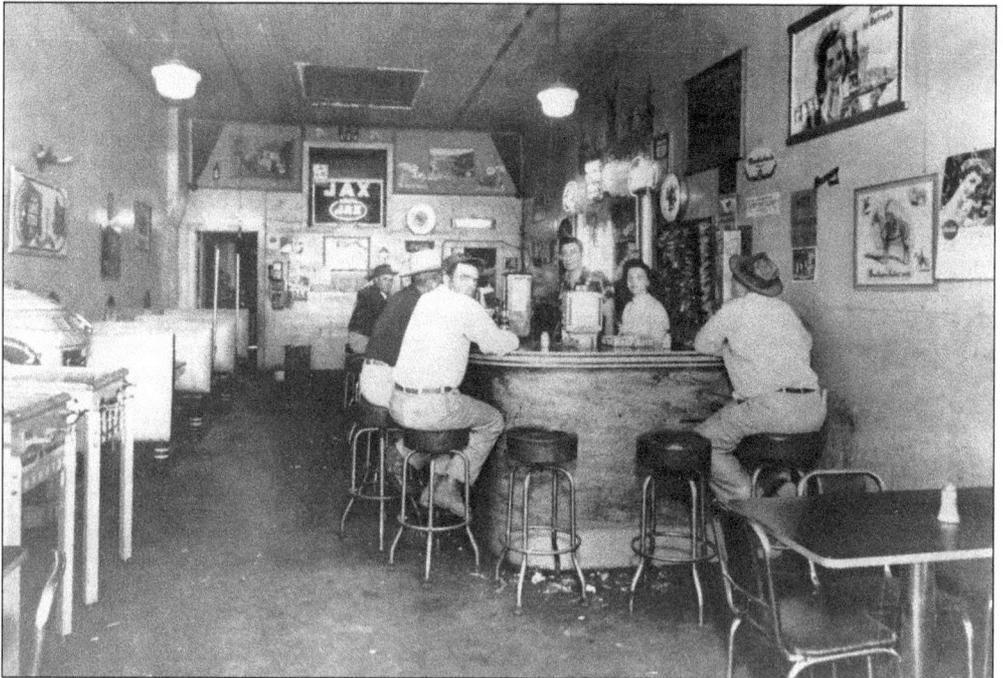

Leonard's Bar was a popular gathering place in the 1950s. It was located on Avenue G, next to the original Rosenberg State Bank. Note the pinball machines on the left. These were new attractions at the time.

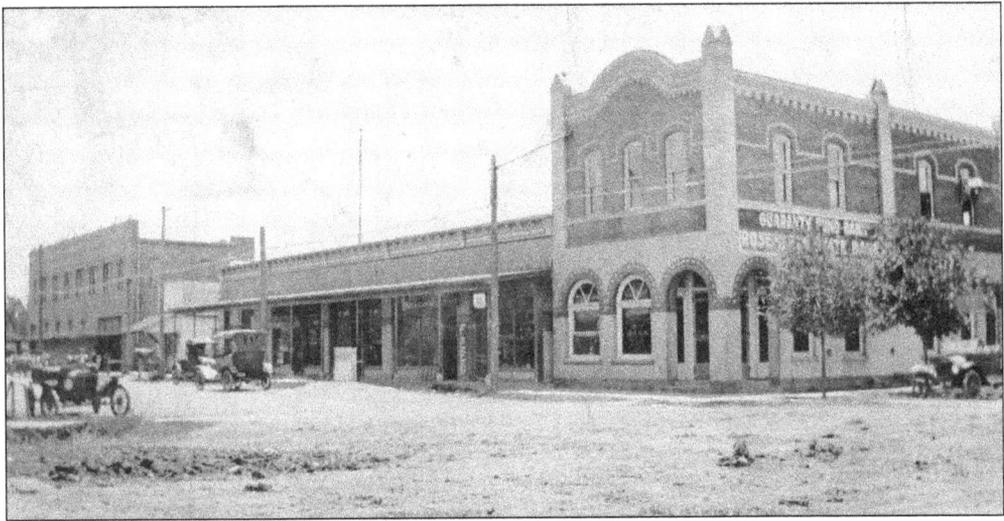

In this east-facing photograph, the original Rosenberg State Bank's two-story building stands on Avenue G. Adjacent to it was a one-story structure that housed several businesses, including grocery stores and Bailey's Feed Store, which opened 1912. The store, owned by Charlie Bailey, was the daily gathering place for local farmers. Ginsburg Dry Goods & Alterations was here from 1948 to the 1960s. Jack Mehrens, brother-in-law of Bailey and the next owner, had a mechanical calf to train people in cutting horses. The Ginsburg establishment had a lot of fires, because Joe Ginsburg left the iron on when he went home for the evening. Also in this block was the Vogelsang beer joint. During the 1930s, Rosenberg's taverns raised the price of beer from 10¢ to 15¢. L.A. Vogelsang resisted the trend, and distributors refused to sell to him. He found a distributor in Waco who cooperated and made the trip to get the beer. Shortly afterward, a truck unloaded 2,700 cased of beer at Avenue G in Rosenberg. The priced remained 10¢. L.A. Vogelsang was the Lone Star Beer distributor. Other businesses that were located in this area were Ann's Dress Shop (1953–1962); Kubena's Boot Shop (1949–1954), which was moved due to the fact that Ginsburg always had fires; City Barber Shop (1950s–1975); Ed's Saddlery (1956–1964); and Leonard's Beer Joint (1960s–1975). This entire area burned to the ground in 1975. It now is Downtown Park, as seen below. (Below, courtesy of BAC Photography and Design.)

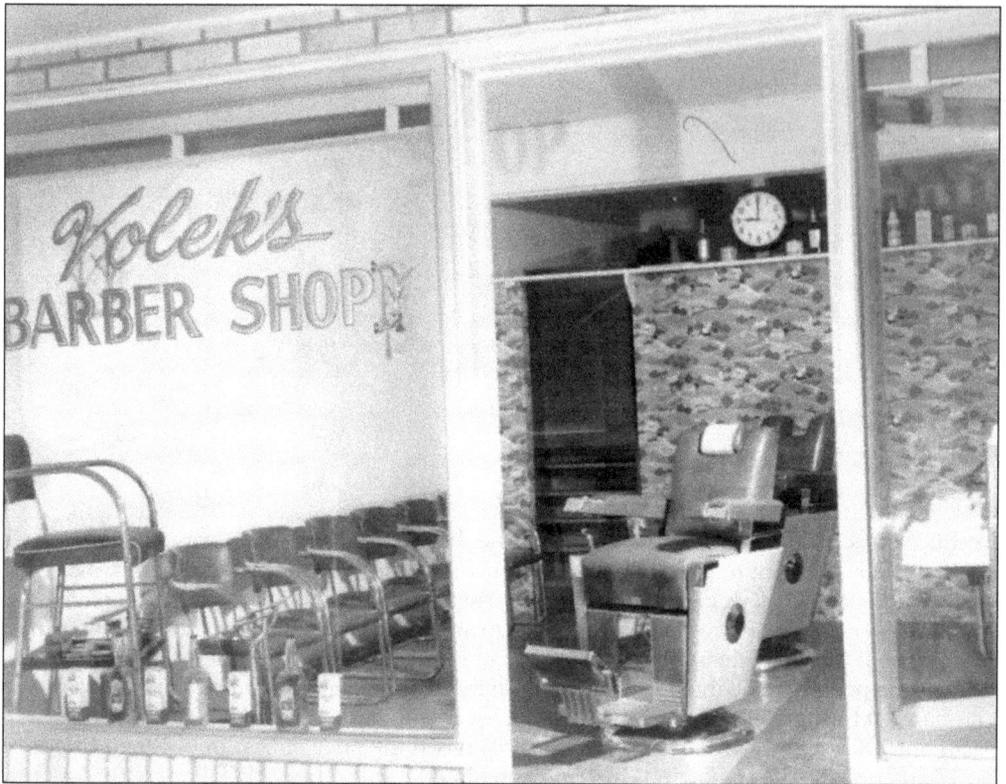

Emil Volek and his wife, Florence, owned and operated Volek's Barber Shop. They moved to this location, 1924 Avenue G, in the early 1950s. Florence was the first female barber in Rosenberg. In the 1940s, cotton buyers Sam Daily and C.J. Dickerson were housed here, and Leo H. Daniels' Insurance Agency rented in the 1970s. Now this is part of Red Queens Attic. Pictured below, at 1924 Avenue G today, is the back side of Red Queens Attic. (Below, courtesy of BAC Photography and Design.)

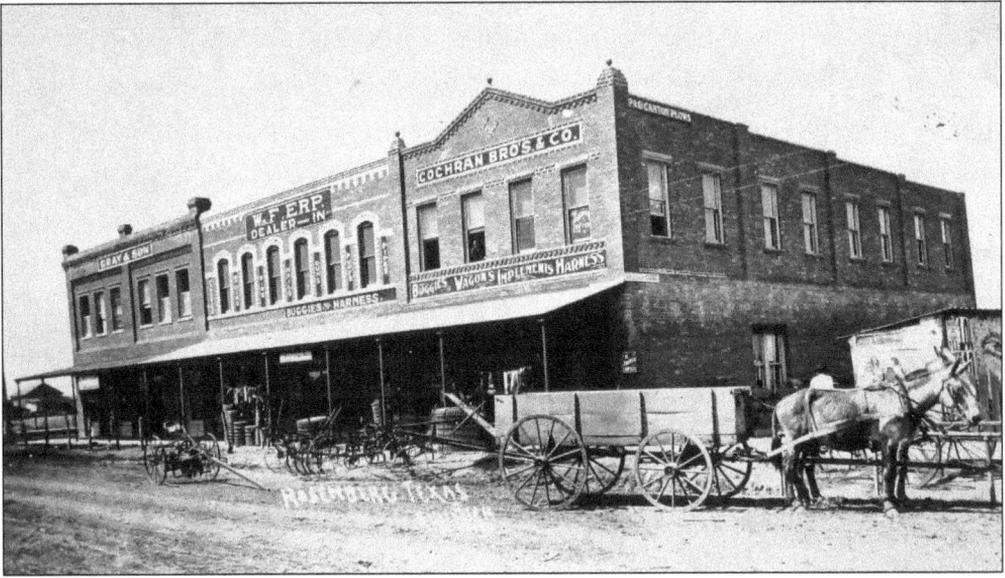

The 1900 block of Avenue G is now the Vogelsang complex. Originally, it consisted of Gray & Son, Wm. F. Erp, and Cochran Bros. Company. This photograph, taken prior to 1920, shows an early version of a U-Haul truck: a wagon operated with "two horsepower." Also located along this block was the Vogelsang beer joint. The bottom picture, taken in the 1980s, represents the later version of the above photograph.

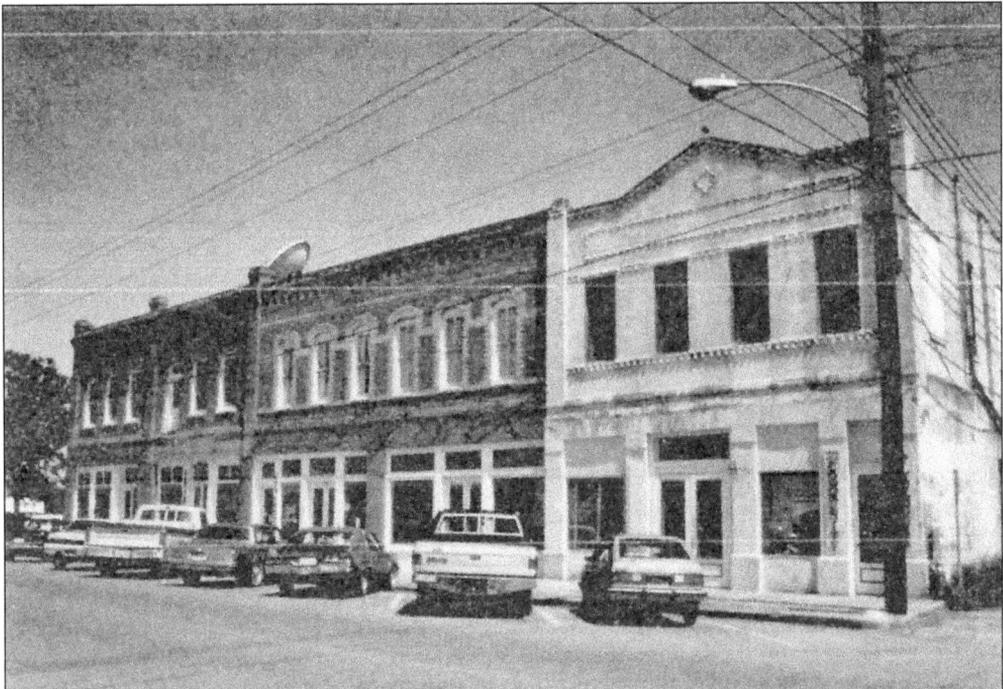

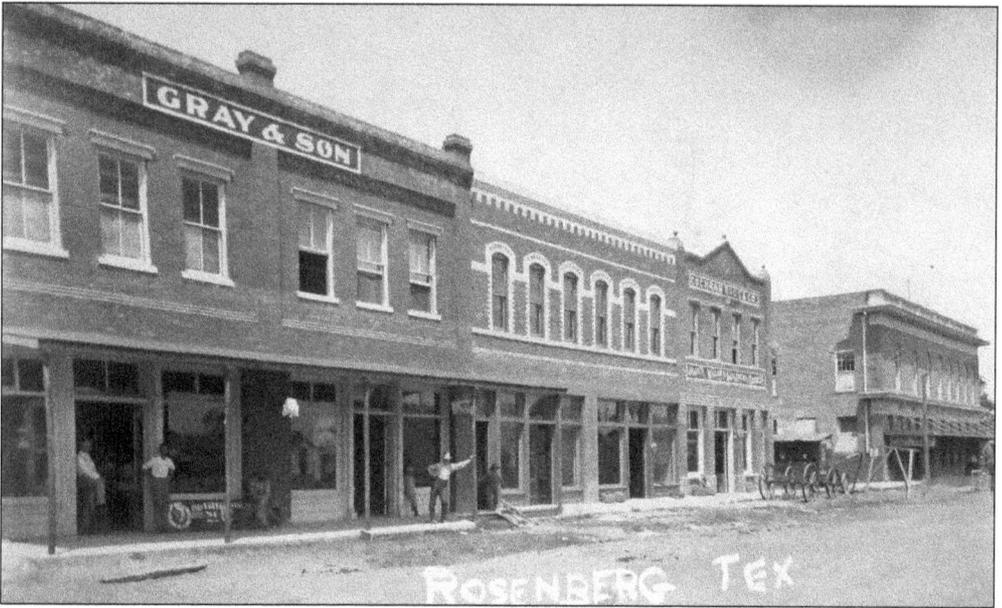

This photograph of the Gray & Son building, located at 1901 Avenue G, was taken in the early 1910s.

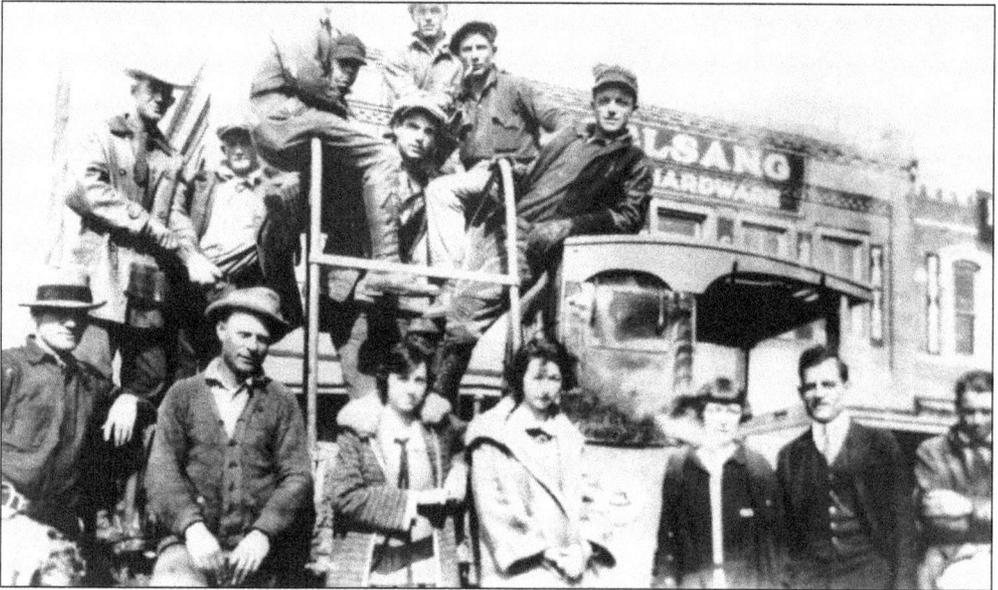

This 1930s photograph shows a group outside of Vogelsang Hardware. The gentleman leaning on the cab is believed to be John R. Sindel from East Bernard.

In 1980, the Vogelsang compound stood on the corner of Avenue G and Second Street. Today, 1901–1903 Avenue G is Ol' Railroad Café and Vogelsang Heritage Hall. (Below, courtesy of BAC Photography and Design.)

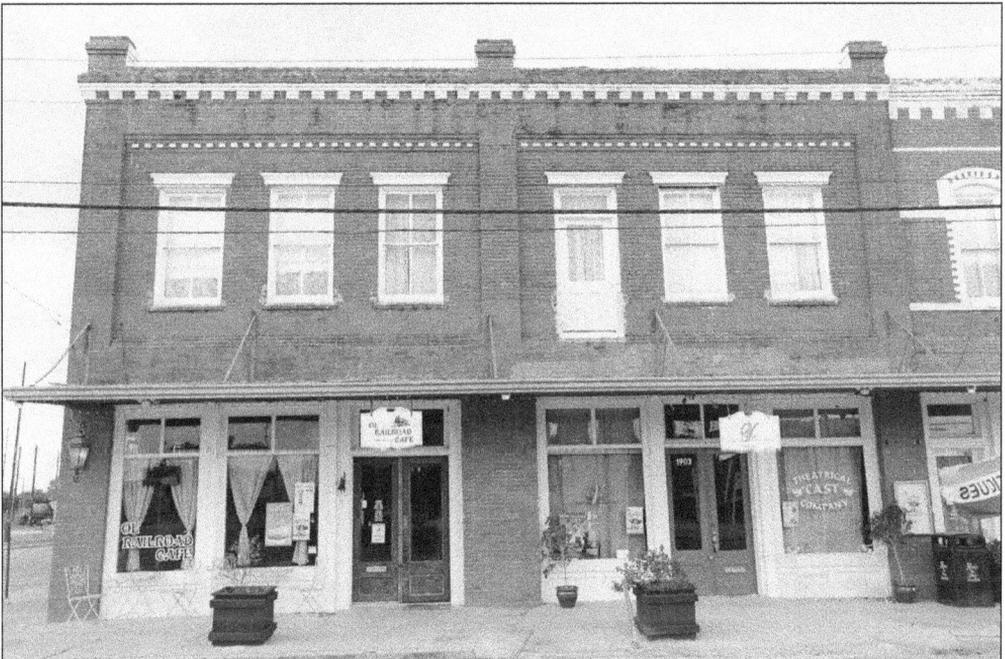

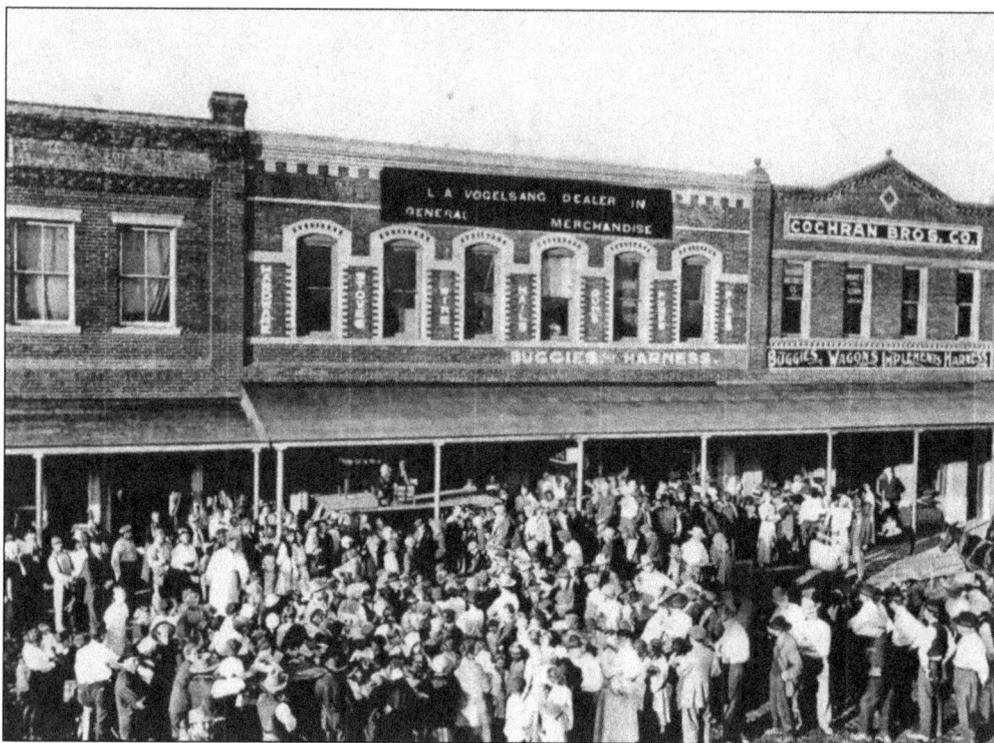

The above photograph, taken in 1916, shows the opening of the Vogelsang General Merchandise store. Pictured below at 1909 Avenue G is Vogelsang Antique Emporium. (Below, courtesy of BAC Photography and Design.)

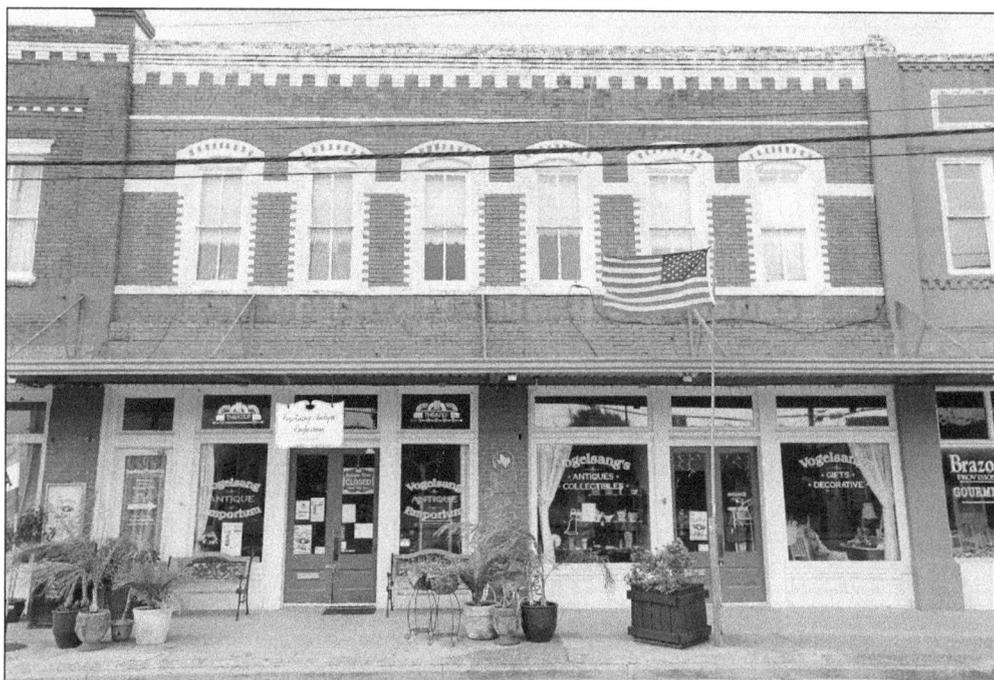

The first elevator in downtown Rosenberg was in the "New Gray Building" at 1909 Avenue G. Built in 1910, the building is now Vogelsang Antique Emporium.

The garage door at far left in this 1980s photograph of the "New Gray Building" still exists. From this Second Street entrance, automobiles took a ramp to the second floor of Knight's Chevrolet, a business that was once located inside.

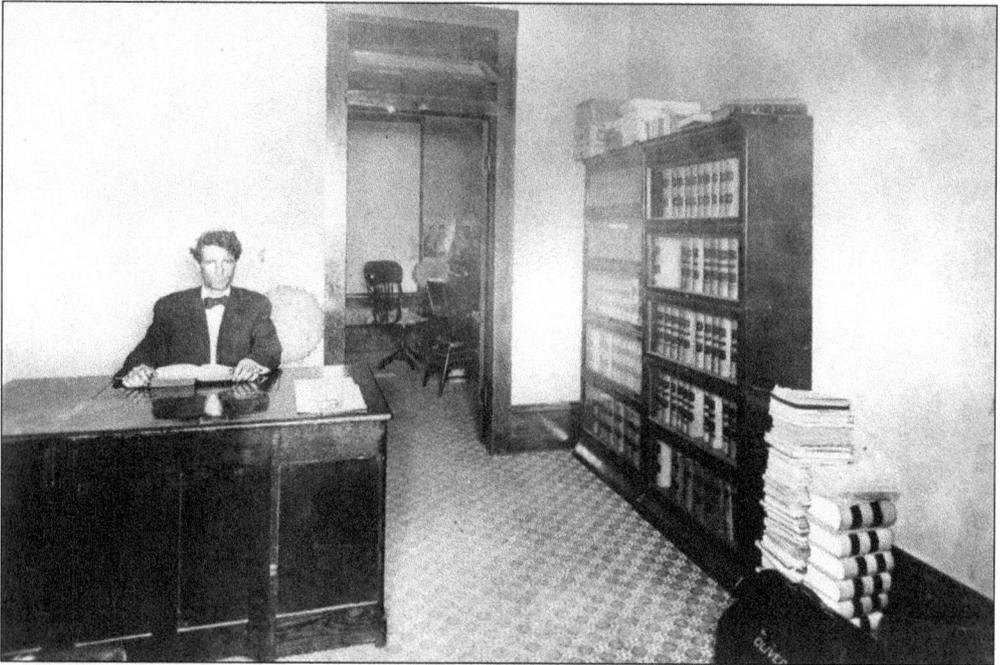

Above, Francis X. Joerger sits in his office at 1924 Avenue G in the early days of Rosenberg. He founded Rosenberg Abstract Company in 1907. Pictured below at 1917–1921 Avenue G are Brazos River Provisions, BR Vino, and Cast Theatrical Company. (Below, courtesy of BAC Photography and Design.)

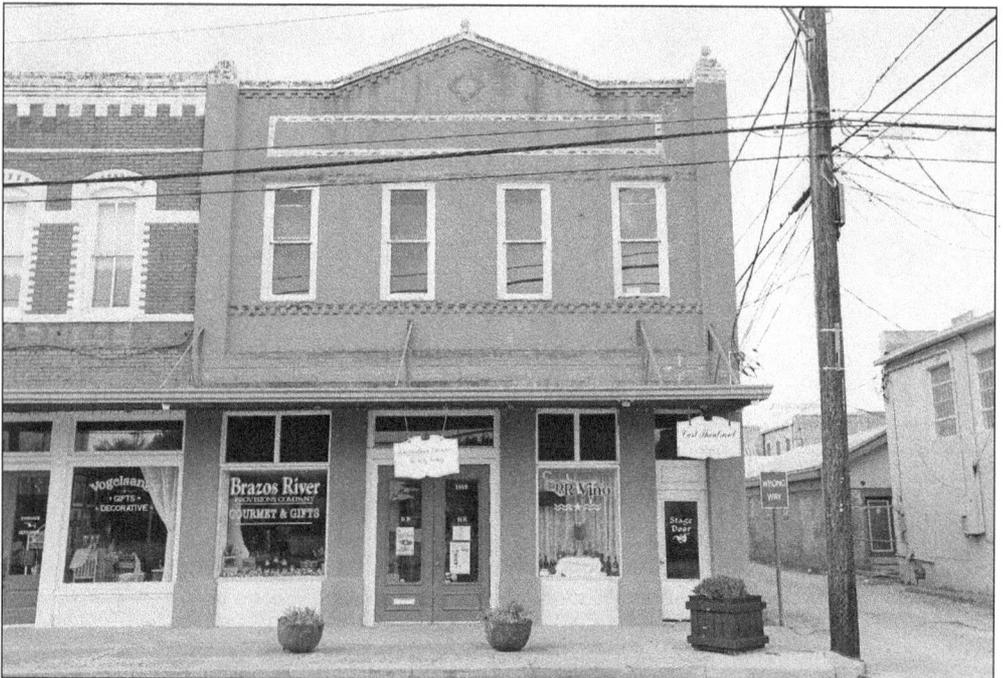

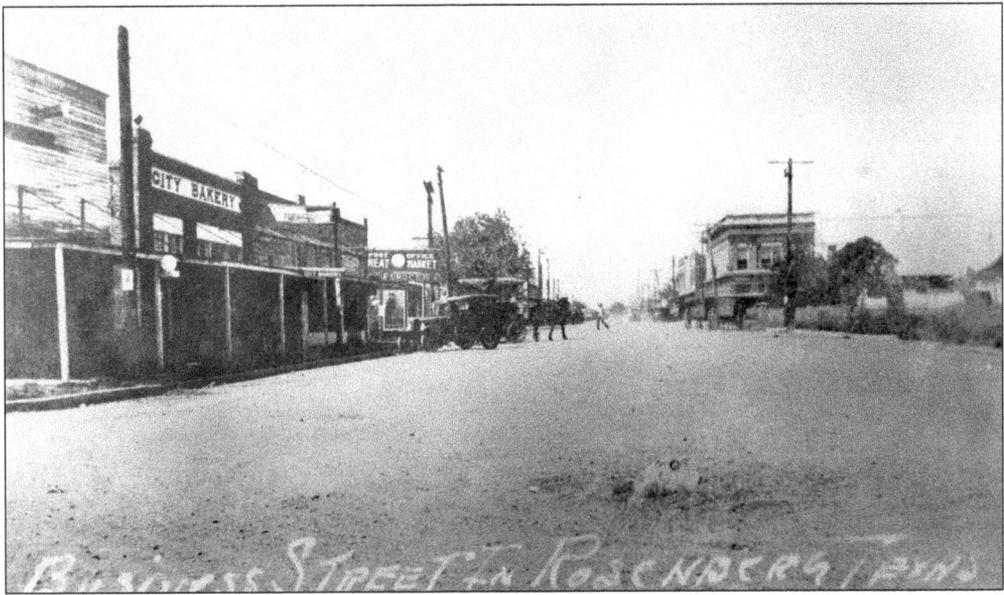

In the 2000 block of Avenue G, the Robinowitz brothers built the structure (left) that housed the post office, Libby's Dress Shop, Rosenberg Grocery Store, and City Bakery. The post office later moved to its present location on the northeast corner of Avenue G and Fourth Street.

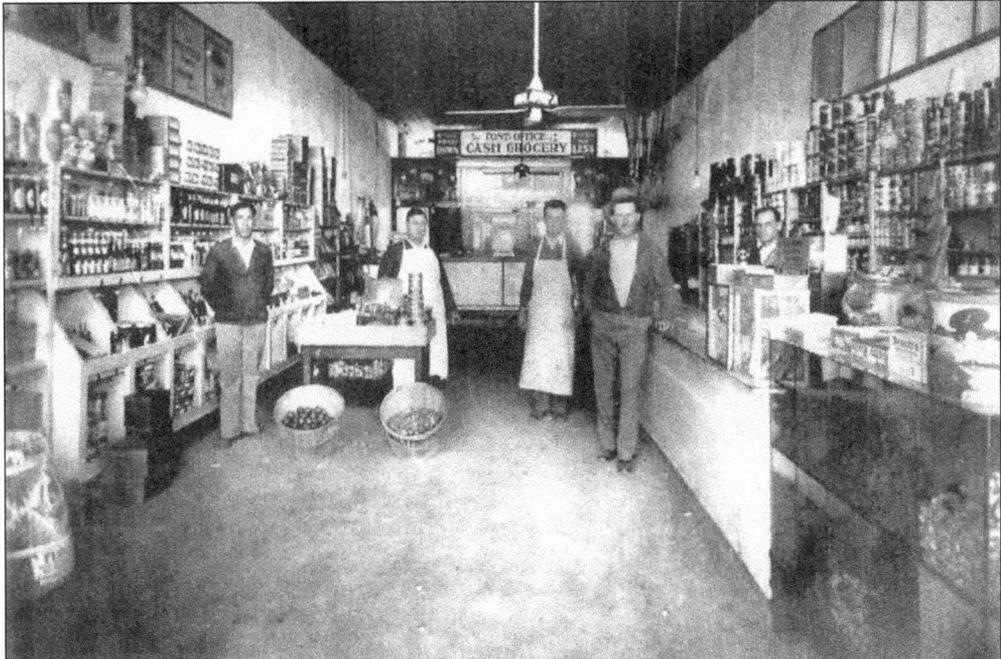

The Rosenberg Grocery Store was located at 2024 Avenue G. Pictured here are, from left to right, an unidentified man, Frank Walenta, Ernest Luksa, and owner Vince Nesvadba. For a time, this location housed the Rosenberg Post Office.

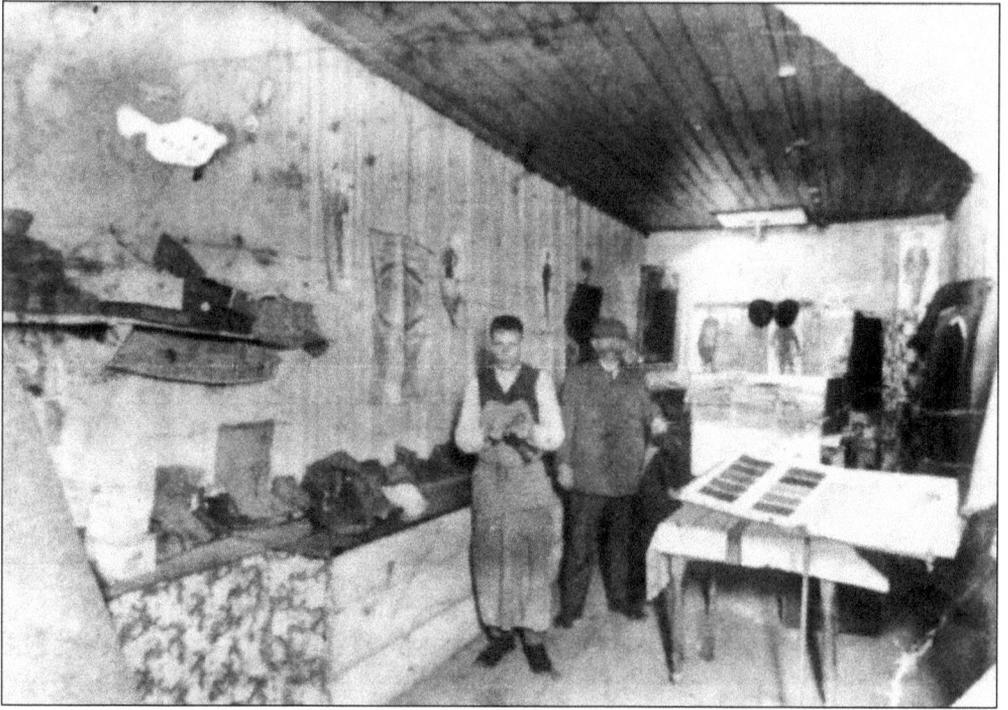

This is the interior of Anton Humpola's Shoe and Tailor Shop in the early 1910s. The store was located on Avenue G. These two employees are unidentified.

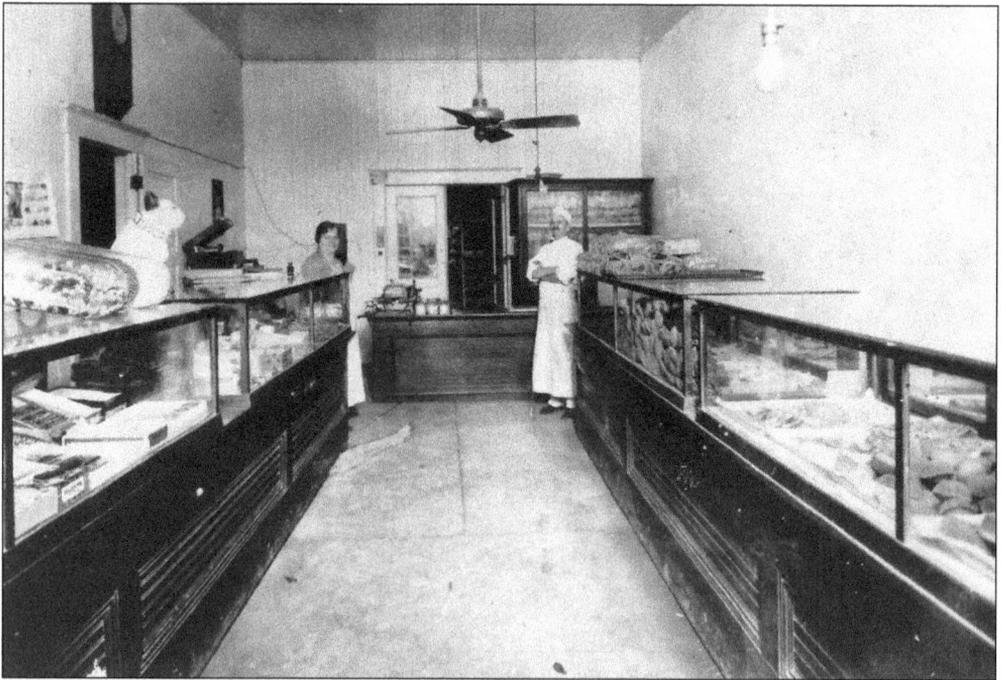

City Bakery, owned by Mr. and Mrs. Louis Tejml, was located at 2024 Avenue G. This structure was torn down to make way for the Fort Bend Federal Savings & Loan.

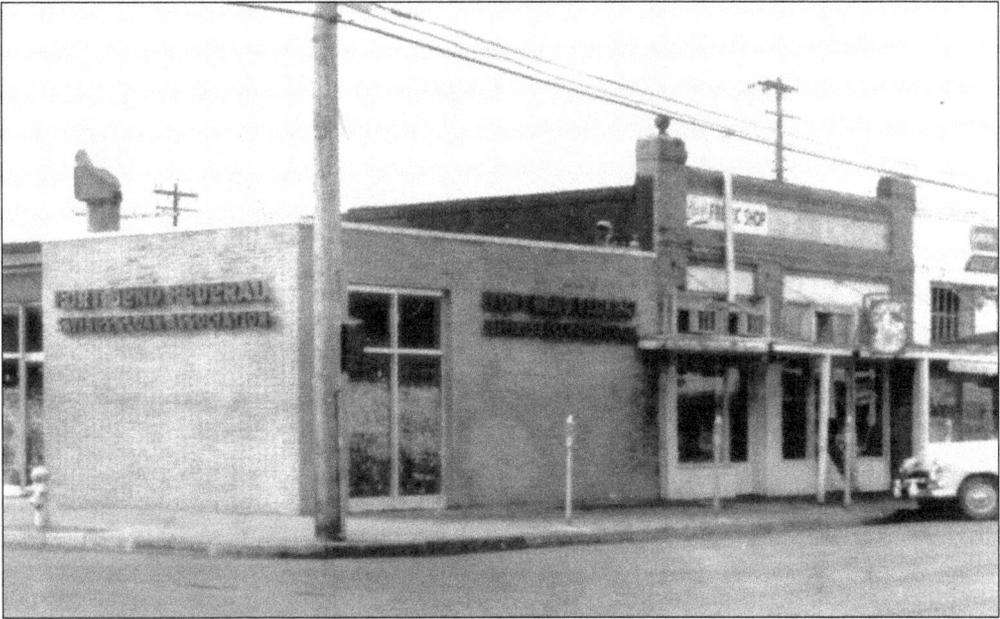

Shown above is the 2000 block of Avenue G in 1957, featuring Lacy's Fabric Shop (1950–1974) and Vacek's Club (1948–1973) to the right. This block housed many businesses, like Libby's Dress shop (1922–1948), owned by Libby Robinowitz Epstien; City Barber Shop (1948–1949); Fort Bend Retail and Whole Fish Market (1950–1951); Baxter Account (1954–1962); Watkins Products (1971–1980); and Gaza's Place (1966–1980). Fort Bend Telephone began buying the buildings in 1972 and expanded the business until the entire block belonged to it. (Below, courtesy of BAC Photography and Design.)

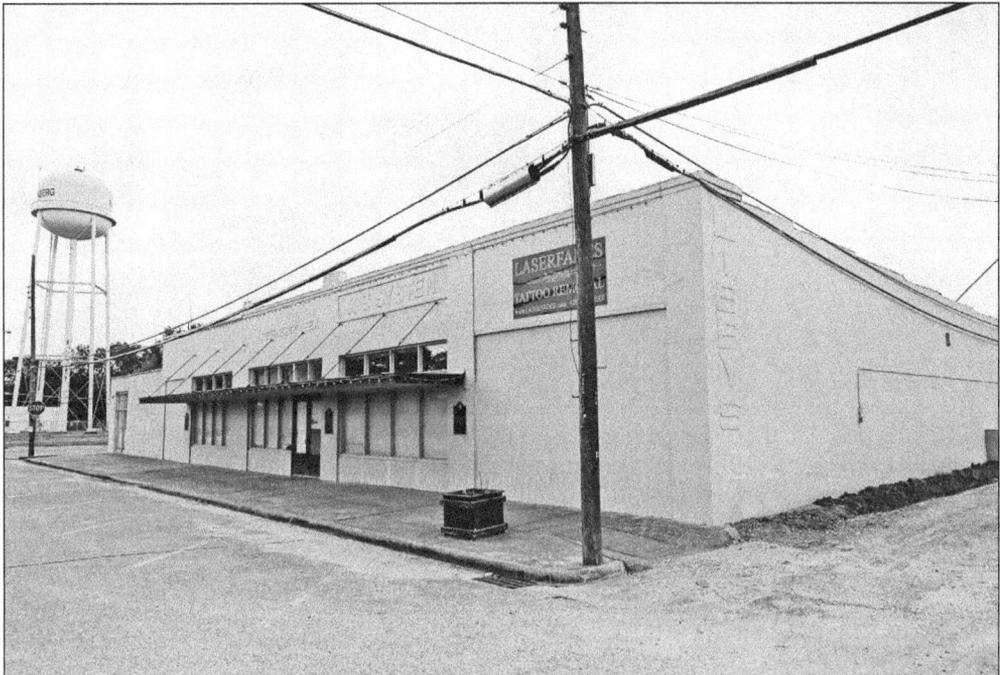

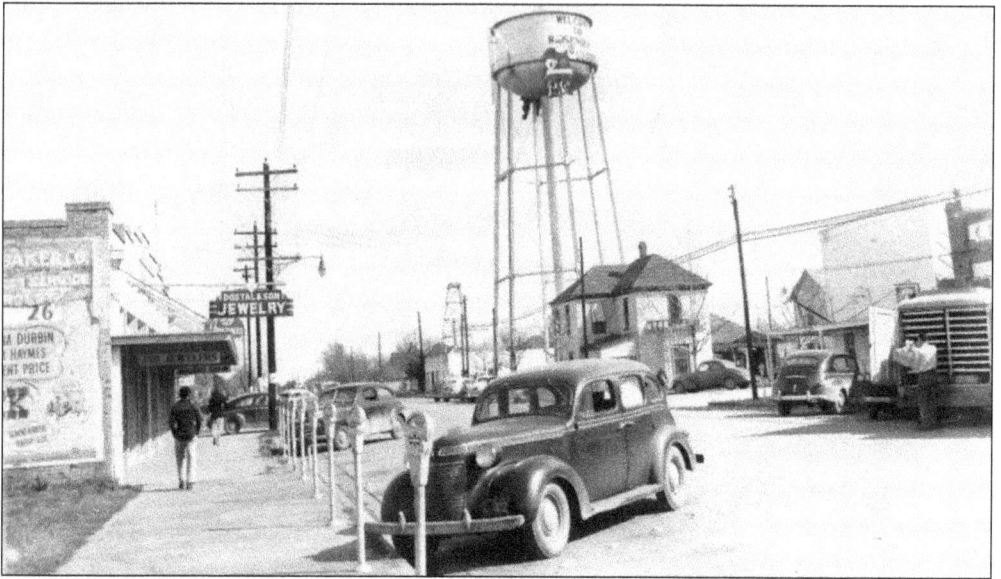

Taken in the 1940s, this photograph features Dostal's and Son Jewelry, located in the rear of 2025 Avenue G. In the background, Santa is seen on the Rosenberg water tower. The front of the building housed Koupa's Appliances.

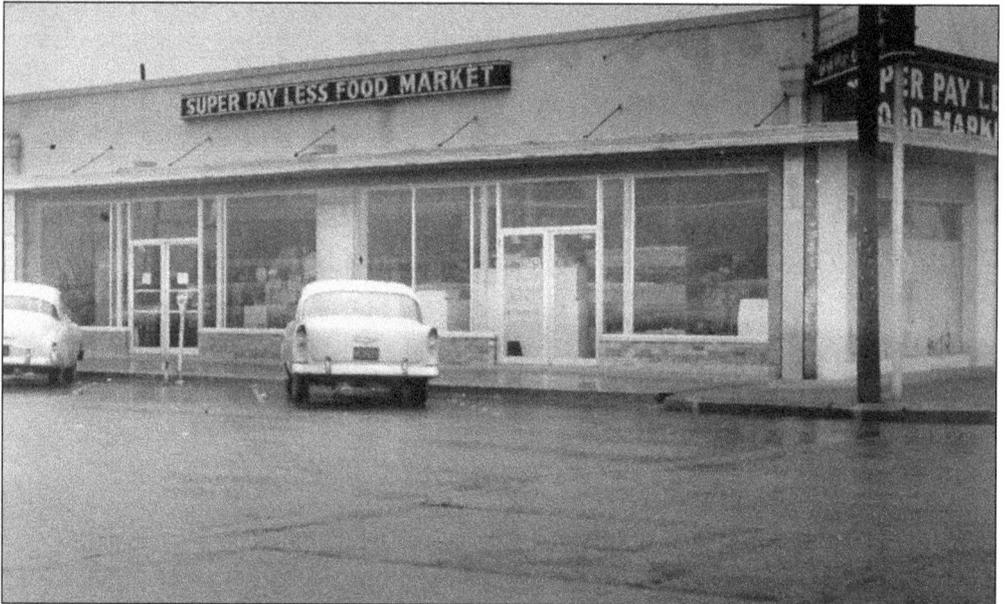

At 2025 Avenue G in the 1950s was Super Pay Less Food Market. Ullrich Grocery Store, owned by Raymond L. Ullrich and Travis Anderson, moved from its location in the other block of Avenue G and was located here from 1951 to 1957. Ullrich was mayor from 1950 to 1958. Later Ullrich bought out Anderson and changed the name to Super Pay Less Food Market, which he sold to Mr. and Mrs. Ben Babovec and Mr. and Mrs. Herman Psencik. In 1973, Torres Food Market, owned by Frank and Tony Torres, was in this location. They changed it to Los Maqueyes Nite Club from 1976 to 1986. Fort Bend Telephone Company had its annex located here from 1990 to 2003. Other tenants included TXU Communications (2003–2006) and Patriot Strategic Investments (2007–2010), and Thomas & Lewin Associates has been housed here since 2012.

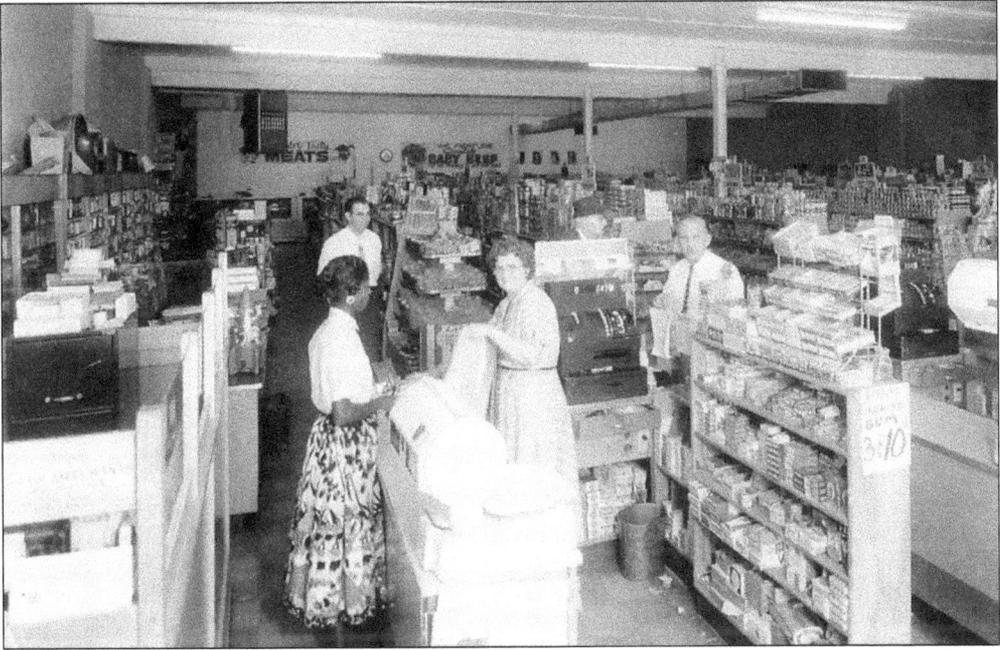

This 1950s interior photograph of Super Pay Less Food Market shows cashier Elsie Muegge and, to the right of her, Raymond Ullrich, former mayor of Rosenberg. Pictured below, at 2025 Avenue G today, is Thomas & Lewin Associates. (Below, courtesy of BAC Photography and Design.)

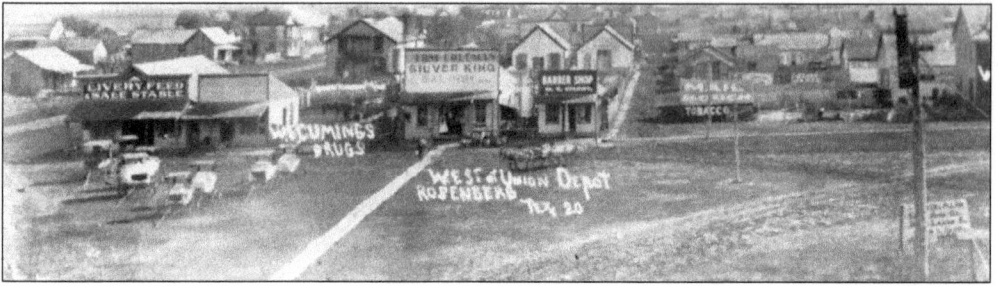

Above is a bird's-eye view of Avenue F and Fourth Street in the early 1900s. At left is Livery Feed & Sale Stable. Other businesses in this location were Rose-Tex Hotel (1948–1955), Cook's Cleaners and Laundry (1962), and Pilgrim's Cleaners (1964). Since 1968, Hernandez Funeral Home has occupied the stable's former location. It is pictured below at 800 Fourth Street. (Below, courtesy of BAC Photography and Design.)

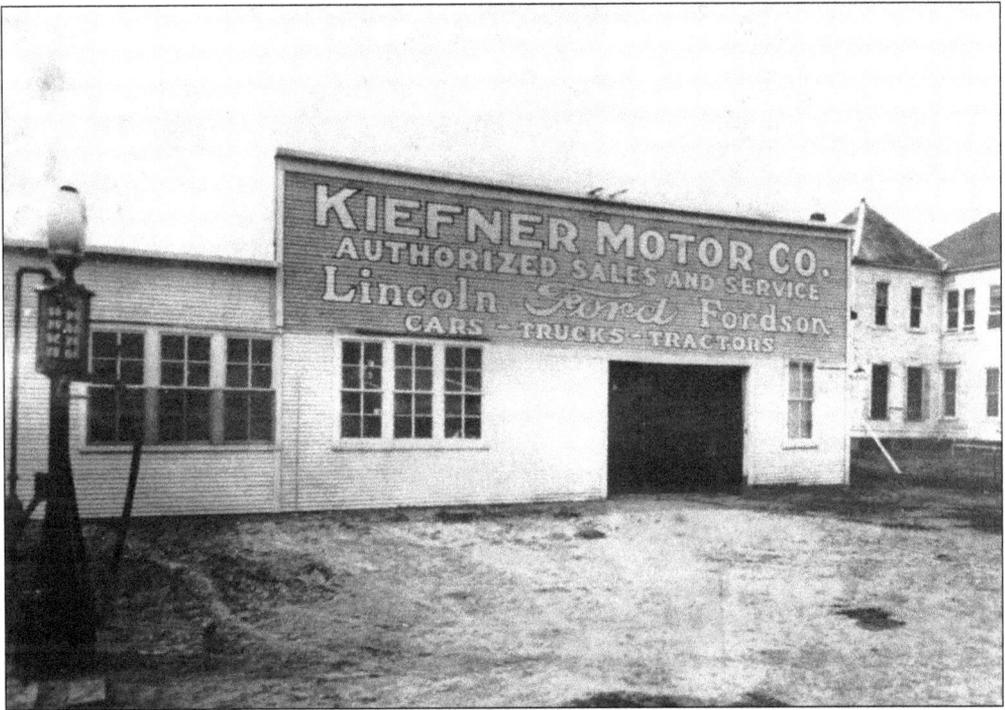

The Kiefner Motor Company, located on Fourth Street in the 1920s, was one of the earliest car dealerships in Rosenberg. In the right background is a portion of the Plaza Hotel.

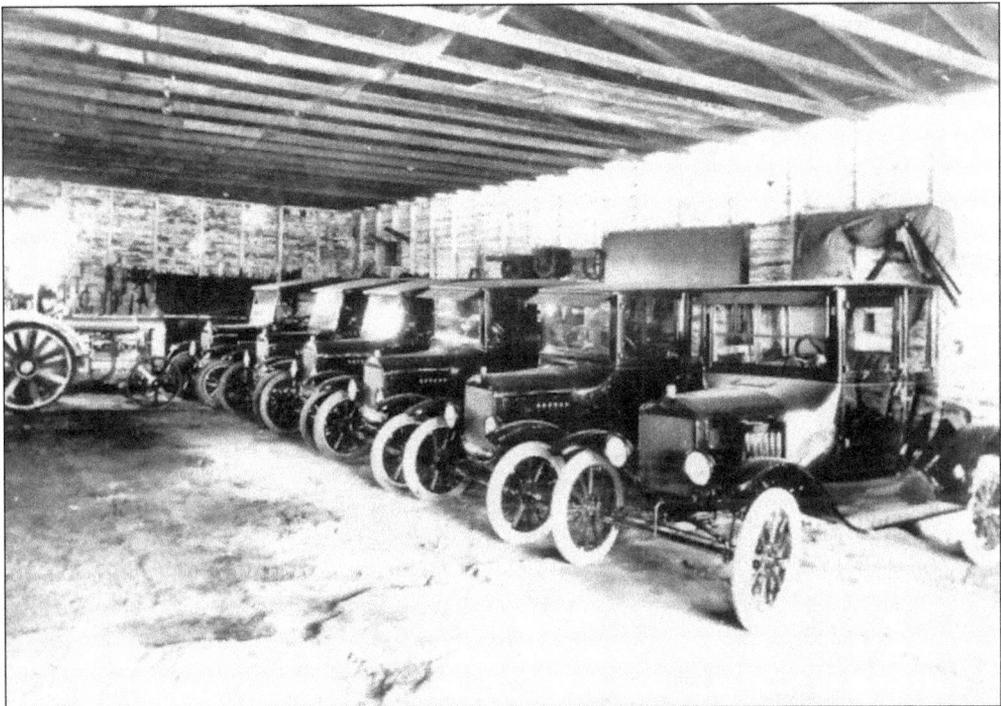

This interior photograph of Kiefner Motor Company shows Ford automobiles and a Fordson tractor in the back in the 1920s.

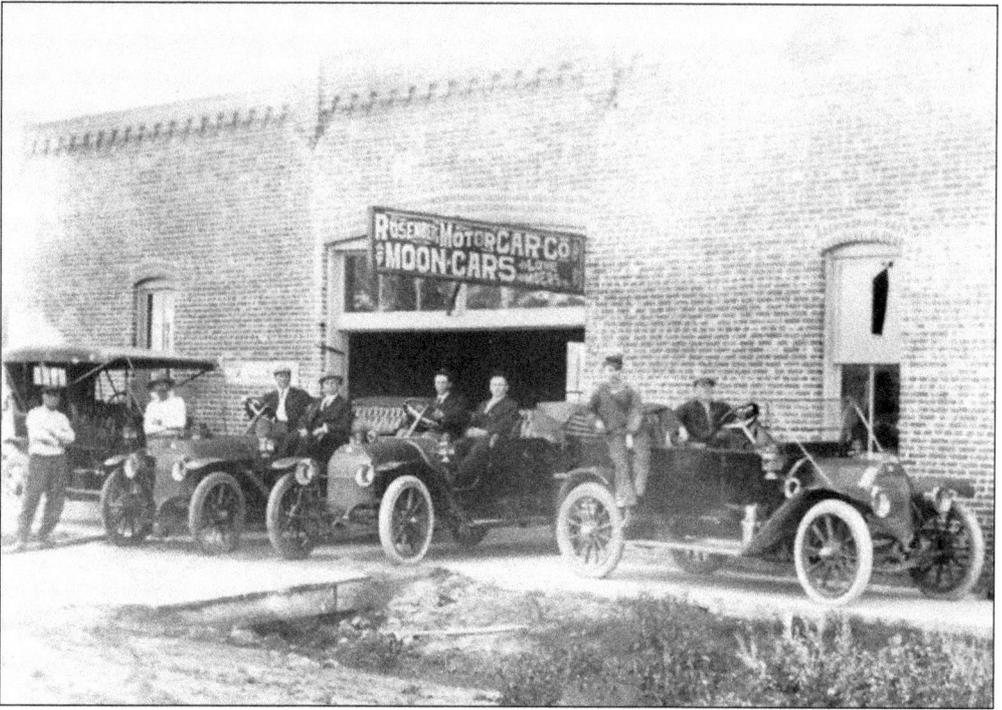

The above photograph, taken in 1910, shows the Lowe-Moers Motor Car Company, located in the 800 block of Fourth Street, which replaced Kiefner Motor Company. Delbert I. Lowe and Herman Fredrick Moers owned the company and were considered the first automobile mechanics and Buick dealers in town. (Below, courtesy of BAC Photography and Design.)

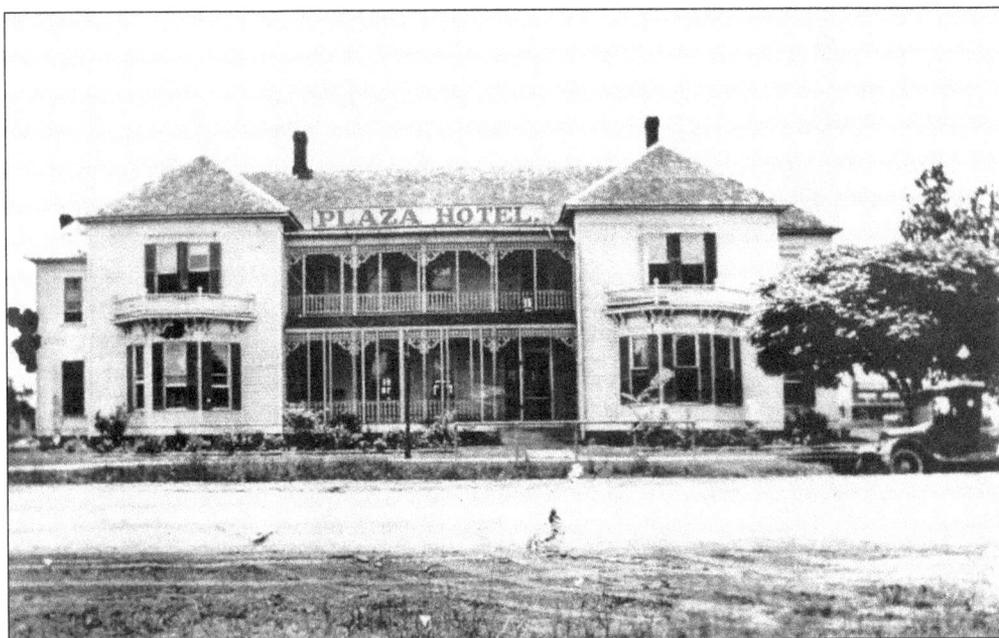

The Plaza Hotel, located on the corner of Avenue F and Fourth Street, was built in the early 1900s. It remained a hotel through the 1960s. Traveling photographers would rent rooms and take portraits of locals. The hotel was demolished in the 1980s.

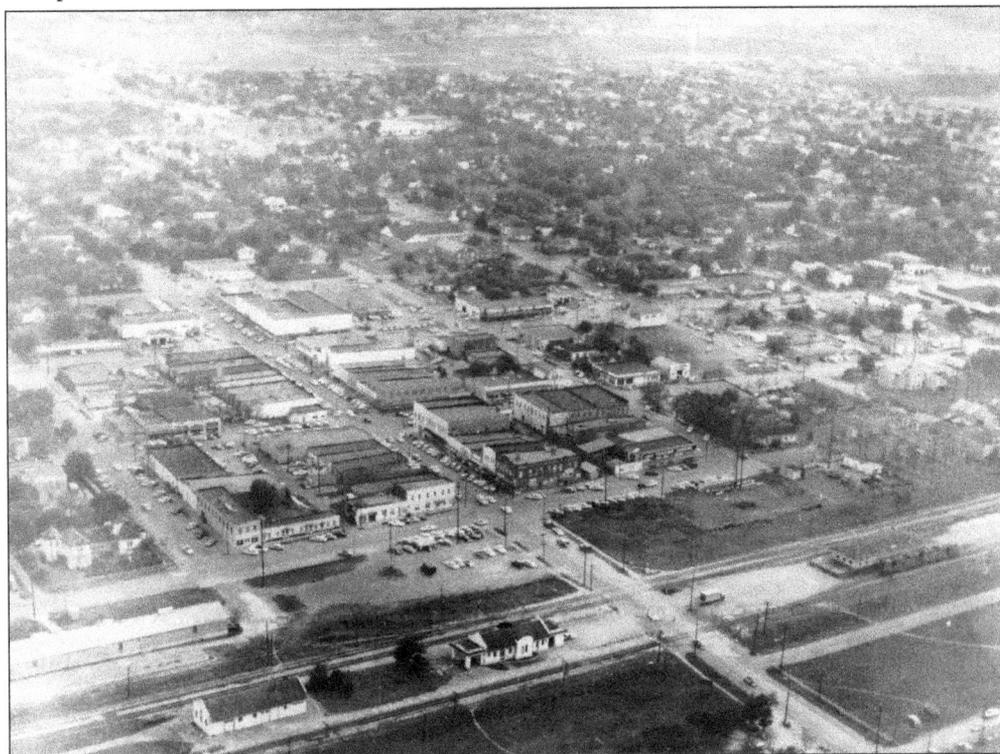

This aerial photograph of downtown Rosenberg dates to the early 1960s. The Plaza Hotel, in the lower left, and the Rose-Tex Hotel across from it are in the proximity of the railroad station.

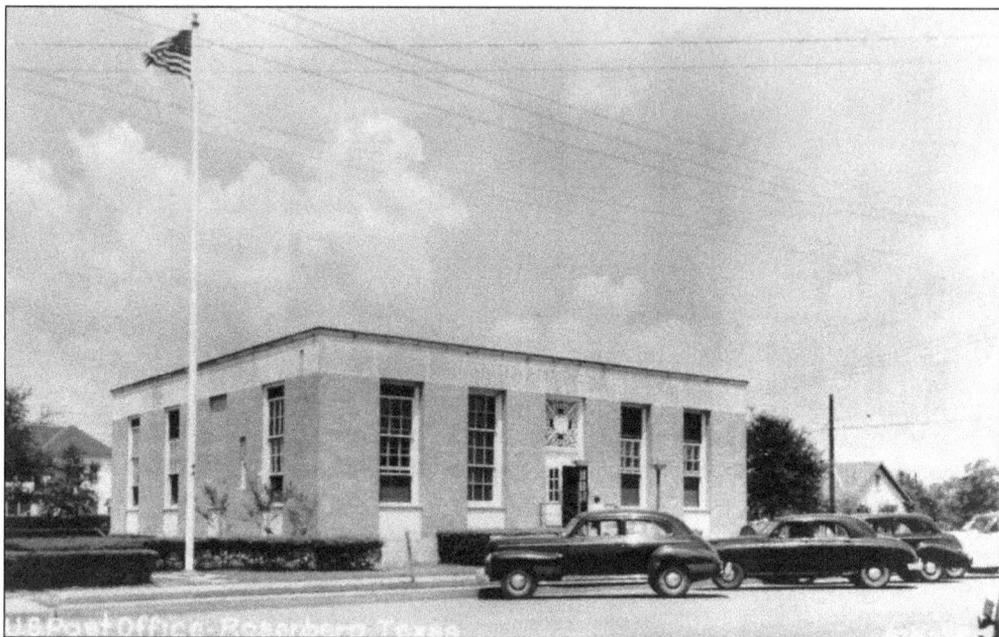

This is the fourth location of the US Post Office in Rosenberg. This facility has a basement that could have been used as a bomb shelter during the Cold War. Previous locations were Avenue F, the 800 block of Main Street, and the 2000 block of Avenue G. The present structure was built in 1938 and enlarged in 1967.

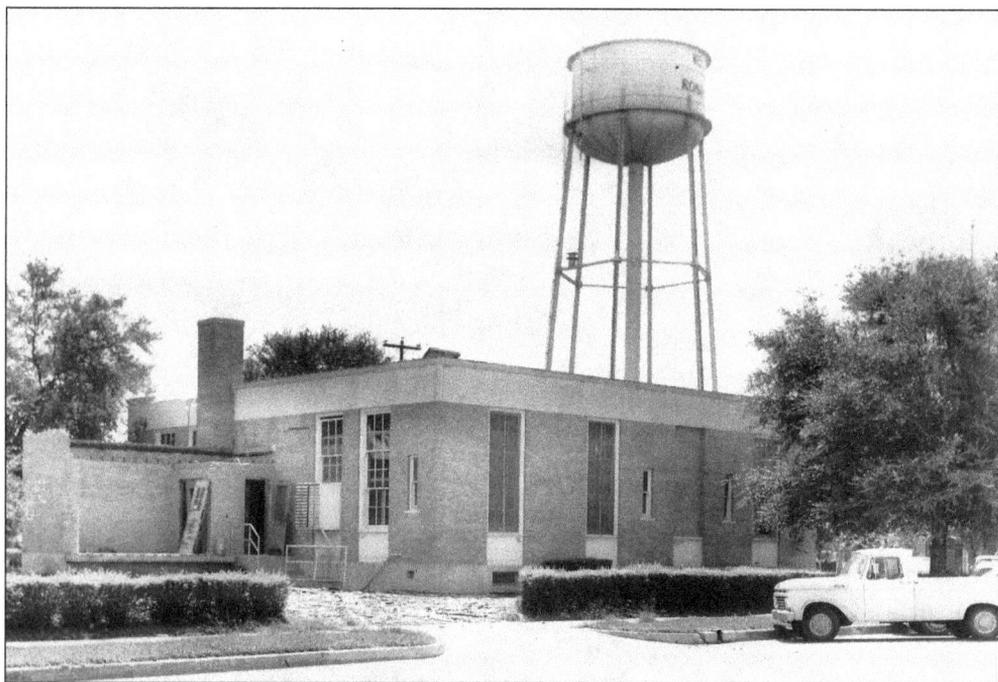

This 1967 photograph was taken during the expansion of the post office. The project included the loading dock seen on the left side of the building. Later, a drive-through service for mail was installed where the pickup truck is here.

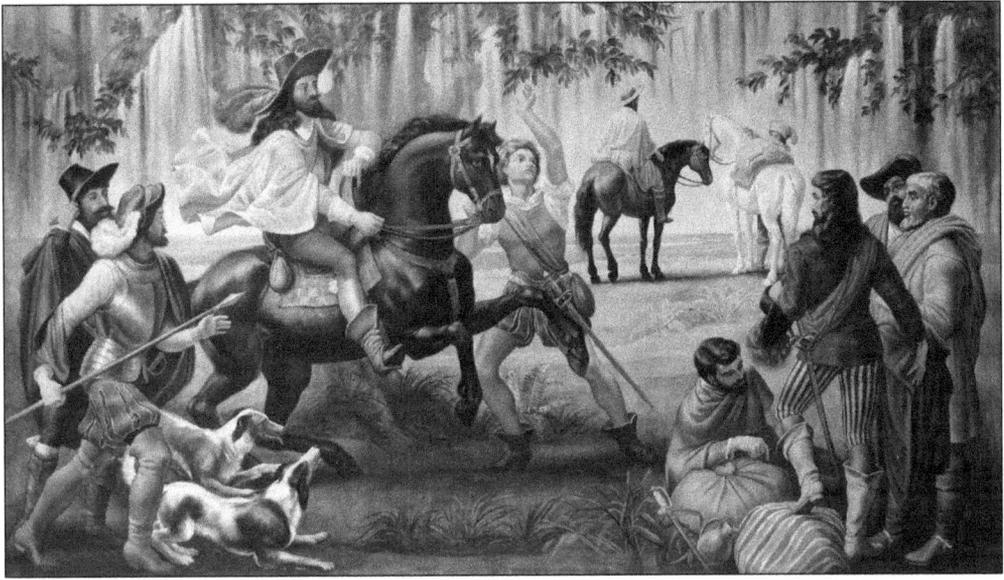

During the Depression, the federal government engaged artists nationwide to create works on local themes to be placed in government buildings. The Rosenberg Post Office was such a recipient. The theme for this work was suggested by local historian Pauline Yelderman. The artist, William Dean Faucett, took some artistic license in depicting LaSalle's crossing of the Brazos River. Installed in 1941, the oil canvas was removed during the expansion of the building and disappeared. Pictured below, at the corner of Fourth Street and Avenue G, is the US Post Office. (Below, courtesy of BAC Photography and Design.)

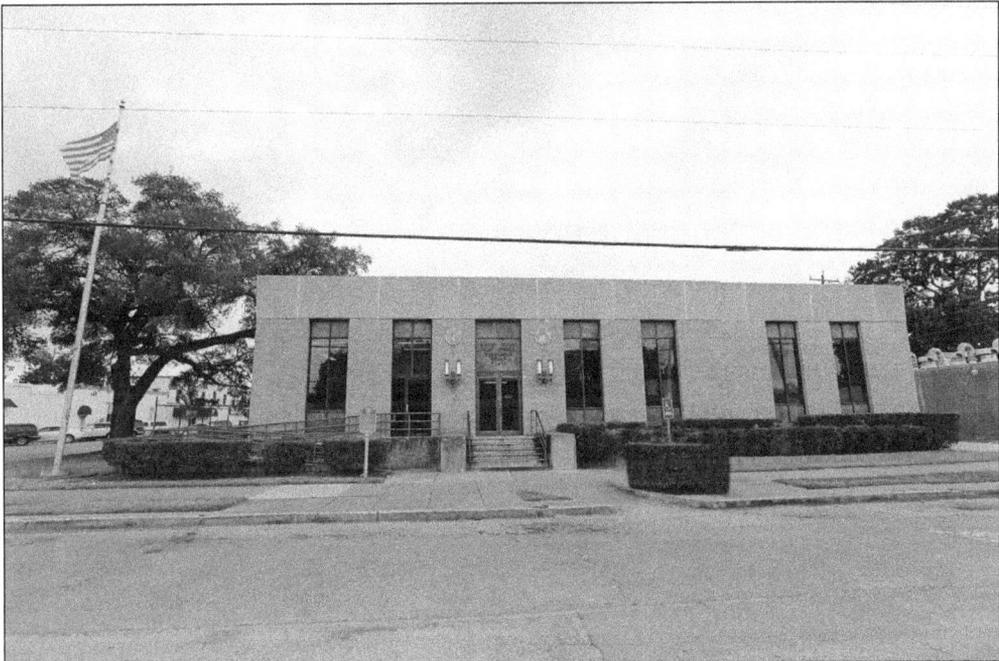

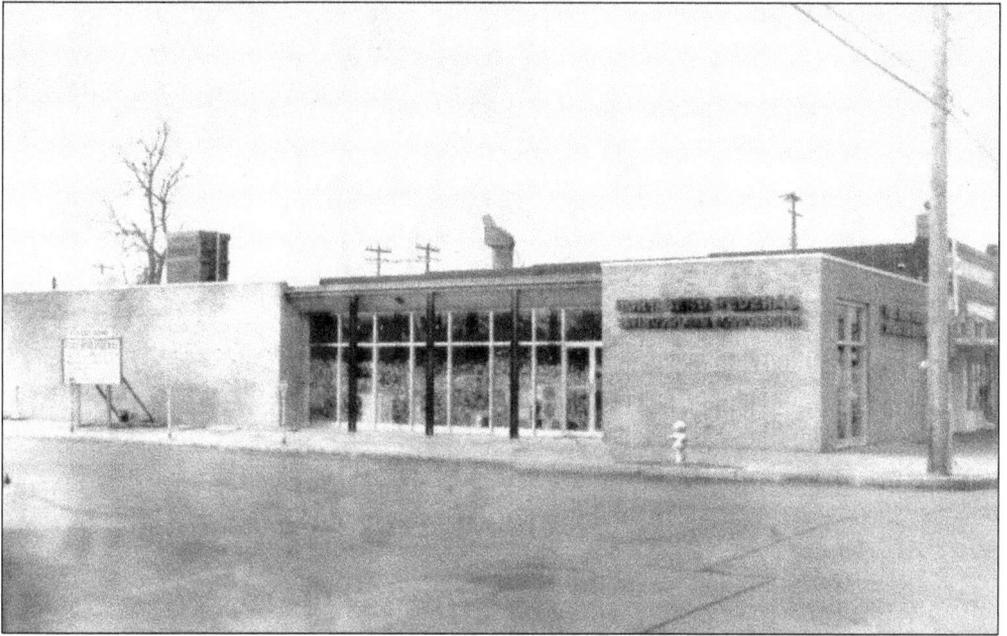

This structure, built in 1957, housed Fort Bend Federal Savings & Loan (above). Other businesses were Fort Bend Telephone Company (1972–2011) and Butler Books' third location (2011–2013). Pictured below, at 900 Fourth Street, is the vacant building today. (Below, courtesy of BAC Photography and Design.)

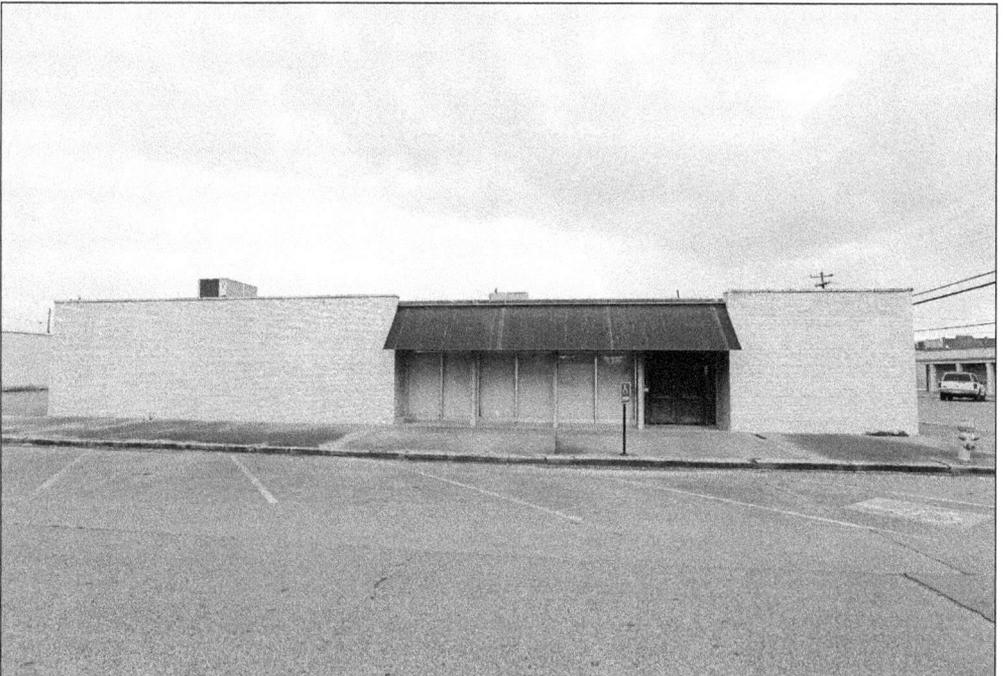

Above, a police officer stands in front of the police department building on the corner of Fourth Street and Old Spanish Trail in the late 1950s. In the background is Guy L. McNutt Insurance. He built the brick building in 1948.

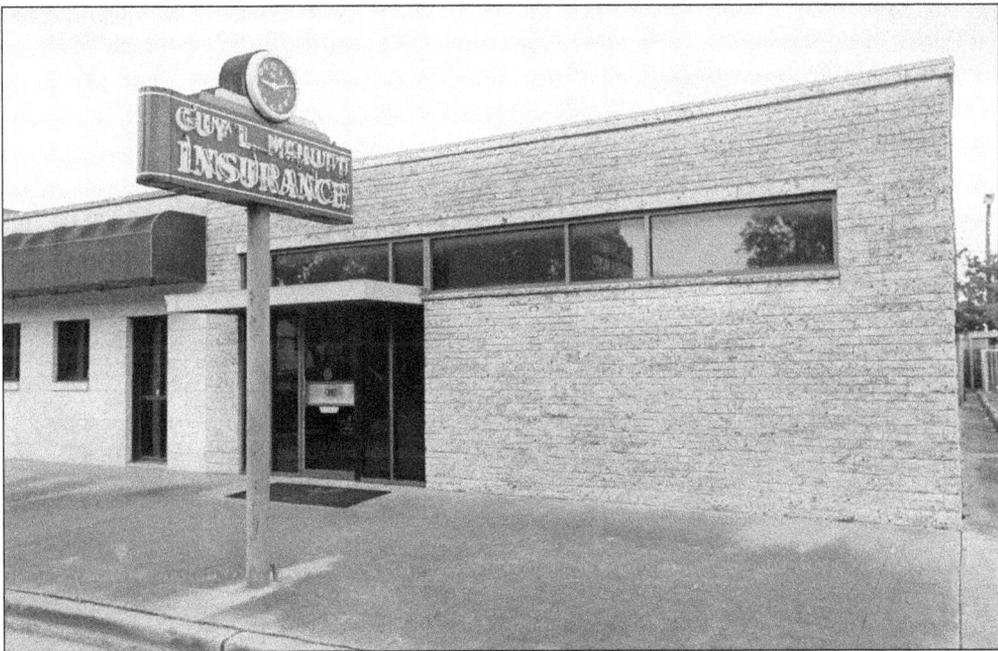

Guy L. McNutt Insurance Agency built this brick building in 1948 at 910 Fourth Street. The business and the same neon sign remain there today. McNutt, known by the moniker "Buy from Guy" opened in 1937 on Avenue G in the Masonic Building, later moving to the Butler Grimes Building on Main Street.

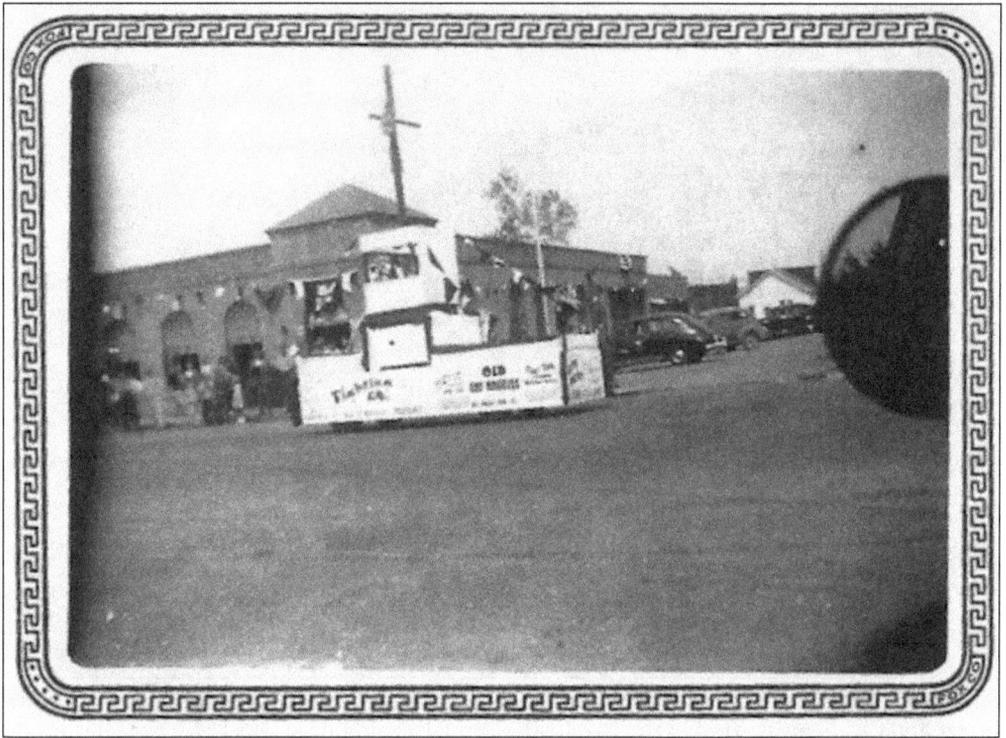

In 1946, a float in the Fort Bend County Fair Parade travels by Fourth Street. Joerger Lindsey/ Rosenberg Abstract Company is in the background. Attorneys F.X. Joerger, Kathleen Joerger Lindsey, and Robert Lindsey were located here from 1948 to 1988. In 1950, the group added Rosenberg Abstract Co., and an additional owner, Greg Knauth, came aboard. Pictured below, 912 Fourth Street is today private. (Below, courtesy of BAC Photography and Design.)

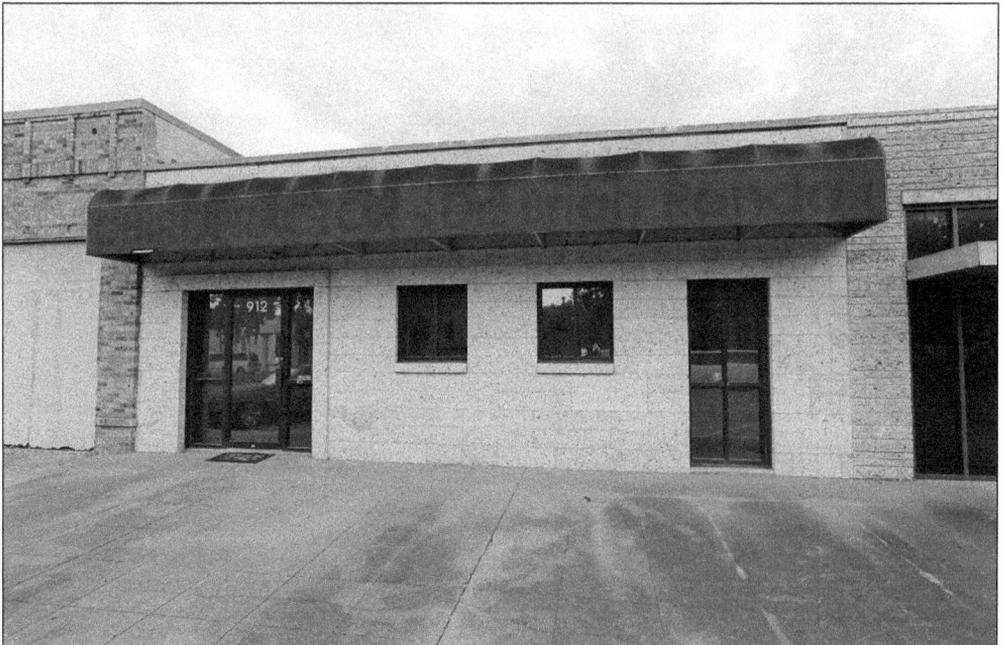

The original Rosenberg Fire Station was located on Fourth Street. It was built in 1915.

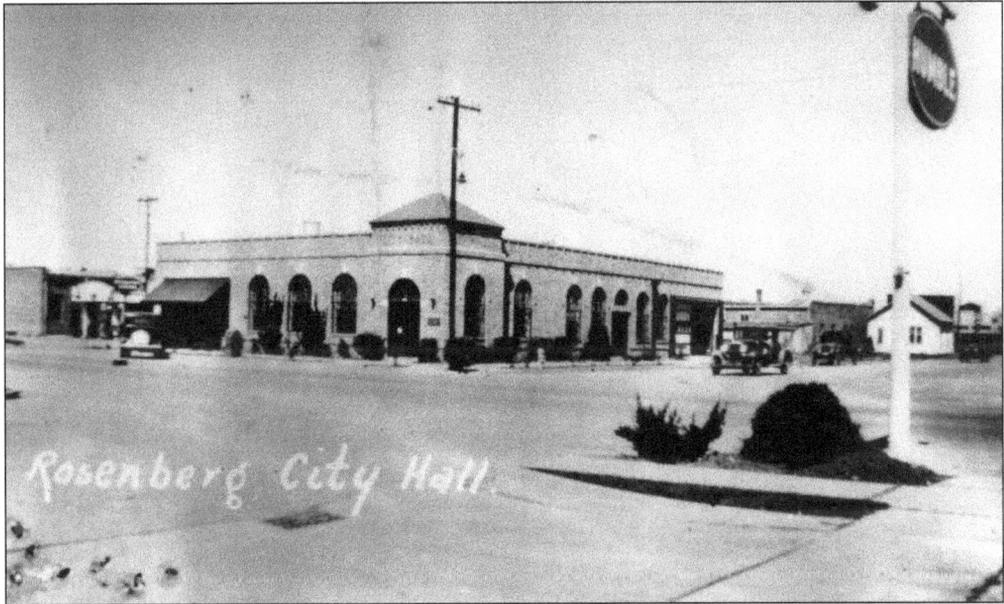

This 1930s photograph of the first Rosenberg City Hall was taken shortly after the paving of the downtown streets. The structure was built with a foundation to accommodate a two-story structure. The police department had two jail cells, and the fire department had two trucks. This was the original location of the Fort Bend County Library, and the Fort Bend Chamber of Commerce was housed here from 1950 to 1955. In 1980, Rosenberg City Hall moved to its new location further south on Fourth Street.

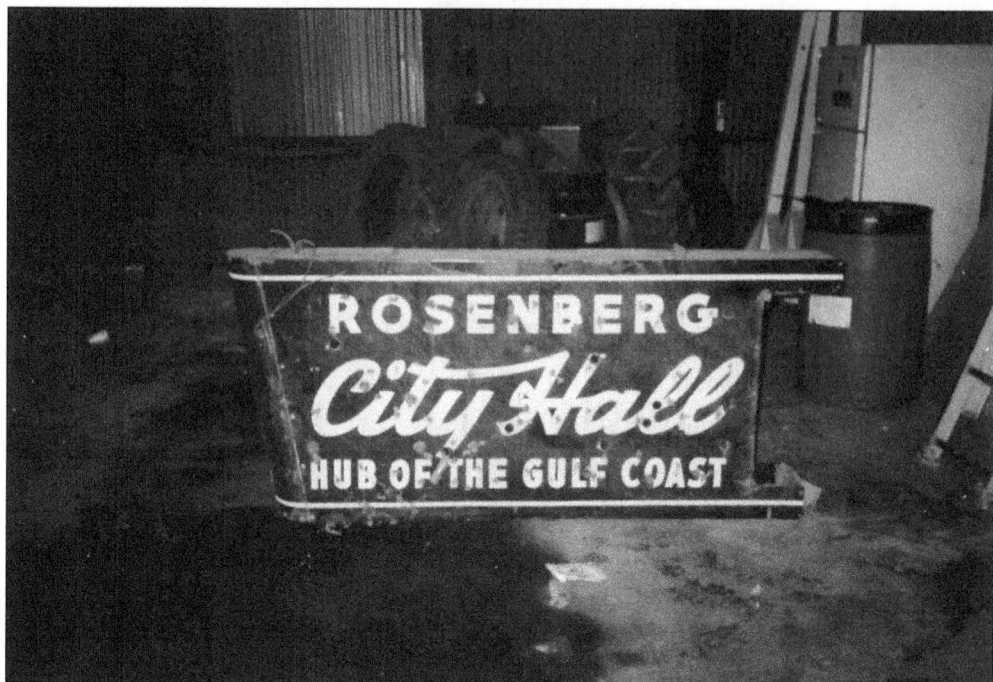

The slogan "Hub of the Gulf Coast" appeared on this sign, which hung above the door of city hall. Pauline Yelderman won the contest to nickname Rosenberg.

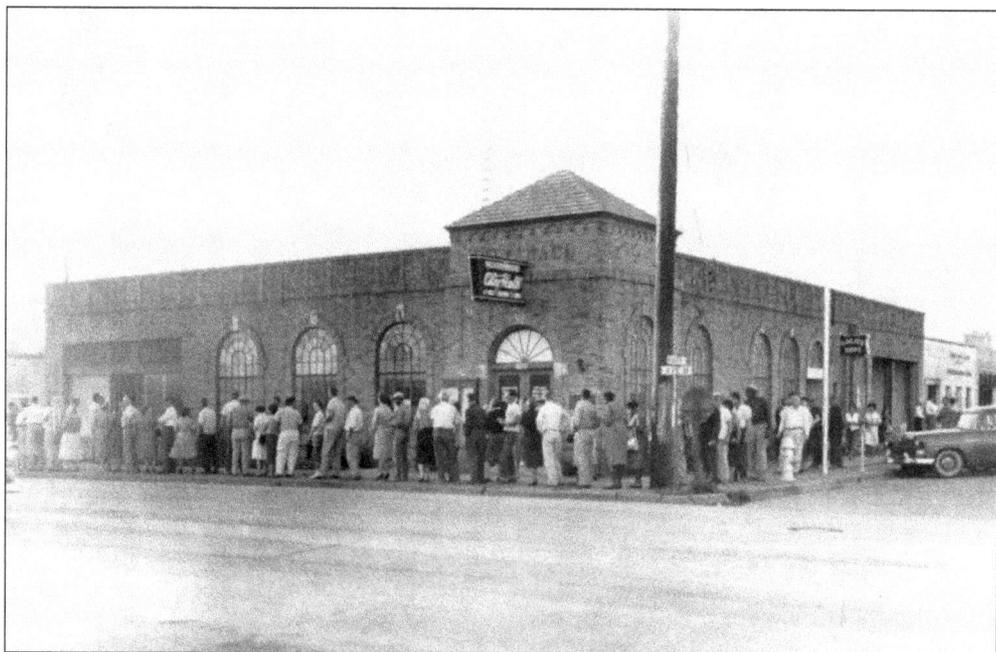

Rosenberg City Hall, built in 1930, was located on the corner of Fourth Street and Old Spanish Trail (Highway 90A). This photograph was taken on Election Day. The city hall complex included the police department and the volunteer fire department. The first city council meeting was held in January 1931.

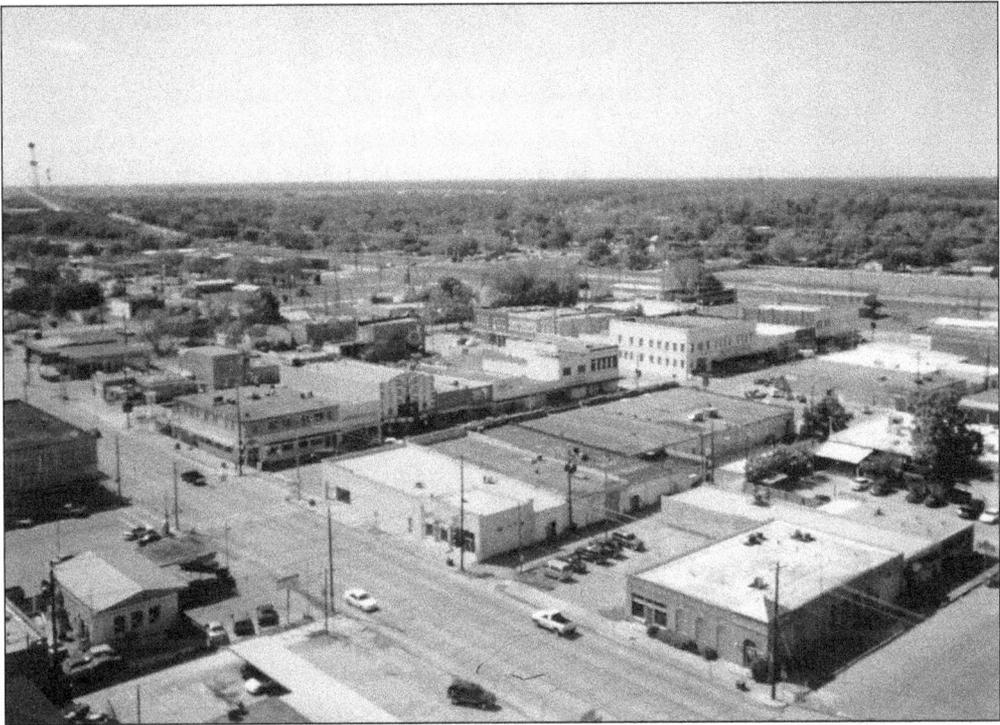

The above photograph, showing downtown Rosenberg from the air, was taken in early 2000. The old city hall is at lower right. The building is shown today, vacant at the corner of Fourth Street and Highway 90A, in the below photograph. (Below, courtesy of BAC Photography and Design.)

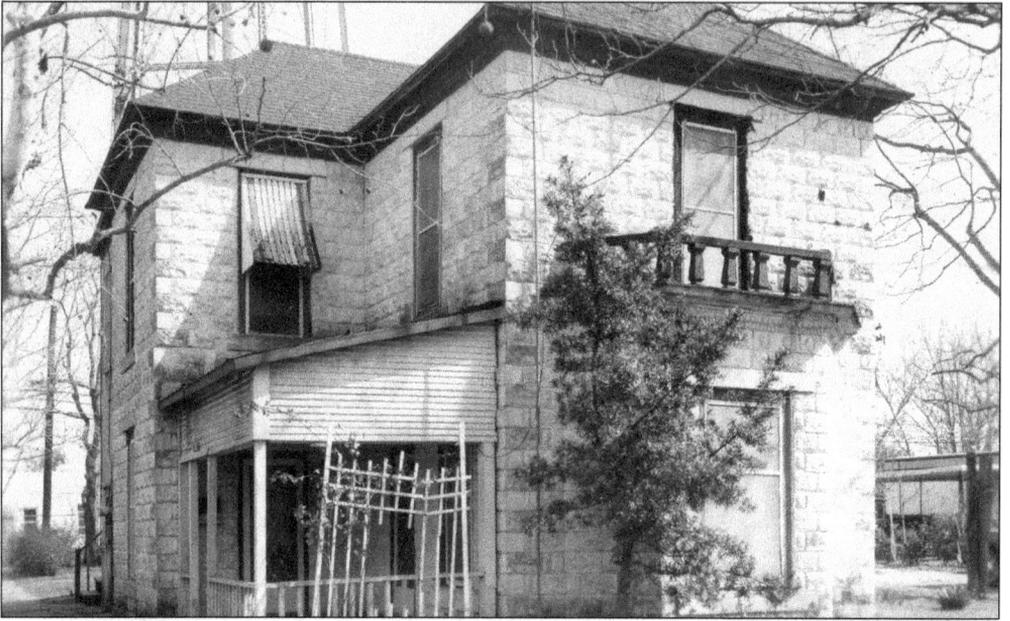

The Jircik boardinghouse is seen here in early 2001. Located on the corner of Fourth Street and Avenue G, it was one of the early masonry buildings, erected in the early 1900s. The building, which was in bad repair, was leveled in 2014. The site is scheduled to become a parking lot in 2015.

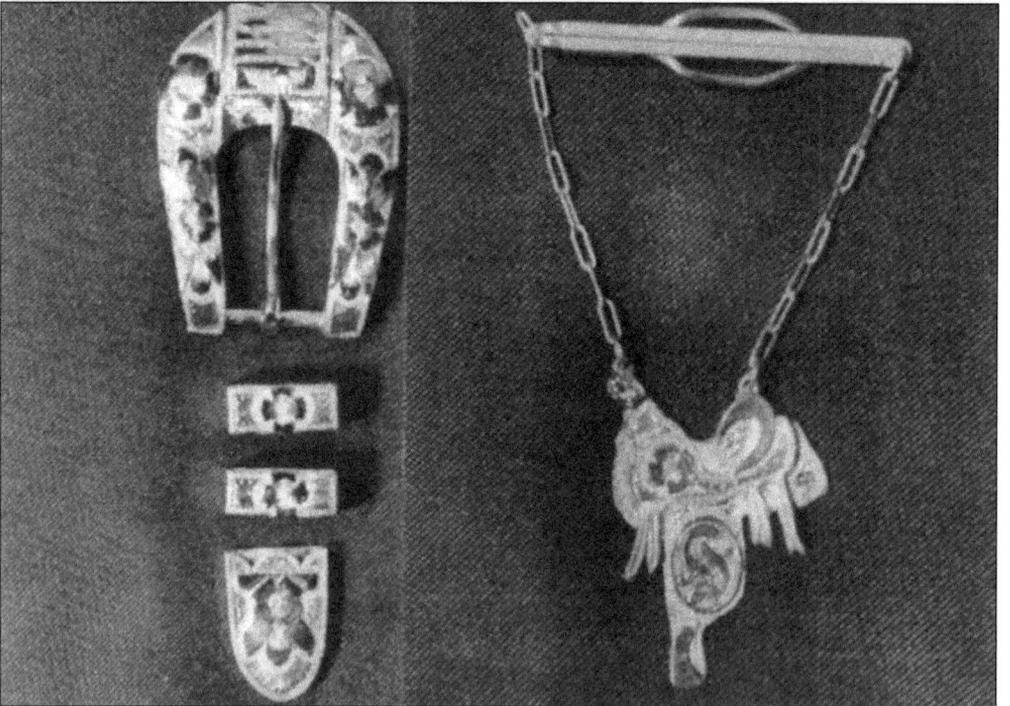

Located at 923 Fourth Street was R.W. Driskell, a renowned Western designer from the 1940s. His designs are sought after to this day. The silver belt buckle (left) was designed in 1945; the jewelry piece at right, a silver tie tack, also dates from 1945. Located on the same block on Fourth Street was the Benson Hotel, which was run by Driskell's dad.

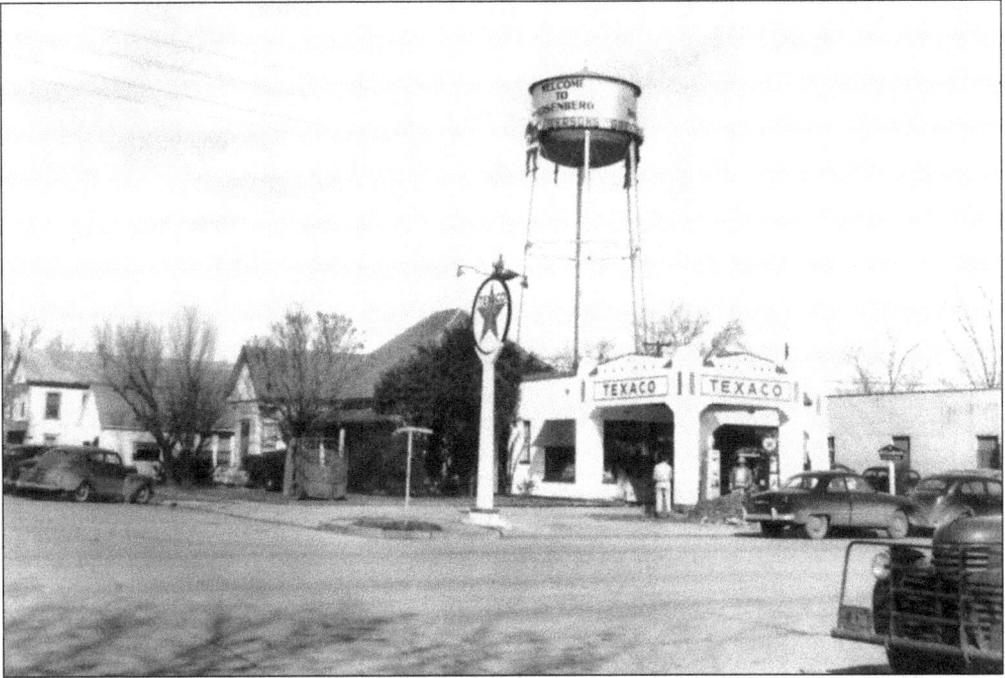

Shown above is the east side of Fourth Street, north of OST (Highway 90A). The establishments shown are, from left to right, the Benson Hotel (operated by R.W. Driskell's dad), Driskell's silversmith shop, a residential home, and the Texaco station. Of these buildings, only the station exists today. It is now home to Transco Transmission. The Benson Hotel had a unique outdoor bathhouse. Many years after the hotel was torn down, that bathhouse was moved to the Rosenberg Railroad Museum for display. Early postmaster Terrell Brewer rented a room in the hotel and had kept a safe in that bathhouse. Pictured below at 2109 Avenue H is Transco Transmission. (Below, courtesy of BAC Photography and Design.)

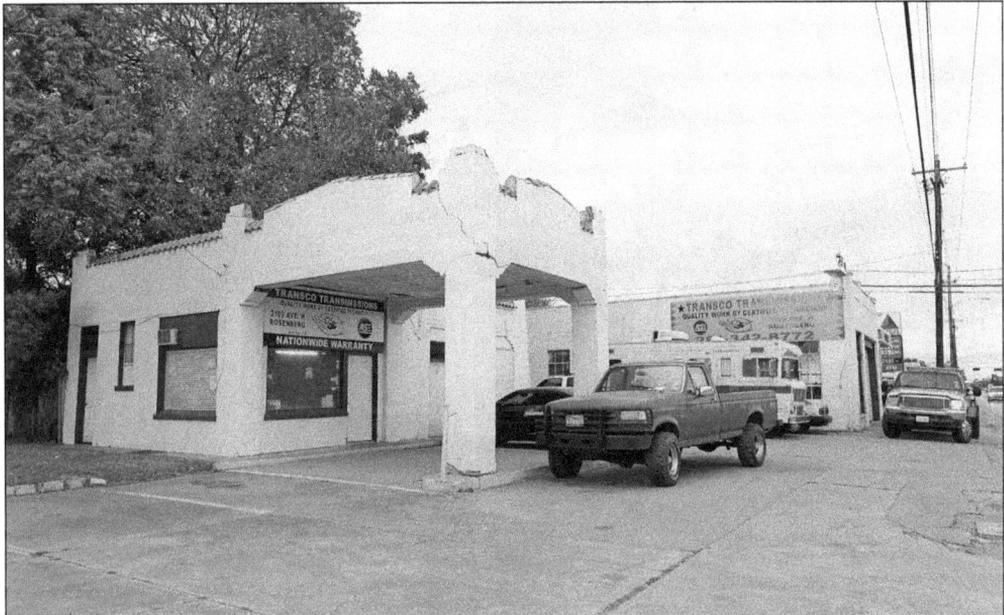

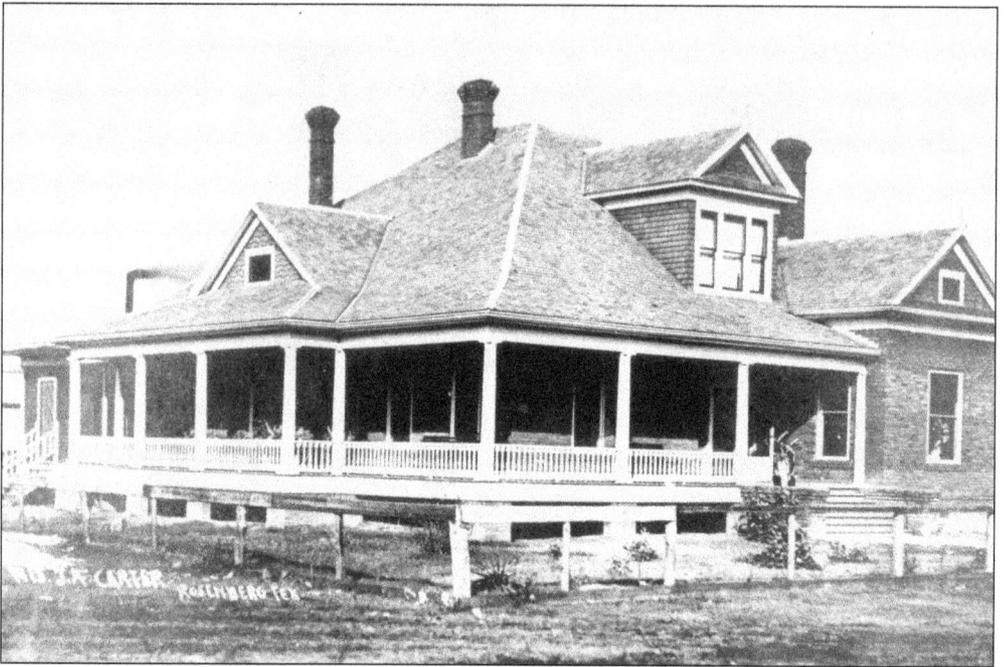

This is an early photograph of the Ebell House, located at 812 Second Street. The residence had four chimneys. J.A. Carter built the house in 1901 for his fiancée, Louise Ebell, a pioneer businesswoman in the then small town. Carter, a brick mason, builder, and contractor, made the bricks on the Brazos River. He was the eighth mayor (1924–1926) of the city of Rosenberg. R.T. Mulcahy, the second mayor of Rosenberg, gave a speech from the steps of the Ebell House. At some point, perhaps after Carter's death in 1928, Louise Ebell rented out rooms, as this was a convenient location, next to the railroad depot. Joe and Doris Gurecky purchased the house in 2012 and renovated it, as pictured below.

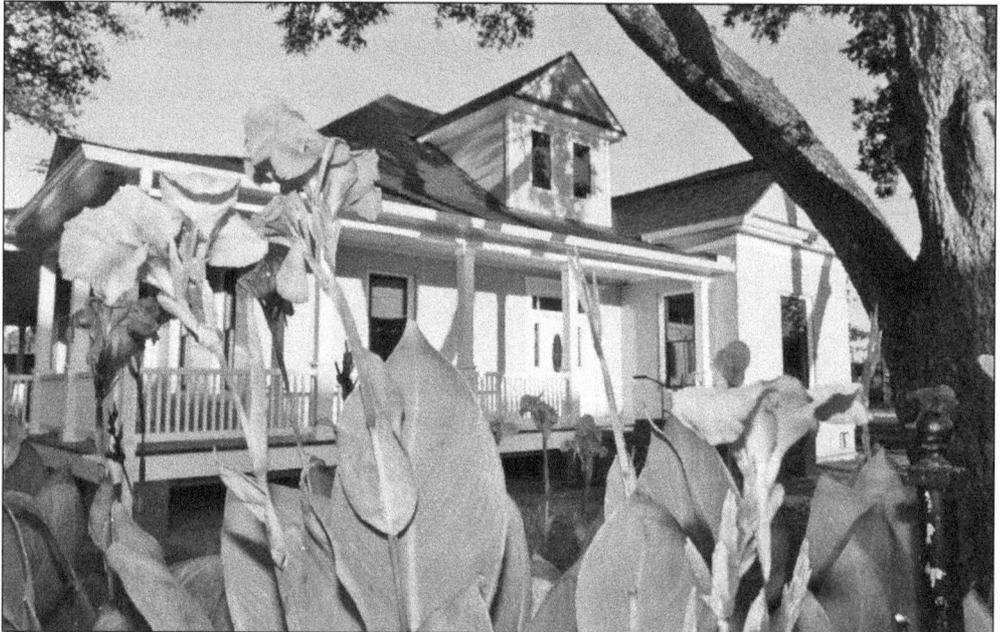

This 1920s photograph looks east toward downtown. The building in the foreground was a rooming house for railroad employees. It no longer exists. The building in the center housed Calloway Auto Company.

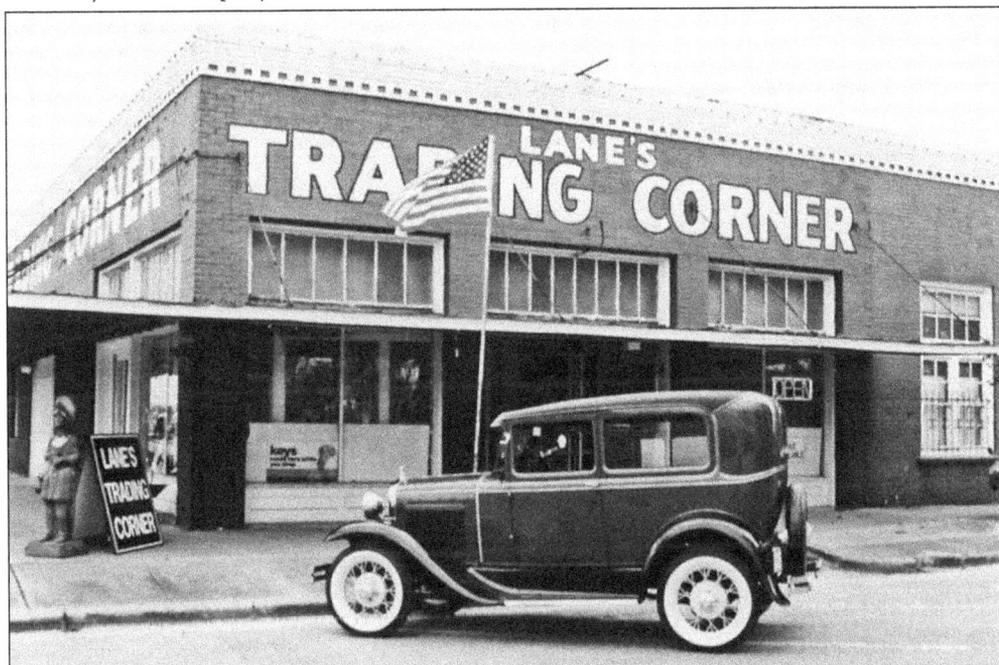

On the corner of Avenue F and Second Street, before the streets were paved, Calloway Auto Company opened its Ford dealership in 1927. Owner Carl Calloway had the first Ford dealership in town. George and James Lane bought the dealership from Calloway at a sheriff's sale. Later it became Lane Motor Company (1948–1951). This picture shows a Model T, which was sold inside the building.

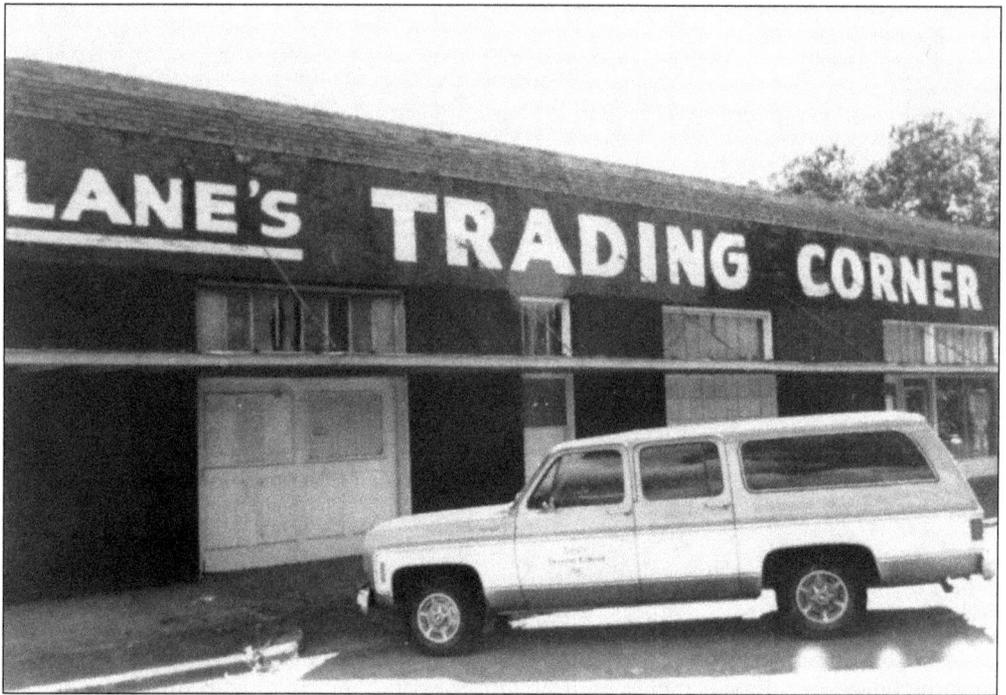

Lane's Trading Corner opened for business in 1951 and was known as the "White Elephant." Owners Mickey Lane and sons Dusty and Rocky had the business until retiring in 1996. Other businesses in this location were Olde Carriage Antique Shoppe (1997–2012) and D&S Mall, owned by Ken Kalamaaz and Debbie Sypert, since 2012. Picture below, at 801 Second Street today, is D&S Mall. (Below, courtesy of BAC Photography and Design.)

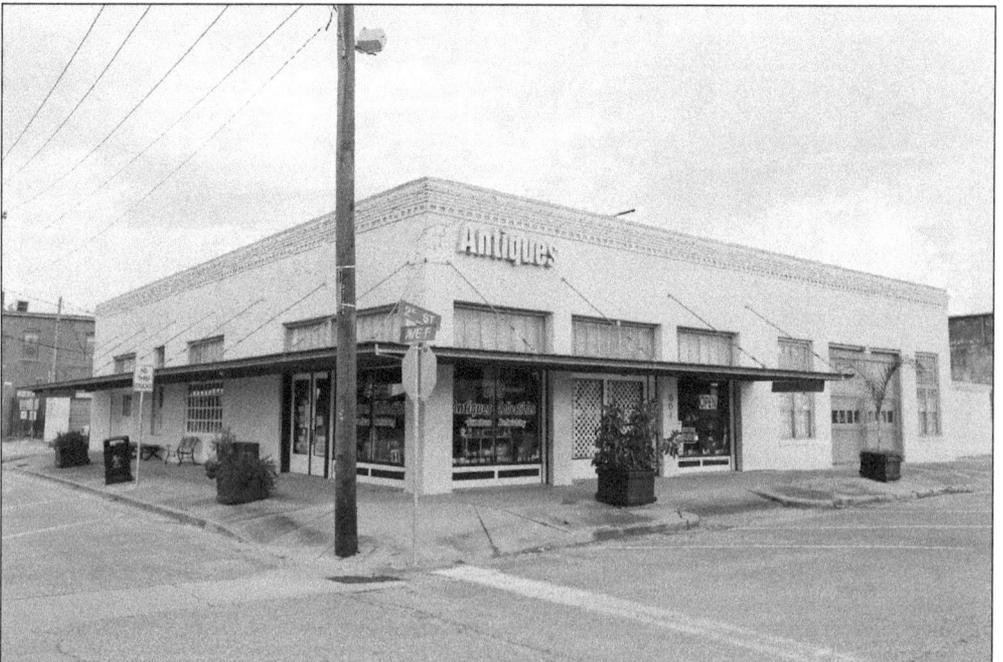

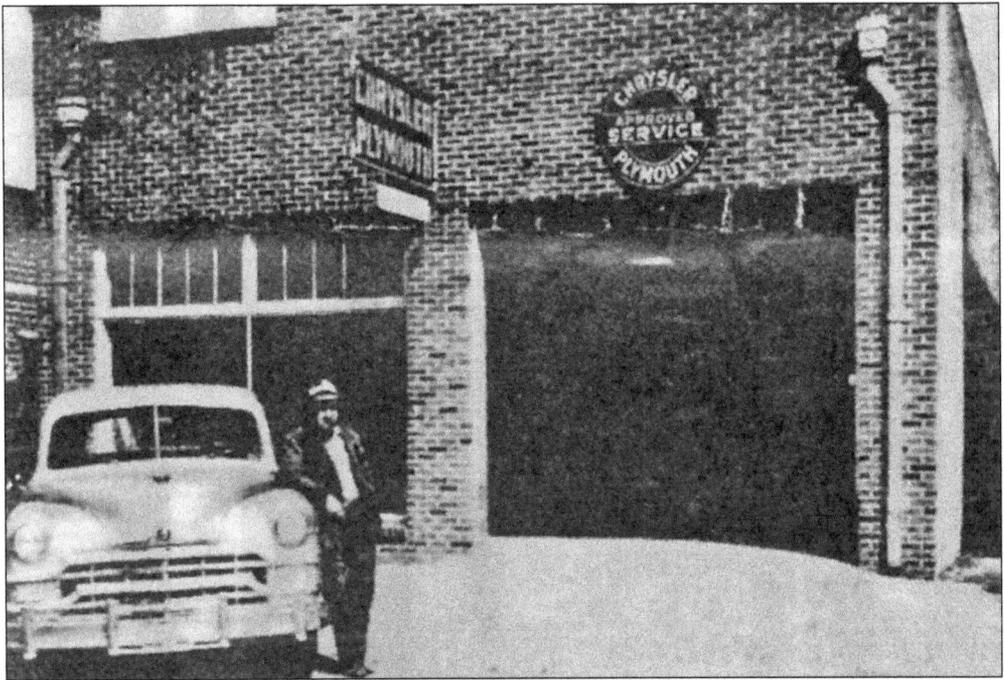

In 1938, W.C. Scherer stands in front of the third location of W.C. Scherer Motor Company, 815 Second Street in downtown Rosenberg. He is leaning on a silver-anniversary edition Chrysler that he drove from Detroit, Michigan.

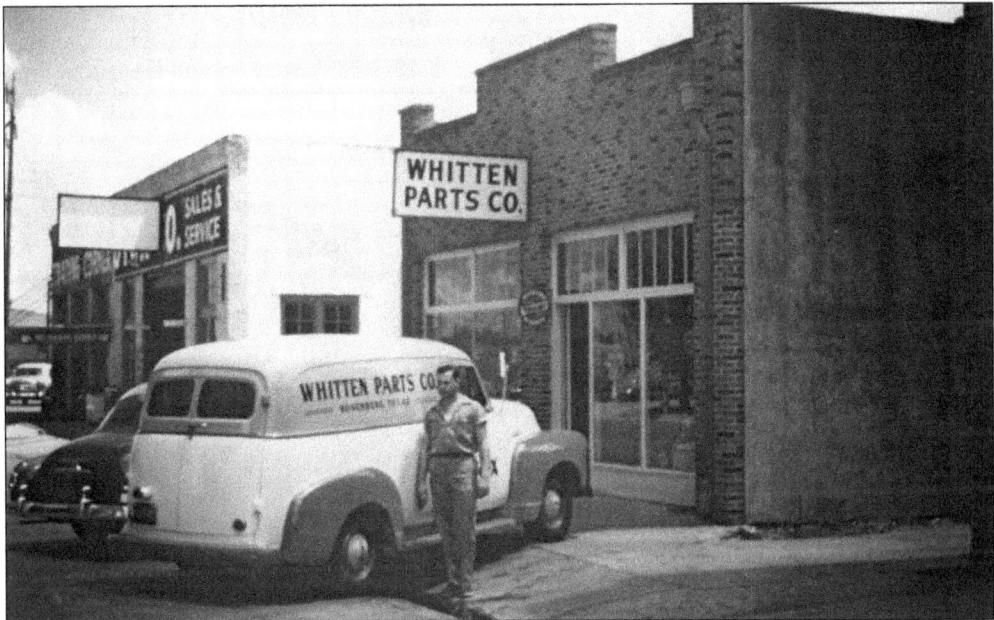

In 1950, Bob Whitten took the building over from his father-in-law, W.C. Scherer. Bob Whitten customized the 1953 GMC panel truck to carry paint to body shops. In this way, the paint colors could be mixed on-site. An employee of Whitten Parts Company stands next to the customized truck. Other businesses housed in the building were All-Tex Contractors Plumbing and A/C (1978–1986) and Y.E.S. Auction House, which has resided in the building since 1994.

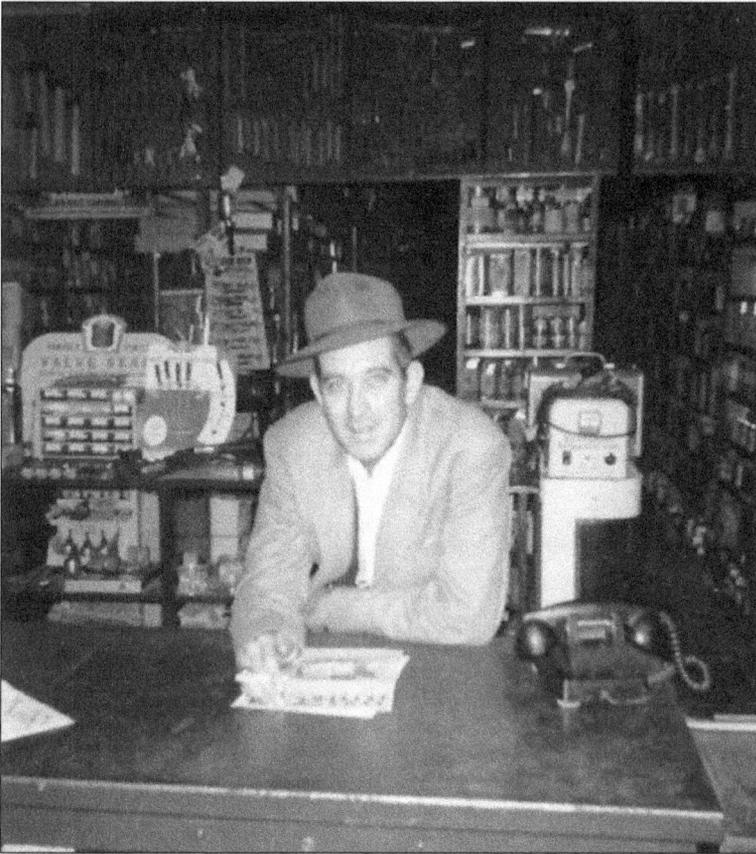

Owner Bob Whitten poses at the counter in his auto parts store in the early 1960s. Pictured below, at 815 Second Street today, is Y.E.S. Auction House. (Below, courtesy of BAC Photography and Design.)

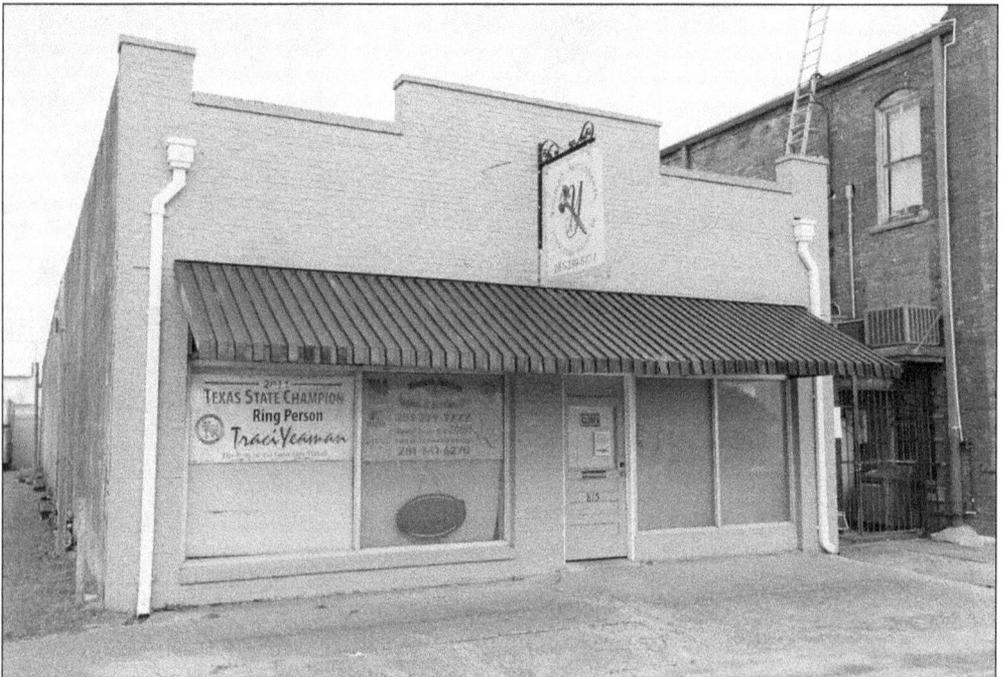

Above, an aerial view of downtown Rosenberg in the 1970s shows Second Street and Avenue G. The sloped roof to the left of center is the present location of Bee Unique, which began in this compound in 1988 and as space became available took it over. There were several businesses in this building, like Red Chain Feed Store (1950–1955), G&G Refrigeration (1980–1986), LaPetite Art Classroom (1969–1970), Powell's Watch Repair (1974–1982), Galicia Boot Shop (1984–1992), and Red Dot TV Repair (1986–2008). Pictured below, at 902 Second Street today, is Bee Unique. (Below, courtesy of BAC Photography and Design.)

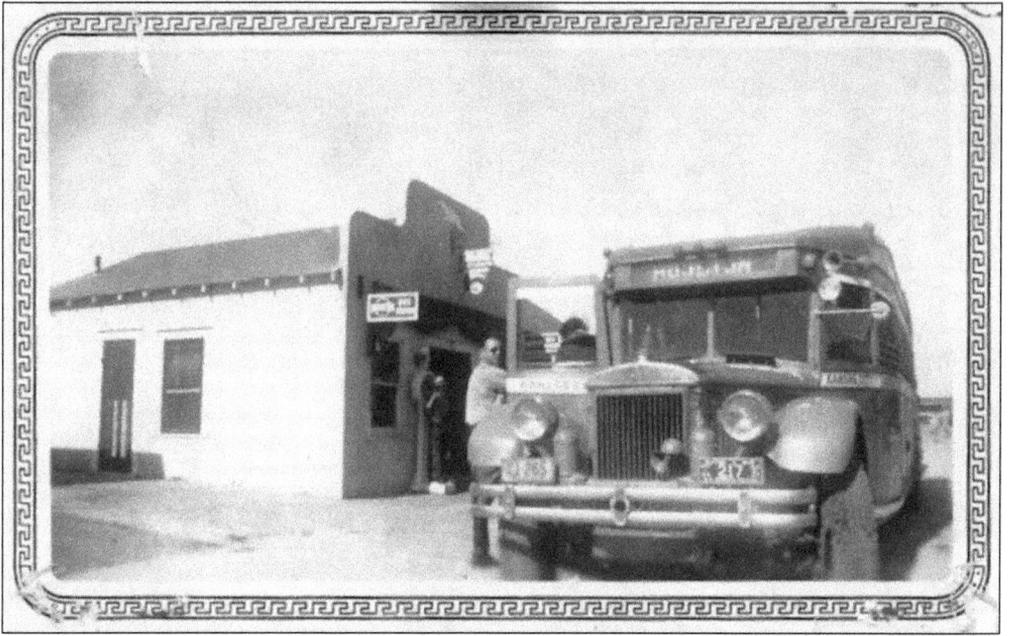

The Greyhound bus station was located at 928 Second Street. This 1936 photograph shows a bus bound for Houston. The building was razed, and the concrete slab is all that remains.

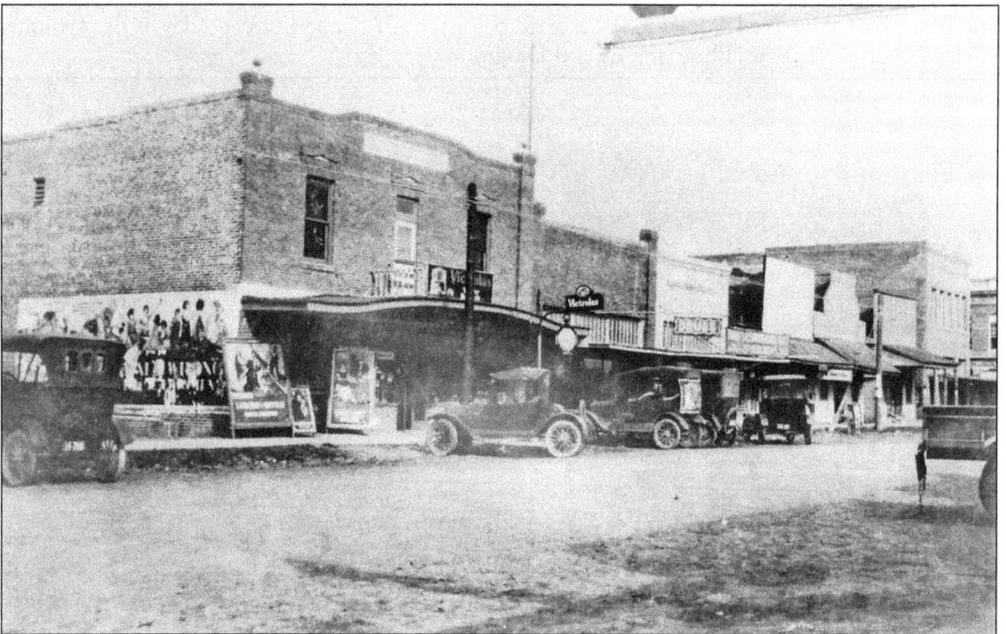

This early 1920s picture shows the playbills for movies being shown at the Liberty Theater, located on Main Street.

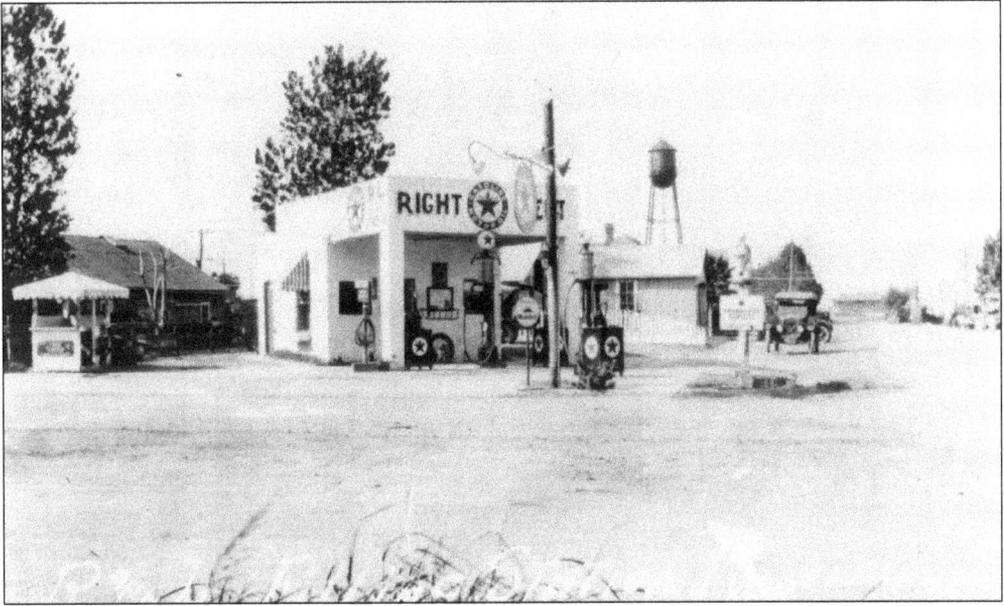

On the corner of Second Street and Old Spanish Trail was the 1920s R&L Filling Station. Owners Rude and Lane sold the business to Bill Allison in the 1930s, and he changed the name to Right and Left Filling Station. Later, the building was torn down, and W.H. Penkert built Penkert's Tire Supply. His son, Leonard, operated it until his retirement, and now Leonard's son, Bill, runs it. Lyndon B. Johnson landed his helicopter on the roof while running for US senator in July 1948, and in 1963, he became president of the United States of America. Pictured below, at 1831 Avenue H, is Penkert Tire Supply. (Below, courtesy of BAC Photography and Design.)

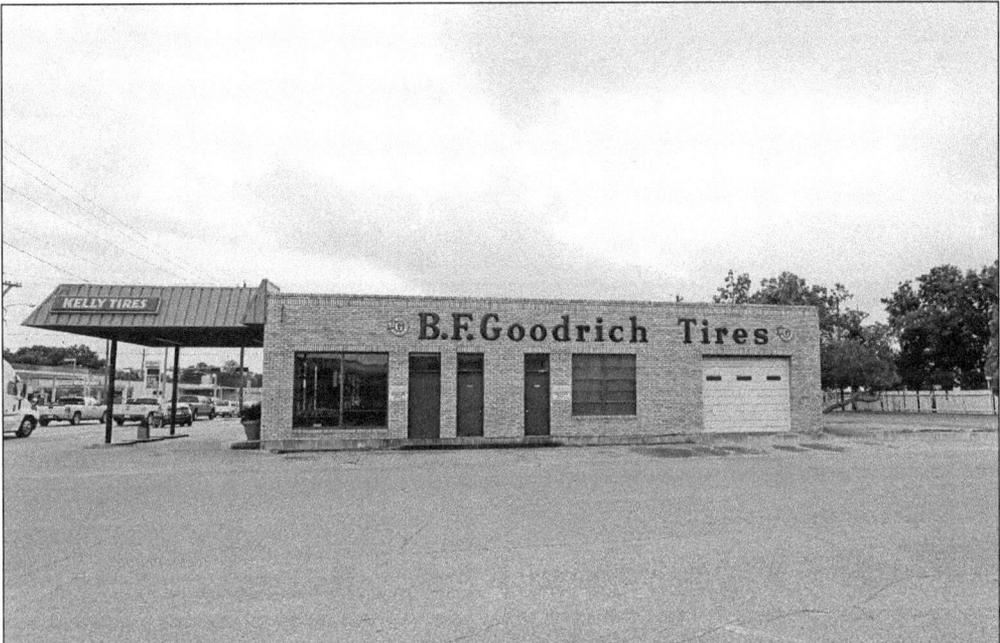

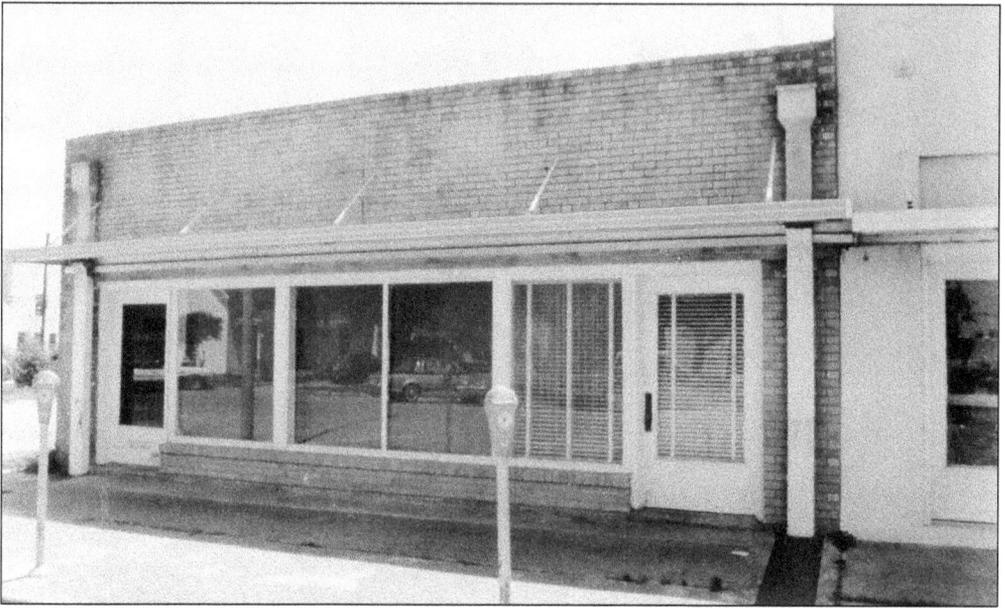

The building at 927 Second Street housed Fort Bend Federal Savings & Loan, its second location, from 1948 to 1957. During this time, Jack Wilkinson, an optometrist, was located in the back (1950–1951). Pink Puff Beauty Salon took over when Fort Bend Federal moved in 1957. Blanche Stupka was the owner and operator, and Charlotte Bosak was an operator. Lori's Fabrics was located here in the early 1970s, and then Today's Respiratory rented from 2004 to 2011. In 2011, Envios y Servicios Express began renting, as is pictured below. (Below, courtesy of BAC Photography and Design.)

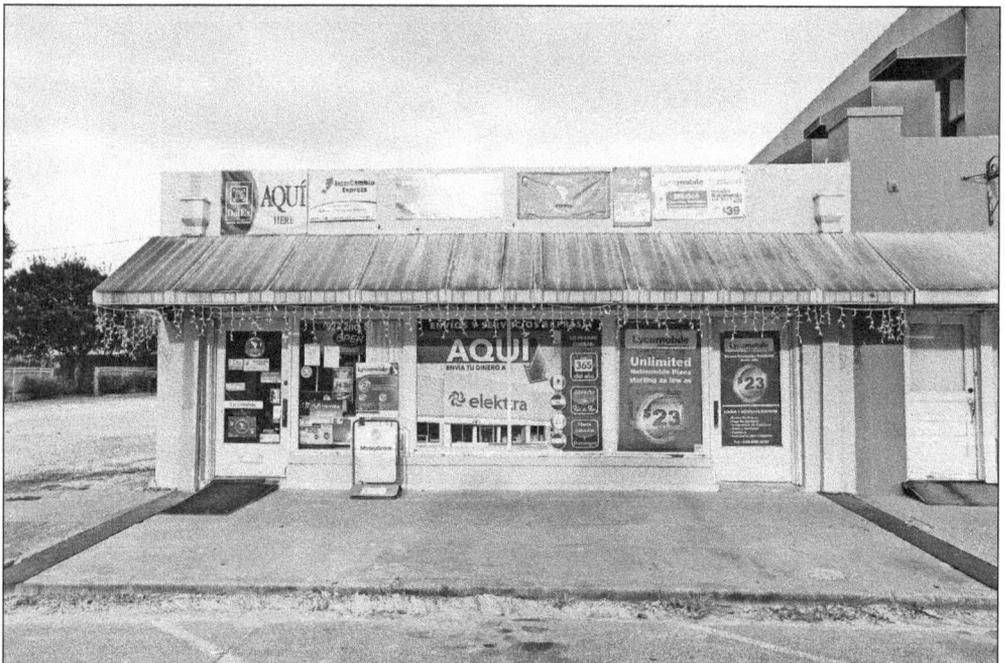

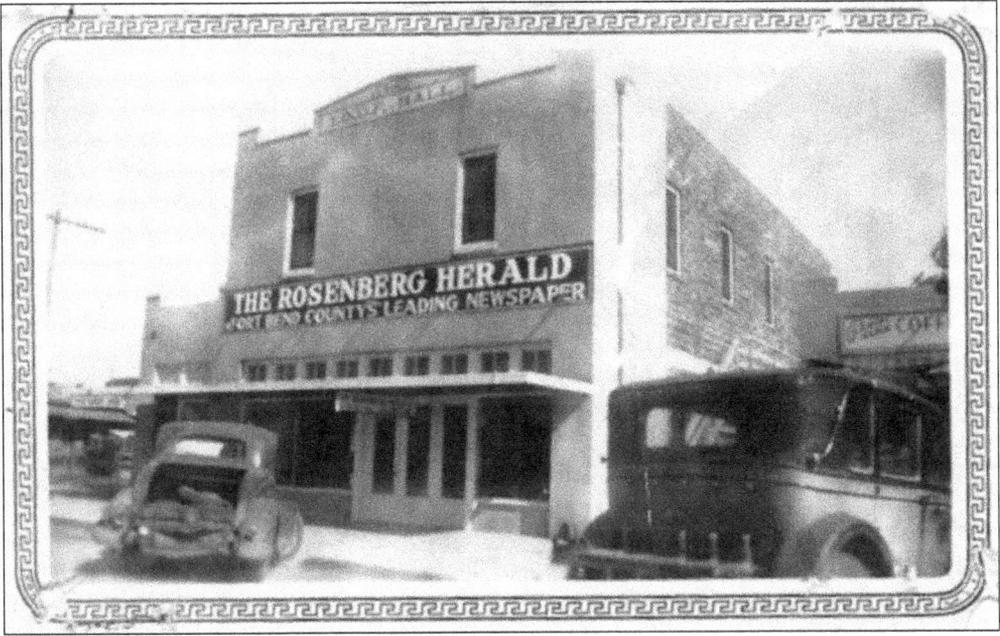

The above photograph, taken in 1936, shows the IOOF (Independent Order of Odd Fellows) Hall building in the 900 block of Second Street. The *Rosenberg Herald* newspaper had its printing press on the top floor to keep it safe from possible flooding. Other businesses were Hand Me Down Shop (1964–1990), J&J Embroidery Works (1992–1998), and Checkered Past Antique Store (1998–2008). As pictured below, 933 Second Street has been used as storage since 2008. (Below, courtesy of BAC Photography and Design.)

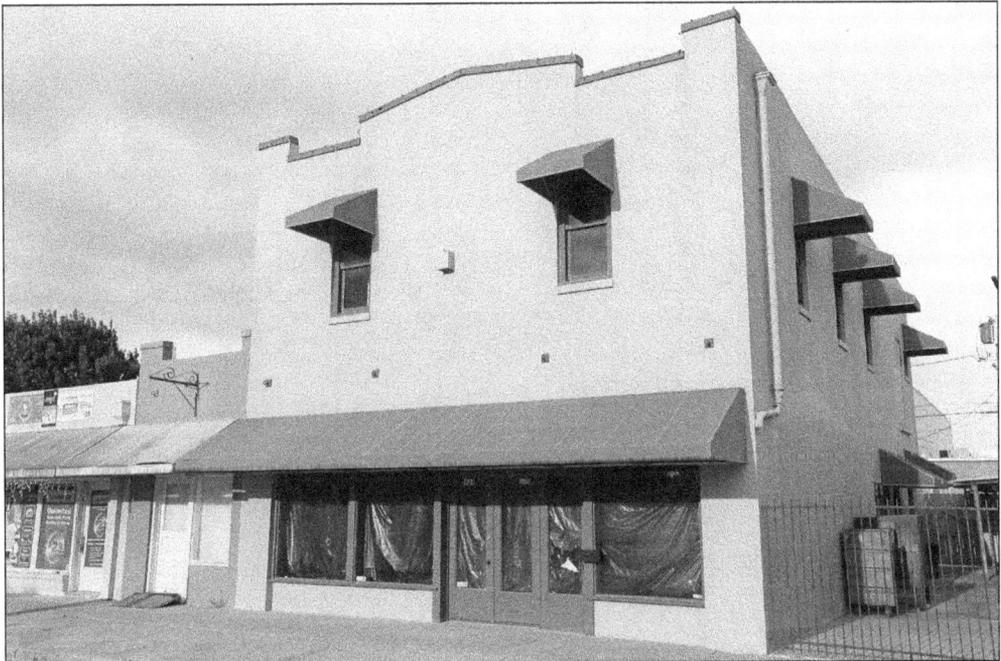

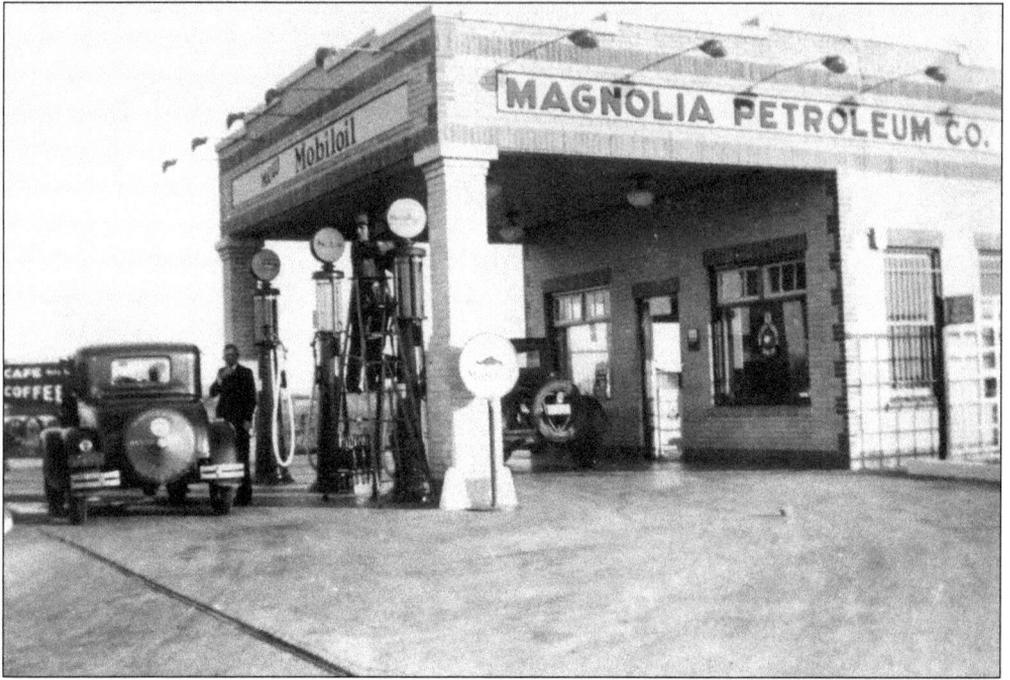

Located at the corner of Second Street and Old Spanish Trail (Highway 90A) in the 1920s was the Magnolia Petroleum Company service station. From 1970 to 1995, it was Joe's Auto Repair. The location has been home to Bob's Taco Station, owned by Bob Alanis, since 2005. (Below, courtesy of BAC Photography and Design.)

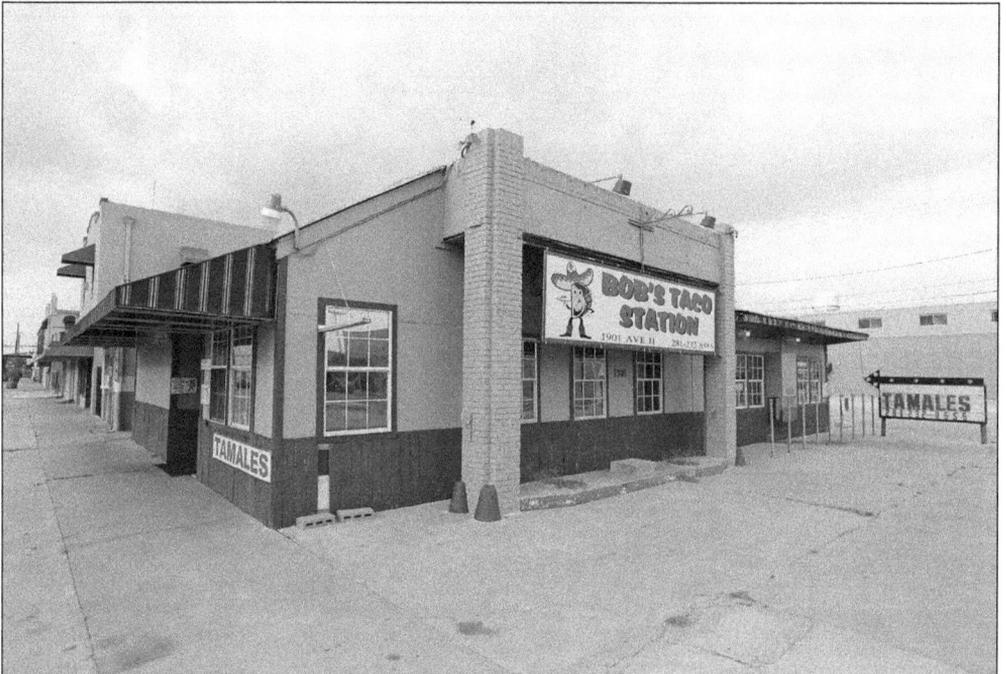

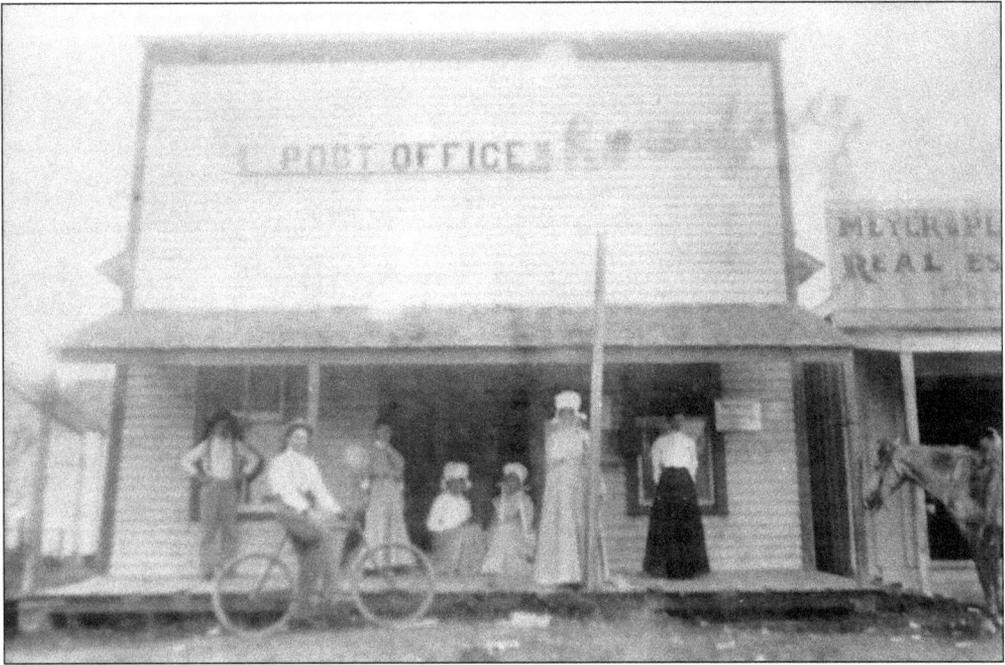

Shown above is a close-up of the Rosenberg Post Office building located on Avenue F in 1899. Harvey P. Ruff was the postmaster. The wooden building was replaced with a brick building that housed Rose-Tex Hotel apartments (1948–1955) and became private residences until the late 1990s. Pictured below, 2034 Avenue F is today a vacant building. (Below, courtesy of BAC Photography and Design.)

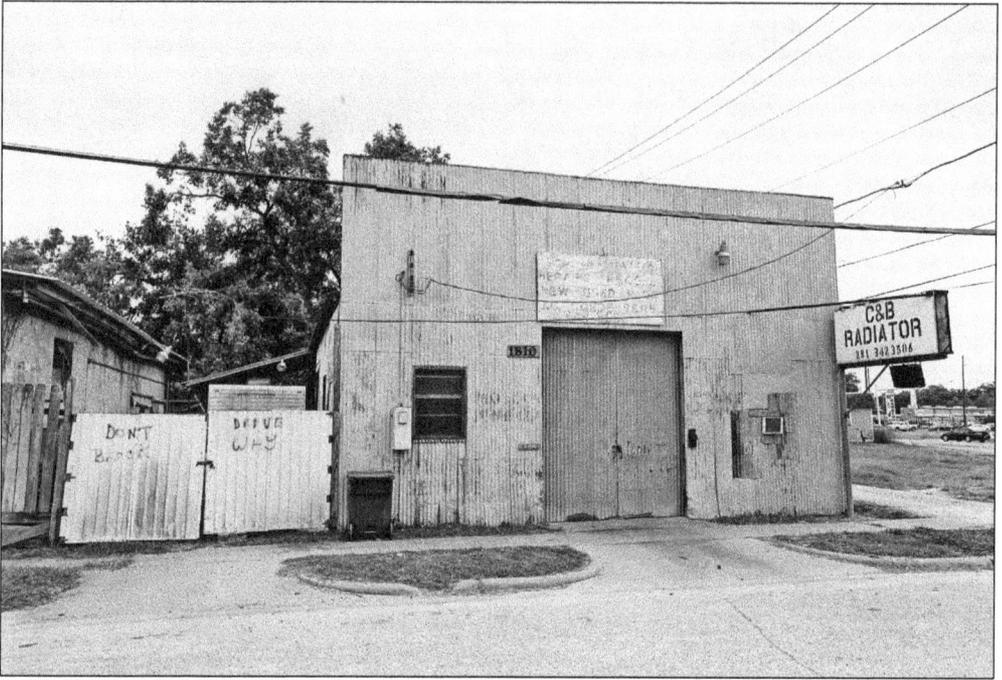

This building, located at 1810 Avenue G, has been the home to C&B Radiator Shop since 1980. It also housed two other shops, Walter Hinsley/Robert Pollock Mechanics Shop (1950s–1960s) and Manuel DeLeon and Sons Mechanics Shop in the 1970s. (Courtesy of BAC Photography and Design.)

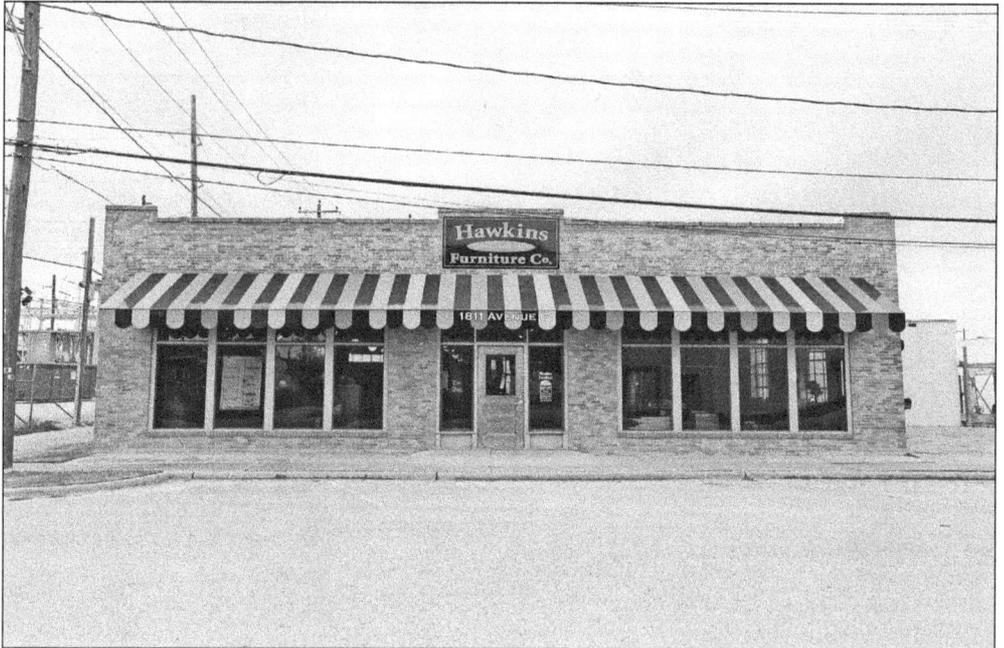

Located at 1811 Avenue G since 2008 is Hawkins Furniture Co. There were other businesses before Hawkins, like Talasek's Tractor Co., an Allis-Chalmers dealer (1936–1948), and White Auto Store (1952–1980). (Courtesy of BAC Photography and Design.)

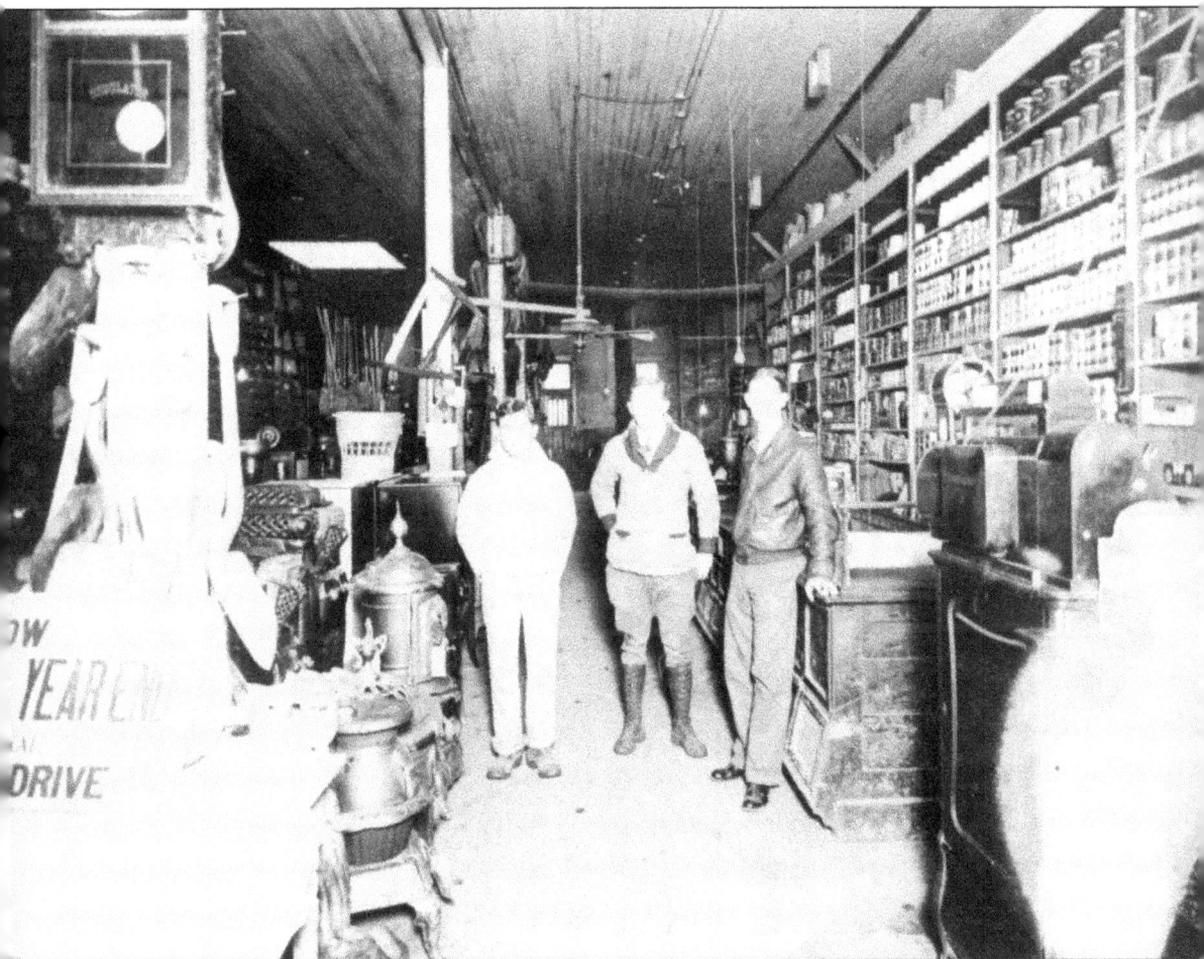

Here is an interior view of J.T. Barnes Grocery, located in the 900 block of Main Street. Posing here are Logie Mikeska (left), Leonard Meyer (center), and operator P.K. Rude Sr.

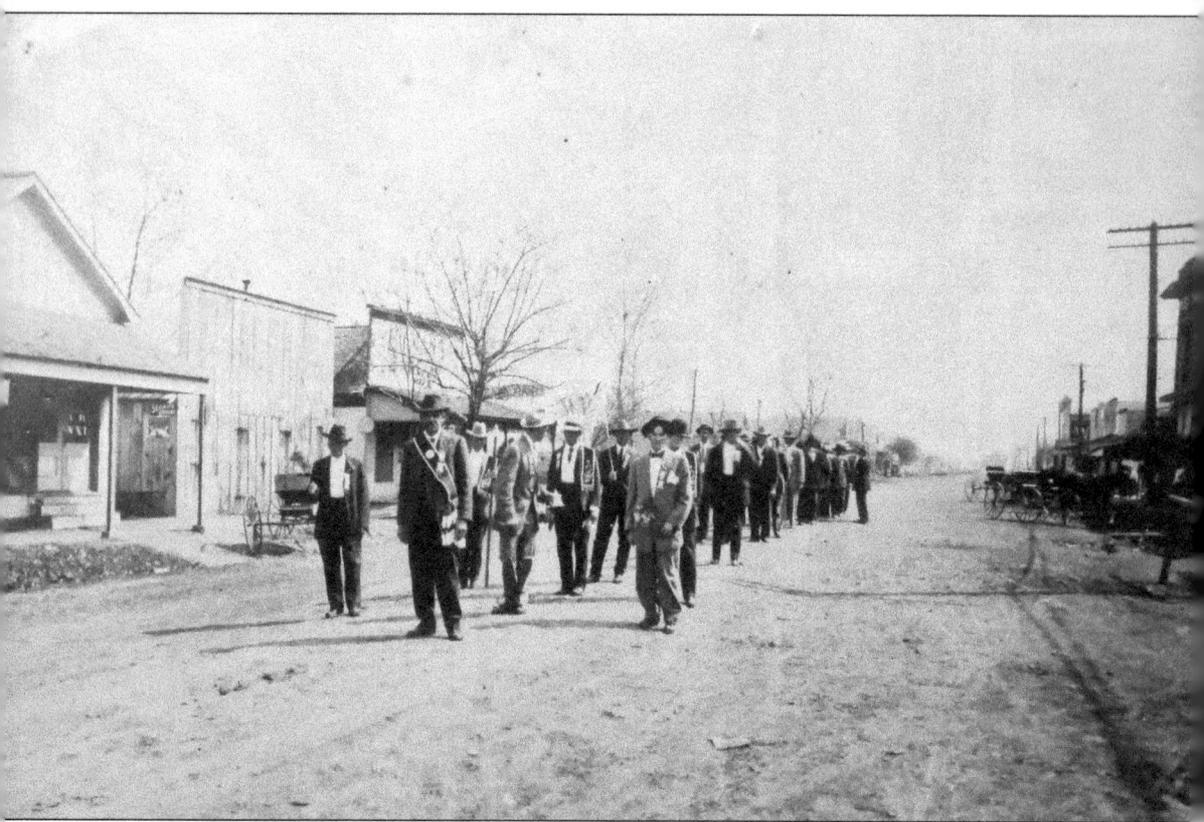

Main Street was the center of activity in Rosenberg. Here, a fraternal organization conducts a parade.

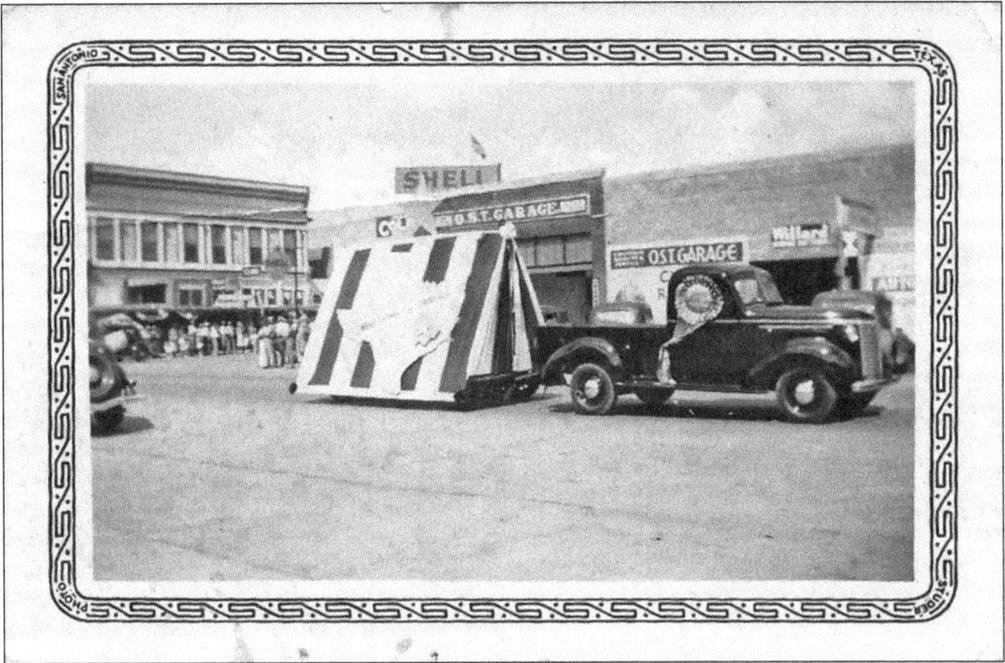

Looking to the left of the float is the Eagle Café, located on OST (Highway 90A) in the early 1940s before it burned down.

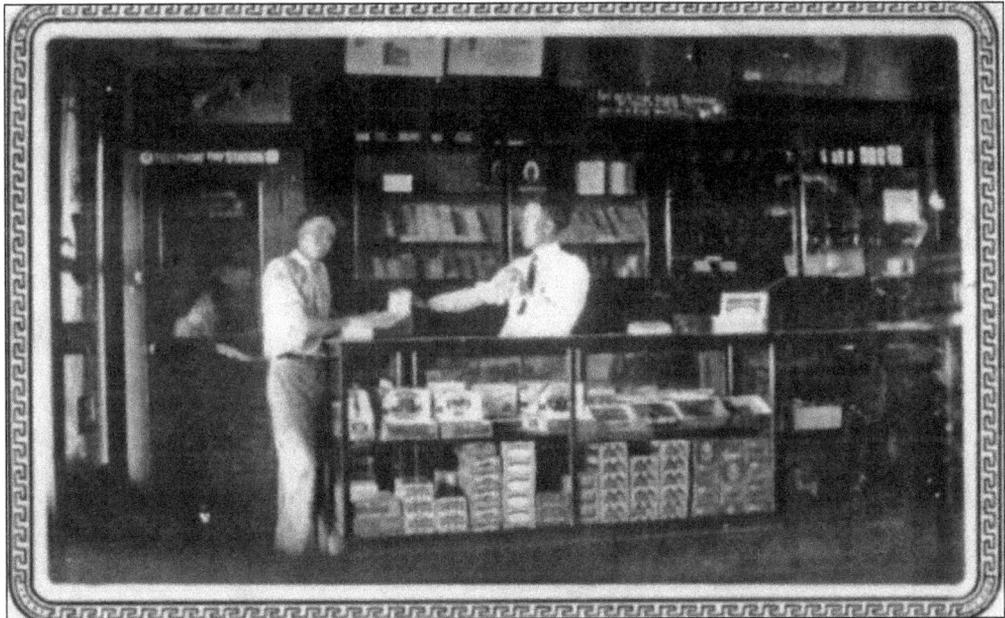

This is a photograph of Pickard & Huggins Drugstore in 1938.

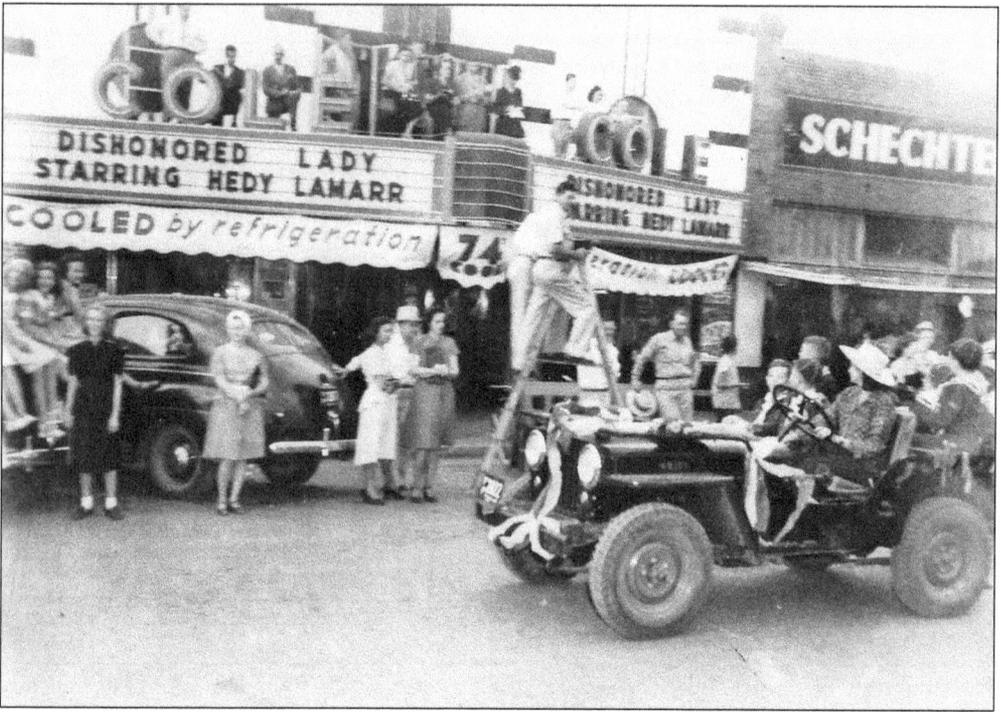

The Fort Bend County Fair Parade is seen here in the late 1940s as it passes the Cole Theater in the 900 block of Main Street. The judges from the parade stood on the marquee of the theater to better view the parade entries.

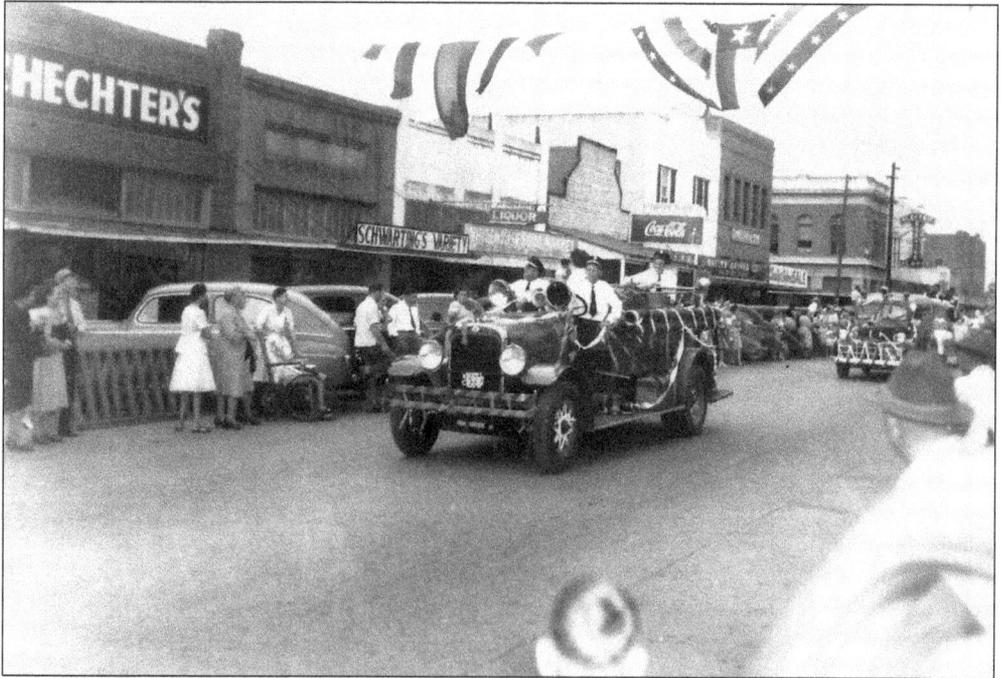

Heading south on Main Street, this parade passes Schwarting's Variety Store in 1941. Slovak's Place was located where the Coca-Cola sign is.

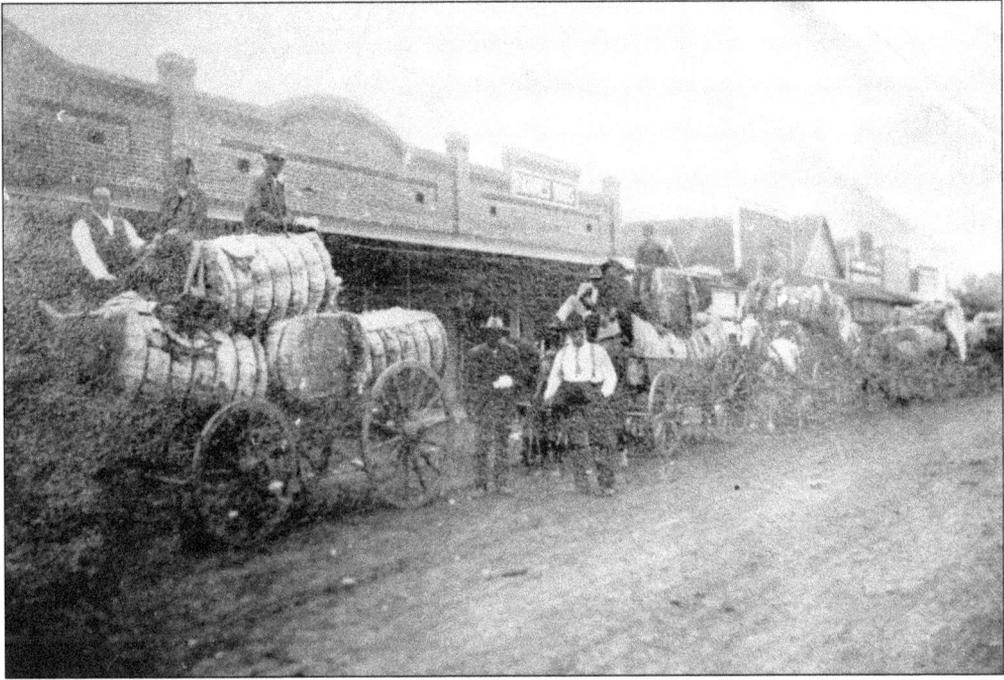

Hauling cotton up Main Street to the railroad depot, this caravan passes in front of the Barnes Bros. store on the east side of the 900 block around 1912.

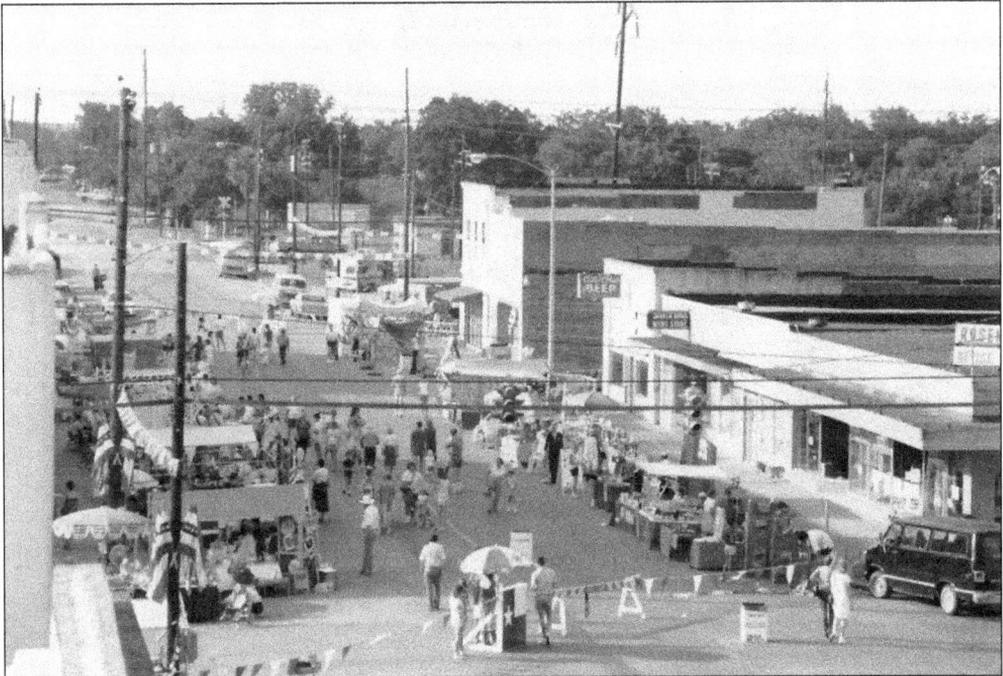

This photograph of the east side of downtown shows the 800 block of Main Street. Among the businesses shown here are the City Club, Janack Bros. Men's Store, and Rosenberg Office Supply. The photograph was taken on July 19, 1986, during the July Jubilee street festival.

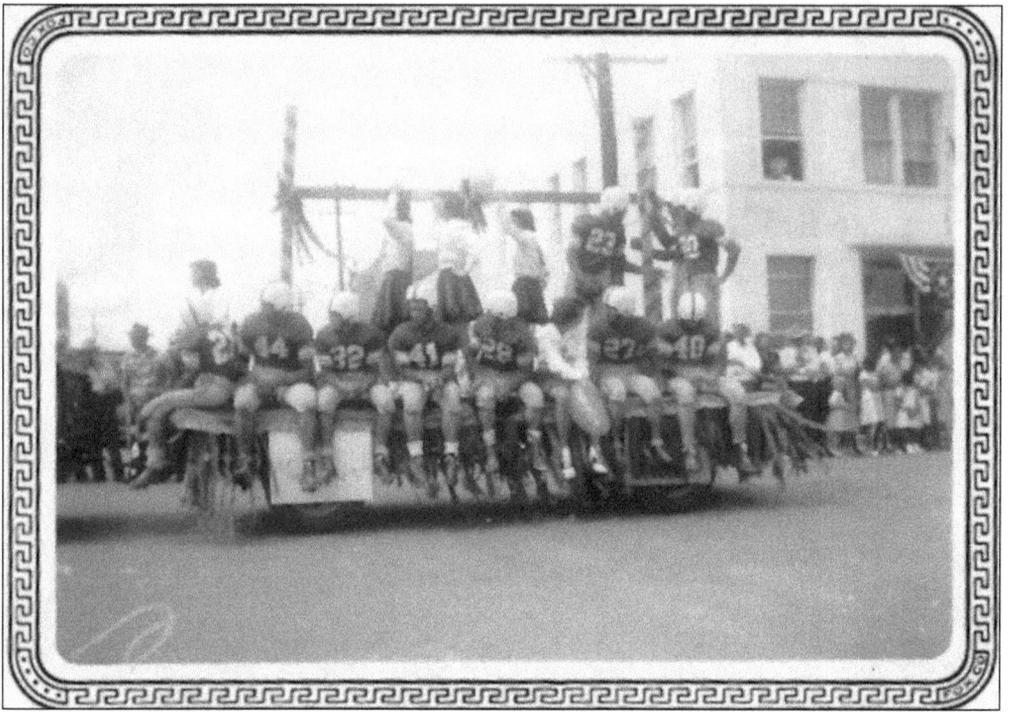

A 1949 parade in downtown Rosenberg travels down Main Street. Rosenberg and Richmond High Schools were consolidated in 1947.

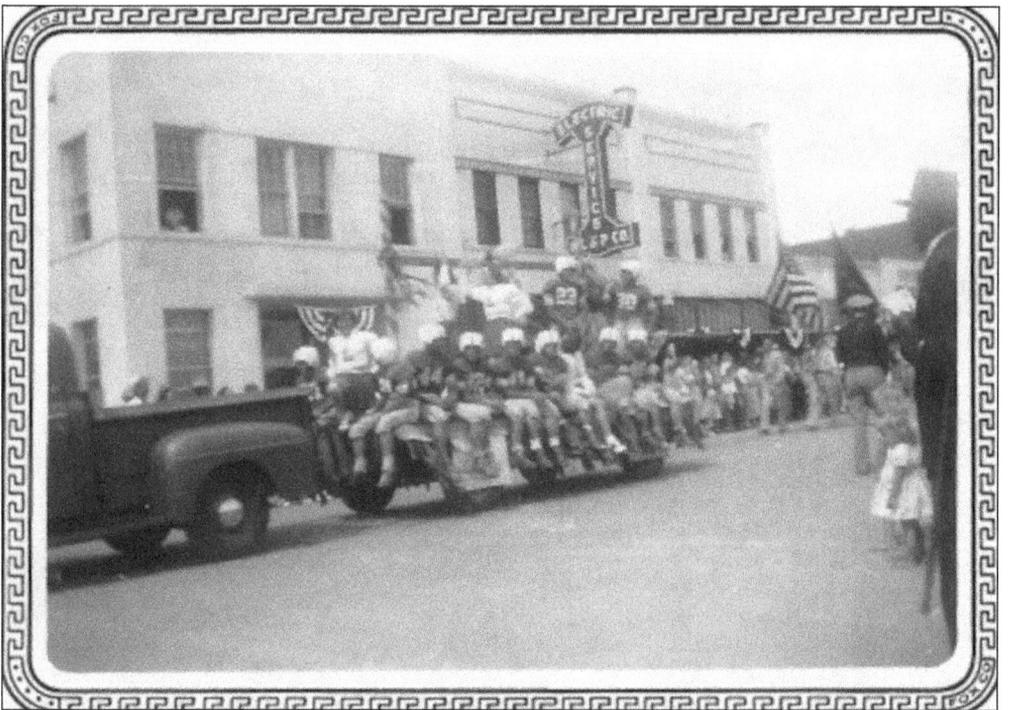

The Lamar Consolidated Independent School District football players and cheerleaders ride in the 1949 Fort Bend County Fair Parade. The player wearing No. 23 is quarterback Al Hochmuth.

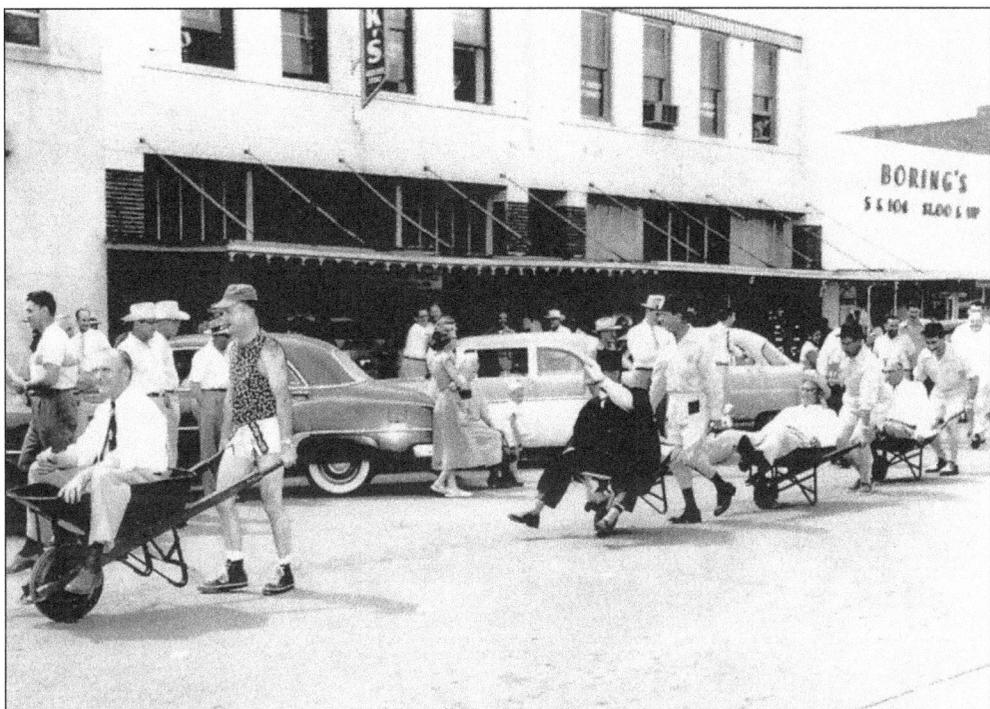

The Rosenberg Lions Club held its Tail Twister Membership Drive on Main Street. At center, L.D. Erwin is pushing "Sona" Foerster in a wheelbarrow in the early 1950s.

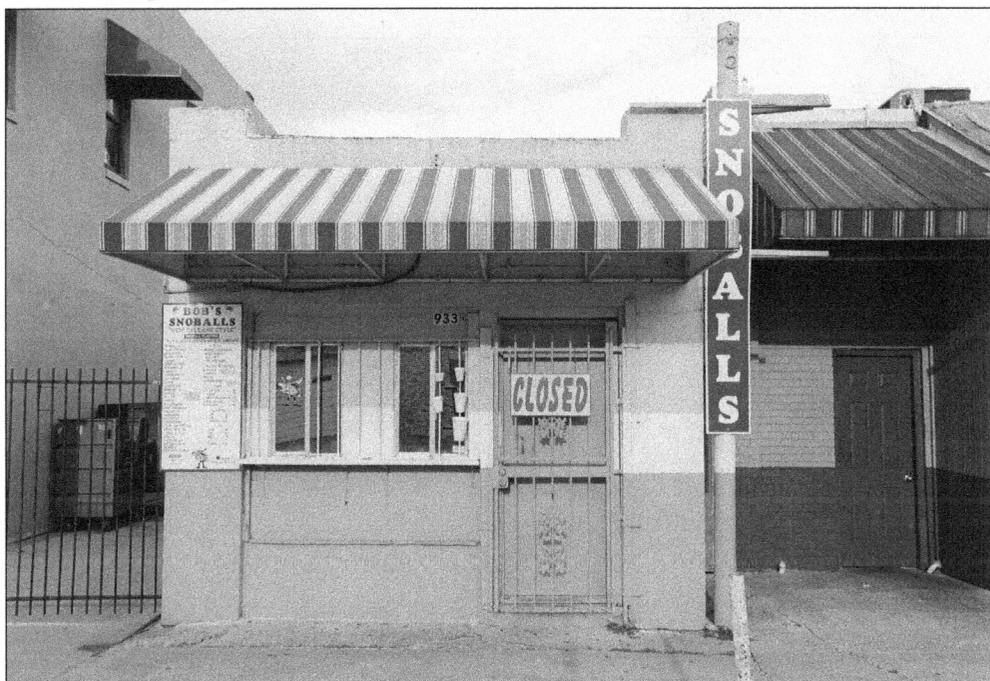

The present location of Bob's Snowball Stand on Second Street is seen behind Bob's Taco Station. This once housed General Printing Shop in the 1920s, Petite Coffee Shop in the 1930s, and Hi-Way Barber Shop in the 1950s. (Courtesy of BAC Photography and Design.)

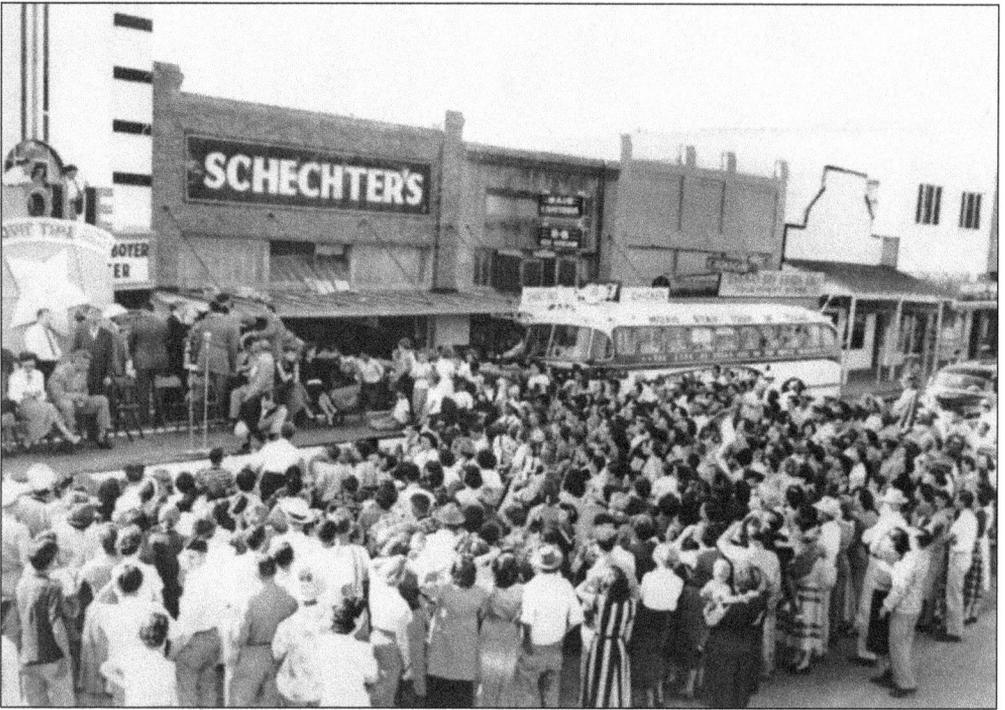

Jeff Chandler, a Hollywood actor, is the gentleman seated on the stage, left of the microphone, in this 1951 photograph. Along with John Wayne and others, he was promoting movies during the ascension of television into homes.

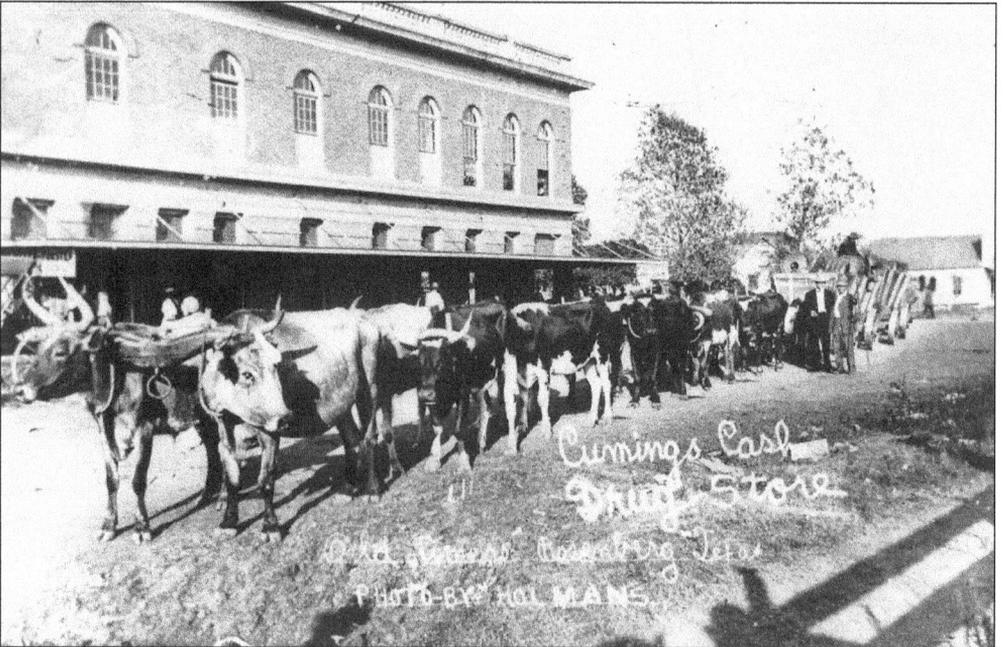

On the corner of Main Street and Avenue G, a supply train led by oxen hauls supplies between Rosenberg and Needville in 1908. The steers were owned by Henry Banker and operated by Paul Lehmann. This photograph was taken facing east.

Three

DOWNTOWN REVITALIZED

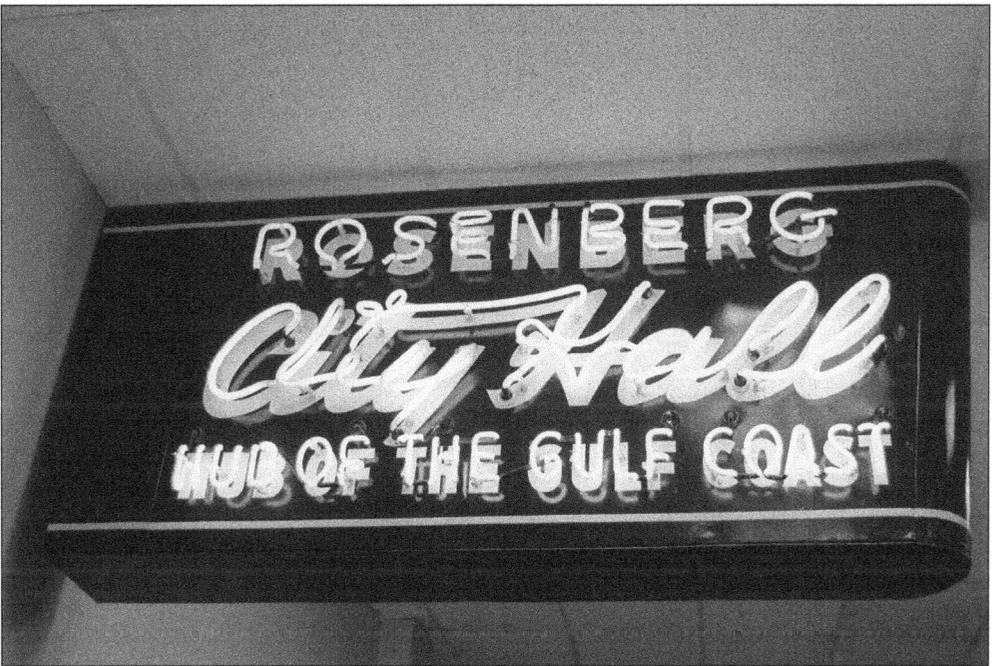

Downtown Rosenberg is back and doing great! Every year in downtown, there are several events, like the Chocolate Walk, Trunk or Treat, Sip and Stroll with the Fort Bend County Fair, Farmers Market in the park, and Christmas Nights in Rosenberg. In 2015, the downtown park on Main Street will have two murals painted on the walls through a community effort. There are no available spaces for rent in downtown anymore. The city's forefathers would be so proud of how it again is a vibrant place for all!

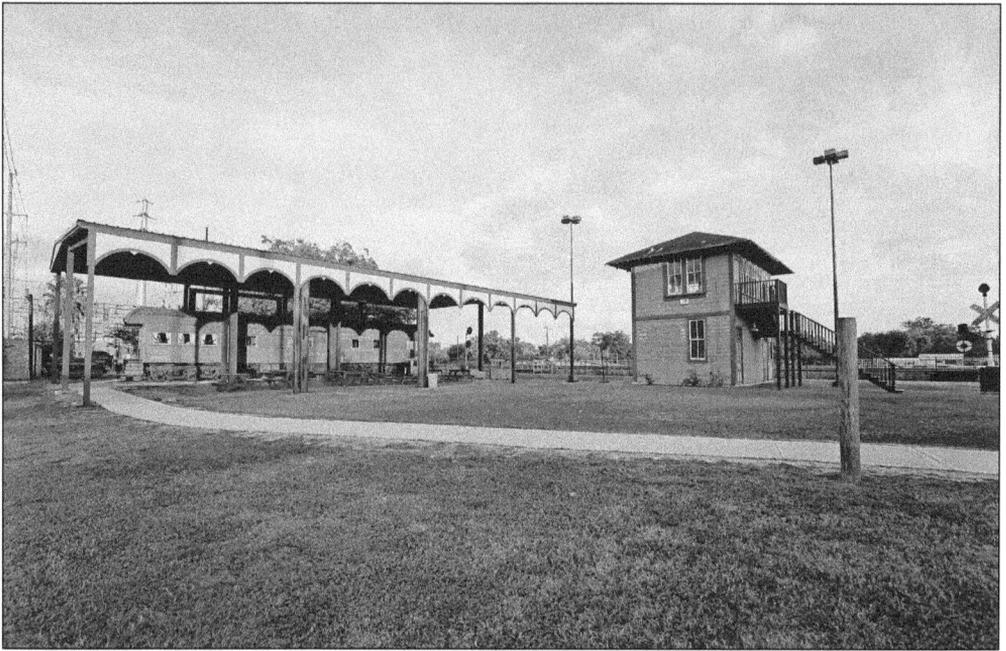

The Rosenberg Railroad Museum opened in 2002. It highlights the importance of the railroad to the area's development. Shown at right is Tower 17, the last traditional interlocking tower in Texas. At left is the 1879 Victorian-era Business Car, which is located on the grounds of the museum. (Courtesy of BAC Photography and Design.)

Shown here is the construction of a garden railroad, a depiction of the Rosenberg-Richmond area. The outdoor model railroad exhibit has a 70-foot water feature representing the Brazos River. This project is scheduled to be completed in the summer of 2015. (Courtesy of BAC Photography and Design.)

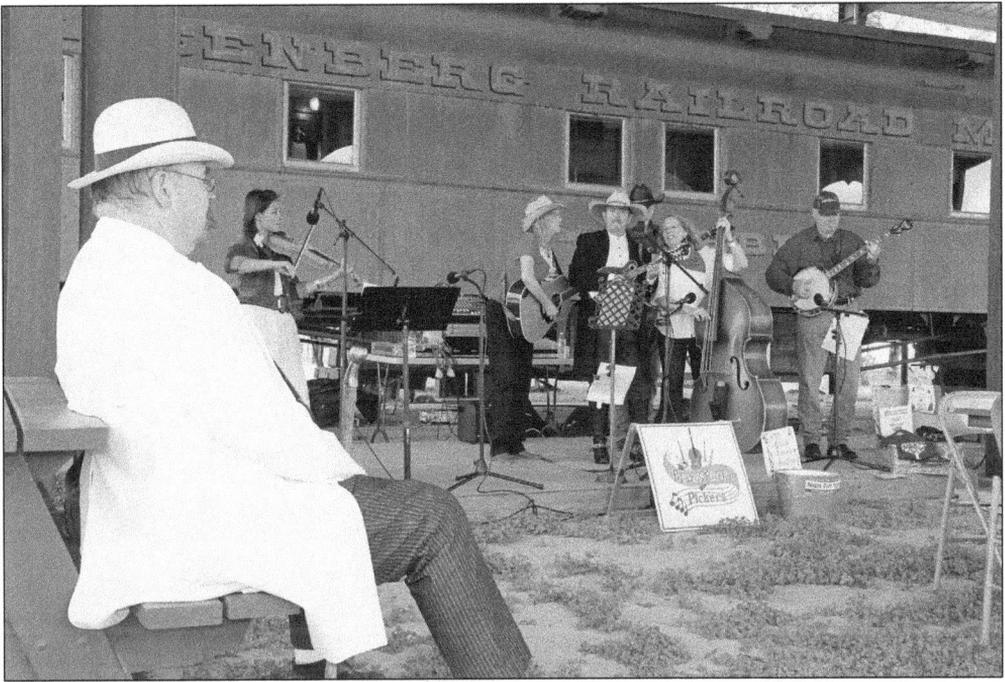

The annual Rosenberg Railfest provides entertainment and fun for the whole family. (Courtesy of BAC Photography and Design.)

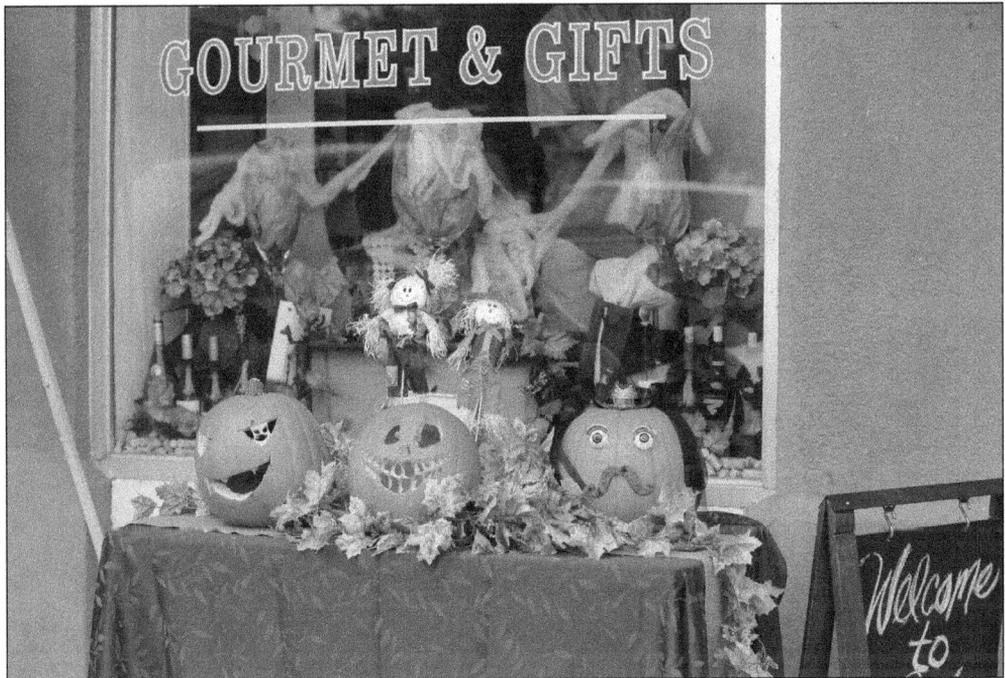

Downtown Rosenberg has its annual Trunk or Treat during Halloween. Local merchants decorate their stores for the festivities. (Courtesy of BAC Photography and Design.)

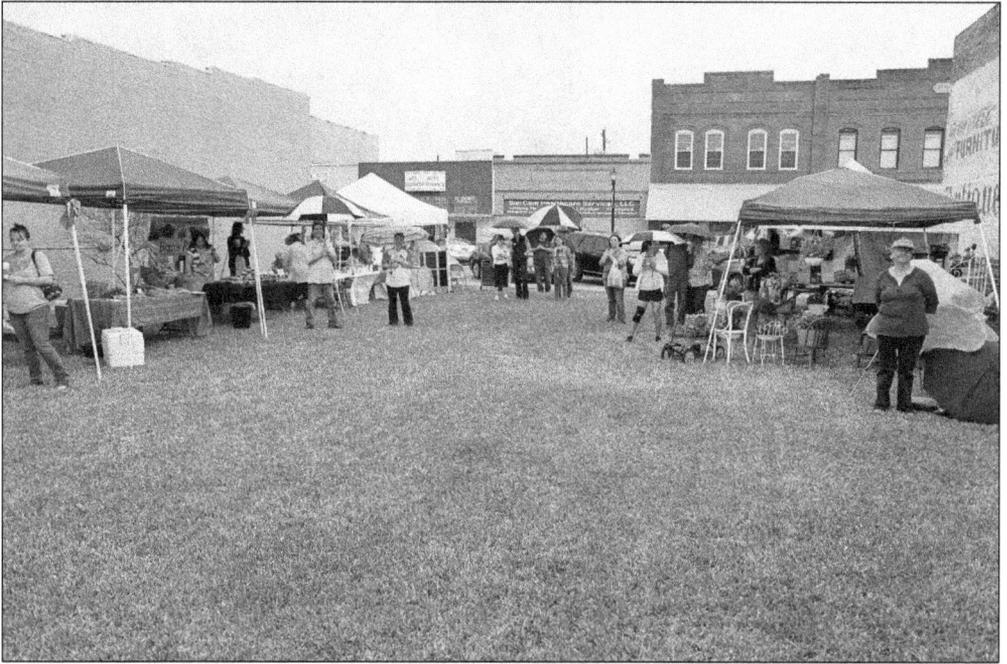

Rosenberg's Farmers Market, located in Third Street Park, offers fresh produce and homemade goods weekly. (Courtesy of BAC Photography and Design.)

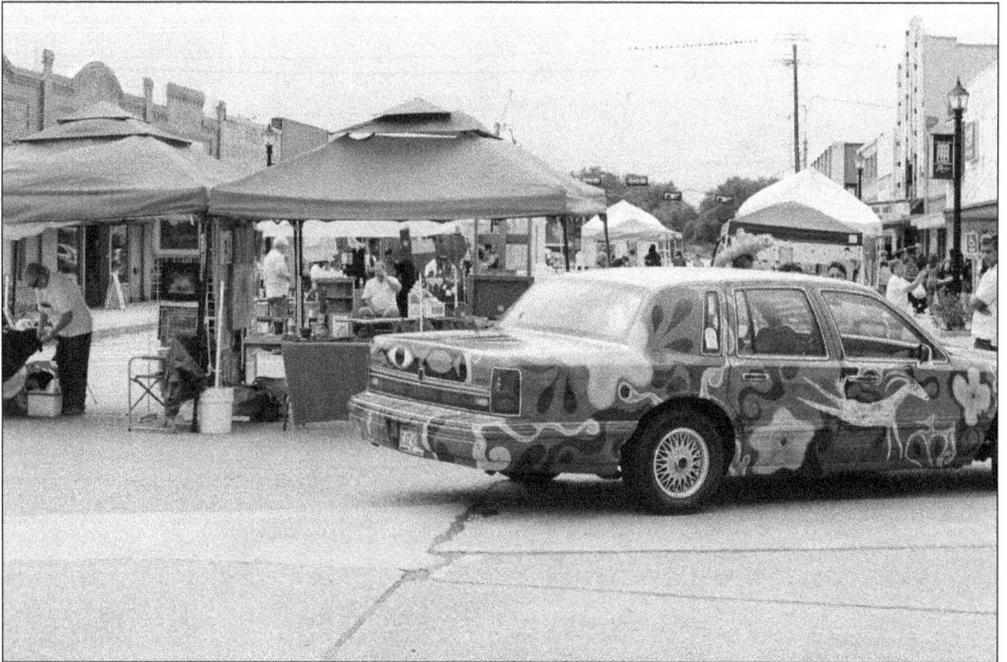

Downtown Rosenberg hosts many art-related activities. The street fair seen here features this local art car. Downtown has been designated a Cultural Arts District. (Courtesy of BAC Photography and Design.)

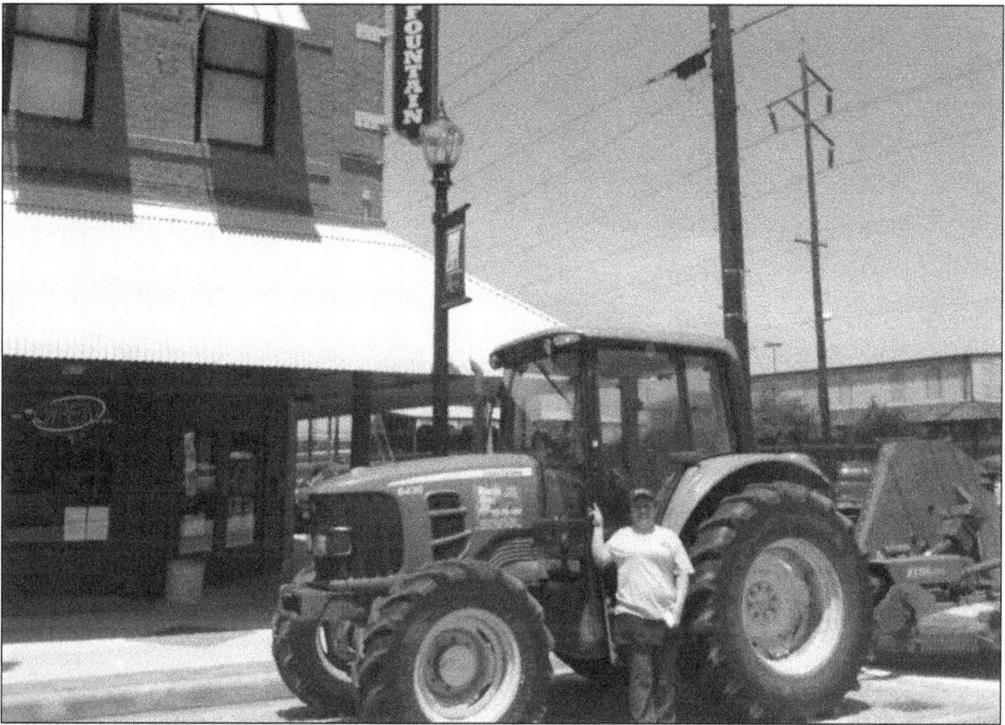

Main Street has always been the thoroughfare for farming since the days of the railroad. On occasion, a tractor comes through, and a thirsty driver stops for a refreshing drink. While the driver is inside enjoying his refreshment, Amy Martinez admires the tractor. (Courtesy of BAC Photography and Design.)

Downtown artist Paul Sanchez of Simply Artistic presents a rendering of one of the murals that will be painted through a community effort in Third Street Park in 2015. (Courtesy of BAC Photography and Design.)

Visit us at
arcadiapublishing.com